Indian Embroidery

Indian Embroidery

ROSEMARY CRILL

Photography by Richard Davis

V&A Publications

First published by V&A Publications, 1999

V&A Publications
160 Brompton Road
London SW3 1HW

© The Board of Trustees of the Victoria and Albert Museum 1999

Rosemary Crill asserts her moral right to be identified
as the author of this book

Designed by Yvonne Dedman

ISBN 1 85177 310X

A catalogue record for this book is available from the British Library

Printed in Hong Kong by Hong Kong Graphic and Printing Ltd

Photography by Richard Davis, V&A Photographic Studio

Jacket illustrations:
Front: Skirt fabric from Memon or Lohana community, Tharparkar,
Sindh, Pakistan or Banni, Kutch, Gujarat, mid-20th century.
(See plate 96).
Back: Bed or wall hanging from Gujarat, for the English market, *c.*1700.
(See plate 1).

Contents

Acknowledgements

I am immensely grateful to Marianne Ellis for identifying the stitches in many of the embroideries in this book. Her expertise in this area is second to none, and if mistakes have occurred in the captions they are entirely my own. Colleagues in the Department of Textiles and Dress patiently answered questions about European textiles. I would also like to thank Richard Davis of the V&A's photographic studio for his excellent photography, and John Gillow for sharing (as always) his wide knowledge of Western Indian and Sindhi embroidery and the communities who made and used them.

Indian Embroidery

There can be few societies in which embroidery has played such a prominent role as it has in India.[1] Whether in the rural tradition, in which embroidery featured strongly as dowry goods, wedding paraphernalia and group identifier; at the courts of the Mughals and other ruling élites, in which embroidered textiles adorned the carved stone halls as well as the persons of the nobility; or in the thriving export market that has made India's textile products famous for two millennia, embroidery has always been to the fore in India's uniquely rich textile tradition.

The range of India's embroidery styles is closely linked to regional variations, both in materials and in stitch types. For example, embroidery in Kashmir is often on locally produced wool, while fine cotton muslin is used as the ground cloth in Bengal, its place of manufacture. While some stitches, for example chain-stitch, may be found all over India, others, like the interlacing *hurmitch*, identify the embroidery as being from certain parts of Pakistan or western India. Patterns may also reflect the place of origin, whether it is the angular *soof* of the carpenter community of Rajasthan and Sindh, the elaborate floral designs of the Mughal court, or the hybrid Europeanised patterns done for the export market. Indian embroidery may be carried out by male professionals in busy urban workshops or by women at home during breaks in their other work, and may be used purely in the domestic context or for more public commissions. Some types of embroidery have all but disappeared from India; others, like the *kantha*, have faltered and been revived; in many cases, the changing way of life of the twentieth century has rendered embroidery redundant except for the tourist or interior design market.

Embroidery has a very long history in the Indian subcontinent. The earliest Indian needles were excavated at Mohenjo Daro (today in Pakistan) and are datable to about 2000 BC. Their existence naturally indicates a tradition of sewing and so also allows the possibility of embroidery. The patterns of textiles represented in early sculptures suggest that sophisticated weaving, printing, and embroidery techniques were known from a very early period, but we have no primary evidence of these early fabrics as none survives. The commentaries of some early travellers to India shed light on the types of textiles used at the courts they visited, although emphasis is usually on the fineness of woven cloths rather than embroidery. In the fourth century BC, for example, Megasthenes, the Greek ambassador to the Mauryan court, was impressed by the elaborate robes he saw there, embellished with gold or patterned with flowers; while these may well have been embroidered, there is no specific reference to the technique at this early date. Similarly, patterns on textiles depicted in the paintings at Ajanta (*c.* 5th century AD) are hard to identify as being embroidered rather than woven or printed.

The oldest surviving examples of Indian embroidery to have come to light so far are two pieces made for Jain nuns in the fifteenth or sixteenth century,[2] but apart from these apparently isolated examples, the two earliest categories of embroidery to survive are pieces made for export to Europe from the late sixteenth century (see plates 1–21), and those made for the Mughal court from the seventeenth century (see plates 22–30), although most of the survivors in both categories are somewhat later.

Embroidery for the European Market

European travellers from Marco Polo onwards have commented on the high quality of the embroideries from Eastern India (Bengal) and Western India (Gujarat and Sindh, today in Pakistan). Marco Polo, travelling in the late thirteenth century, was particularly impressed with the embroidery on leather, a tradition still alive today in Sindh

and western Rajasthan. He remarks that 'in this kingdom [Gujarat] works of embroidery of leather are better made and more cunningly and with greater skill than is done in all the world beside...'.[3] Polo does not mention the fine chain-stitch silk embroidery for which Gujarat became renowned, and in fact this is not recorded until 1518, when the Portuguese traveller Duarte Barbosa praises the 'very beautiful quilts and testers of beds finely worked' that may be identified with the type that was exported to Britain from the Gujarati port of Cambay (present-day Khambat) (see plates 1–2).[4] The tradition of chain-stitch embroidery worked with a hooked implement as well as a needle originated with the Mochi community who were professional embroiderers and shoe-makers working originally on leather. If Marco Polo's account is to be believed, it appears that the Mochis had not yet made the transition to embroidery on cloth when Polo visited Gujarat. This type of embroidery became one of the most renowned of all Indian textile arts, as it was used for pieces for the Mughal court (plates 22, 24–6) as well as for export to Europe (plates 1–9). The British East India Company targeted these 'Cambay quilts' as lucrative export goods from its foundation in 1600, and in the early eighteenth century Alexander Hamilton declared that 'they [the people of Cambay] embroider the best of any people in India, and perhaps in the world'.[5]

These chain-stitch embroideries were probably made in several centres in Gujarat, but were particularly associated with Cambay as that was the port from which they started their sea journey to Europe. Patan, nowadays associated with the double ikat silk *patola* sari, was another centre of manufacture mentioned in company records. The earliest surviving pieces of this type that we know of are probably the set from Ashburnham House in Sussex (plates 1 and 2), and related examples such as the bedspread with *peris* (angels) at Hardwick Hall in Derbyshire.[6] These embroideries, sometimes grouped together as 'Ashburnham type', are characterised by the use of deep colours, especially dark blue and red or pink, done in very compact chain-stitch in meandering tree or vegetal patterns. These are also inhabited by birds, squirrels and unidentified animals, often strongly influenced by European prototypes. An existing English crewel-work embroidery of practically identical design to the Victoria and Albert Museum's Indian piece (plate 2) suggests that patterns or even finished embroideries were being sent out to India to be copied by the late

seventeenth century,[7] although these were already showing signs of cross-cultural influences that merged to form a hybrid chinoiserie style.

Export embroideries from Gujarat continued to be strongly influenced by European designs throughout the eighteenth century, when elements taken from sources such as English Jacobean embroidery (plate 4), French 'bizarre' silks (plate 3) and Dutch engravings (plate 6) were incorporated into the Indian designs. Painted cotton ('chintz') bedcovers and hangings were also sometimes copied in embroidered form (plate 5), often in the deeper green and purple tones that became popular, especially for the Dutch market, during the eighteenth century.

The introduction of satin-stitch, sometimes on a silk rather than cotton ground, to export-market embroidery seems to be a somewhat later development, and may have been the result of Indian contact with Europe or the Far East, where satin-stitch was dominant. While a type of satin-stitch is the primary stitch used in the early Jain embroideries and also (together with a related type of brick-stitch) in early Nepalese embroidery,[8] it took a noticeably secondary role to chain-stitch during the Mughal period. Satin-stitch was, however, particularly suited to the fine dress materials with small, repeating patterns that became popular in Britain in the late eighteenth and early nineteenth centuries, and these were often embroidered with coloured floss silk (plate 10).

In Eastern India, the large embroidered bedcovers exported from Bengal were especially popular with Portuguese patrons from the mid-sixteenth century, and subsequently also with the English (plates 17 and 18). A surprising number of these survive, probably because of the robust nature of their materials and construction, and they are frequently mentioned in Portuguese and English records. The Portuguese, who had settled in Goa very soon after Vasco da Gama's successful navigation of the sea route to India in 1498, established themselves in Satgaon in Bengal in 1536, and they drew on local traditions of *kantha* embroidery and local materials of cotton and tussar silk to commission these impressive, densely embroidered quilts, called *colcha* in Portuguese. Their designs frequently incorporate Portuguese coats of arms or classical myths such as the Death of Actaeon or the Judgement of Solomon, which are usually depicted within a framework of compartments embroidered with Portuguese soldiers, hunters and ships. It was probably a quilt of this kind that was described in the

1603 inventory of Hardwick Hall as 'a quilt of yellow india stuffe embrodered with birds and beasts', and indeed a piece survives at Hardwick that may be this same piece.[9] Bengali embroideries were certainly on sale in England during the early seventeenth century: a record of a sale in February 1618 describes 'a Bengalla quilt ... embroydered all over with pictures of men and crafts [ships] in yellow silk'. This fetched the notably high price of £20.[10] It is possible that even Oliver Cromwell may have owned one: in the inventory of his personal belongings made at Hampton Court in 1659, after his death, one record lists 'one standing bedstead the furniture and needleworke being ye labours of Hercules cont. [containing] Tester, head-cloth and double vallons'.[11] The likelihood of this being an Indian embroidery is increased by the fact that such subjects were not usual in English embroideries of the time.

These Bengal or Satgaon quilts were made in a variety of materials and styles. One category is embroidered entirely in rich, yellow tussar silk on cotton, with no other colours used for details or outlines, and with very dense chain-stitch used for the figures (plate 17). The background is quilted and patterned with back-stitch, and borders sometimes also use French knots around roundels. These are very robust and heavy quilts. A second category is much lighter in appearance and in weight. These examples are not quilted, and do not have a stitched background to the figures. The outlines of the figures are worked in chain-stitch, but the figures may be left empty inside (plate 21) or selectively filled in with back-stitch (plate 19). The overall effect of this type is very delicate and subtle, and is suited to garments rather than to heavy bed-furnishings. A third type uses an additional colour for parts of the design, either red (plate 18) or blue, which is less frequent. The background is quilted in yellow silk, and in some examples additional heavy outlines of braided red silk are added to the main figures. This last feature is seen on embroideries done in Portugal itself rather than India, and it seems likely that the embroideries including this element were done in Portugal, although they share designs with the Indian pieces.

The vague designation 'Indo-Portuguese' for these embroideries reflects the uncertainty that still exists over their provenance. It is worth noting that the Portuguese intended to bring Indian embroiderers to Lisbon as early as 1511 in the ill-fated *Flor de la Mar* which sank off Sumatra: although those unfortunate needlewomen never reached Portugal, it seems likely that other Indian embroiderers may have been brought to Lisbon, where they may have produced this kind of hybrid work.

Mughal and Courtly Embroidery

Contemporary with the fine export embroideries that were being made in Gujarat were pieces made in the same region for the Mughal court. We know from the *A'in-i Akbari*, the record of Akbar's reign, that special workshops (*karkhanas*) for all types of textiles and other crafts were set up in the royal compounds,[12] and a later observer, François Bernier, describes in 1663 how one of these workshops was given over exclusively to embroidery.[13] A striking feature of many of these embroideries is the use of the same silk chain-stitch seen in many of the export pieces, although a considerable amount of satin-stitch in floss silk is also apparent (e.g. plates 23, 27, 28).

The designs of the Mughal pieces are in most cases quite distinct from those made for the European market, as they often make use of the favourite Mughal motif of the single flowering plant, often within an arched niche (plates 24 and 25). Others combine Mughal floral elements with European conventions (plate 26), or use the deep pink and blue colour scheme and floral motifs of the export pieces on floorspread patterns, with additional corner quadrants and central medallions in a typical Islamic layout. One exceptional piece adopts a more naturalistic design incorporating animals, birds and trees (plate 22). This coat, one of the finest surviving examples of Indian embroidery, uses an unusually delicate colour scheme in a design that incorporates Chinese and Iranian elements, and is contained within a typically Iranian border, which is also seen on the floorspread (plate 26).

Furnishings such as floorspreads and tent hangings are by far the most numerous of the textiles from the Mughal or other courts to have survived; garments and other items of more delicate fabric have mostly perished. These furnishings are frequently very elaborate, and may incorporate metal-wrapped thread as well as silk embroidery (plate 23). Even on the move between cities or on military campaigns, the living quarters of the Mughal emperor and his nobles were extremely lavish, and although the tents in which they camped had plain cotton exteriors, red in the case of the royal tents, the interiors were lined with chintz, brocades or

embroidered hangings like those seen in plates 23–5. Smaller, more personal items such as turban cloths (plate 29), waist-sashes (plates 27 and 28) and the decorative knuckle-guards used when holding a shield (plate 30) are rarer survivals, but show how widely embroidery was used in male as well as female contexts.

Later Urban Embroidery

Most of the Indian embroidery that has survived is from either the rural domestic tradition or from urban (as opposed to courtly) workshops, and mainly dates from the nineteenth and early twentieth century. Both traditions are still evident in India today, but both have suffered a marked decline in quality during the present century, with the result that most of the later pieces in this book date from the mid-nineteenth century, when much of the Victoria and Albert Museum's textile collection was acquired for the India Museum.[14] Amongst the finest of the nineteenth-century urban pieces are the embroideries of Kashmir (plates 31–4). The fine under-hair of the Kashmir goat has been woven into light but warm cloth since very early times, and we know that in the late sixteenth century the emperor Akbar was fond of wearing two Kashmir shawls at a time. The finest and earliest patterned shawls had woven floral designs in their borders, but they later developed elaborate woven patterns all over in response to European, especially French, demand. It was only in the early nineteenth century that the same patterns, along with some totally new ones, began to be embroidered on to the shawls instead of being woven; this was a cost-cutting measure traditionally attributed to an Armenian merchant named Khwaja Yusuf, who had come to Kashmir as the representative of a Turkish shawl company in 1803.[15]

Needleworkers or darners (*rafugars*) had traditionally been involved in the shawl-making process only as repairers and to piece together the many individually woven elements that made up the whole shawl, but now their contribution greatly increased. Many of the embroidered shawls had designs based on the traditional Kashmiri cone or *buta*, and closely followed woven designs (plate 33), but others were decorated with intricate scenes involving human figures and animals, which would have been exceedingly complicated to weave on a loom (plates 32 and 34).

Amongst the most ambitious of this type of figurative embroidered shawl is the 'map shawl' which depicts the whole city of Srinagar (plate 32), complete with Dal Lake and the main bridges, mosques and gardens of the city, all worked in fine woollen thread on a woollen ground. Possibly undertaken as a gift to the then Prince of Wales, later Edward VII, on his visit to India in 1875–76, the shawl never reached its royal recipient and was probably sold from the Kashmiri royal stores in the late nineteenth century. Another shawl, on which the labels to the sights are in English rather than Persian, did reach Queen Victoria, and it is still in the Royal Collection.[16]

North India, especially Delhi, was the centre for several types of fine silk embroidery on woollen cloth, which would have been imported from Kashmir, during the mid-nineteenth century (plate 36). These ornate floral designs in brightly coloured floss silk satin-stitch were strongly influenced by European motifs, and were largely made for the British market. Similar designs were also embroidered in a single colour, and others on net for a lighter effect (plate 37). High quality satin-stitch embroidery, also on a woollen or velvet ground and frequently combined with metal-wrapped thread, was also a speciality of Hyderabad, Sindh (today in Pakistan), where cushion-covers, table-cloths, book-covers, slipper-tops and other decorative items (like the *pachisi* board, plate 38) were made for both the local and European markets.[17]

The small Pahari ('hill') kingdoms of the Himalayan foothills (today the Indian state of Himachal Pradesh) were the source of a distinctive group of embroidered coverlets and hangings known generically as 'Chamba *rumals*', i.e. coverlets from Chamba (plates 40–3), although it is likely in view of the wide range of styles that these embroideries were done in several other centres, such as Kangra and Basohli, as well as Chamba. They are embroidered in floss silk on fine muslin, and the fine drawing and workmanship of the earlier pieces (e.g. plates 40, 41) suggest that they were designed by court artists and then embroidered by professionals. While they are most often square in format, and apparently meant to cover trays at times of ceremony or ritual, some very large examples survive (plate 41) that were clearly meant to hang on a wall. Some *rumals* are purely abstract in design (plate 42), but they more often show religious or mythological scenes, especially alluding to the life of Krishna (plate 43). Wedding scenes, also often involving Krishna, were popular, as it was at weddings and

other rituals that these *rumals* would have been most often used. While the earlier *rumals* are strikingly close in their designs to contemporary miniature paintings, later pieces show a decline in quality and increased abstraction of forms, as well as a greater use of coarser cotton cloth as the ground fabric. It seems likely that a popular equivalent to the courtly *rumals* already existed that made use of much more abstract forms and less pictorial designs.

A distinctive type of urban embroidery arose in Calcutta and Dhaka (today in Bangladesh) and seems to have spread to Lucknow, capital of the kingdom of Oudh, under a group of Bengali craftsmen in the mid-nineteenth century. Characterised by the use of white cotton embroidery on white (or today pastel-coloured) cotton cloth, this so-called *chikan* embroidery (plates 44–48) died out in Bengal, and is now mainly associated with Lucknow, where it is still produced for *kurtas*, saris and small furnishings. Examples from Gwalior (plate 45) and Madras also survive in the Victoria and Albert's collection. *Chikan* work uses a range of techniques to vary the effect of the monochrome embroidery (although golden-coloured *muga* silk was also used in Lucknow for a subtle variation in tone, e.g. plate 48), including thickly textured areas of stitching and a type of openwork (*jali*) in which the threads are not actually removed, but carefully parted with the needle. Fine Bengali muslin, usually plain but sometimes depicted in paintings with white embroidery, was a favourite fabric at the Mughal court from Akbar's reign onwards, and *chikan* embroidery had been admired by Europeans since the seventeenth century.[18] Fine Indian muslins patterned with small embroidered sprigs (e.g. plate 45) were sent to England to be made into delicate women's and children's garments in the late eighteenth to mid-nineteenth centuries. The more elaborate patterns with flowers and leaves connected by stems (e.g. plate 48) seem to derive from the European whitework embroideries of the 'Dresden' and Ayrshire styles brought to India by European ladies in the early nineteenth century.[19]

Also embroidered in Bengal by professionals were the subtly coloured turbans and saris which used *muga* silk thread embroidered on fine fabric woven in a mixture of silk and cotton (plate 52). This type of embroidery, known as *kasida*,[20] was done by Muslims, usually women, and was exported in great quantity to the Middle East, notably to Jedda, today in Saudi Arabia, where pilgrims to Mecca from all over the Islamic world formed its most significant

market. Embroidery in *tussar* or *muga* silk on a white cotton ground was also carried out in Bengal in the nineteenth century (plate 53), providing a link to the earlier Satgaon quilts (plates 17–19).

Embroidery of a very individual type was carried out in Surat by Chinese immigrants specifically for the Parsee market (plates 55–8). Traditional Parsee costume, which in some ways is very close to other urban Indian types – the wearing of the sari, for example – did include some distinctive garments that made use of these exotic *chinai* ('Chinese') embroidery designs. The most decorative of these was the *jubla*, or sleeveless shirt (plates 55–7), worn by young women with loose trousers and a round embroidered cap. The designs on these simply-shaped garments, as well as the use of stitches not usually associated with Indian work, frequently reflect the Chinese origins of their embroiderers (plates 56, 57), while others of the same cut were embroidered by Gujarati craftsmen in cross-stitch (plate 55) or metal thread. The other use to which *chinai* embroidery was put was for sari borders (plate 58). These were often on a dark ground in order to blend with the black or deep purple satin saris favoured by Parsee ladies, and sometimes entire saris would be embroidered in *chinai* style, often in white thread on black silk.

The use of metal and related materials, such as iridescent beetles' wing-cases, to embellish textiles has been immensely popular in India at least since Mughal times, and probably earlier. Some metal embroidery styles are thought to have been introduced into India by the Portuguese, but it was during the nineteenth century that the widest range of metallic embroidery materials were used on all sorts of garments, furnishings and accessories (plates 59–66). Although they tend to be grouped together under the generic term of *zardozi*, simply 'gold embroidery', there are many varieties of material and technique used to give a wide range of effects. These included a flattened metal strip (*badla*), which would either be laid on the surface of the fabric or, in a technique called *mukesh*, embroidered through the fabric using its own pointed end in place of a needle; twisted and coiled metal wire (*salma*) to be sewn on to the fabric; silk thread wrapped in a thin strip of gilt silver wire (*tilla* or *marori*), which would be embroidered with a needle; wide ribbon woven from metal strips and silk (*gota*), which was applied as edging to saris and skirts, or cut into shapes and appliquéd onto garments; sequins (*salma* – flat, or *katori* – domed); and tiny pieces of

coloured metal foil to imitate jewels or beetles' wing-cases. These types of metal embroidery would be used on fine muslin, velvet, satin, silk or (occasionally) wool, or in a lavish combination with floss-silk embroidery and velvet (see plates 60, 61). The variety of objects decorated with metal thread ranged from heavy velvet floorspreads to diaphanous garments and decorative caps for the courts of Delhi or Lucknow, or men's robes from Sindh and Panjab.

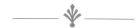

Folk and Tribal Embroidery

The embroidery types discussed up to this point have all been the product of professional workshops, done to commission or at least for sale, and yet a large proportion of the embroidery done in India has always been domestic, made by an individual (almost always female) for her own use or that of her family. Embroidery is not essential to the construction of a textile or a garment, so much of the purely decorative needlework on these items has been added for weddings, festivals or worship, but a surprisingly large amount of extraordinarily beautiful work was once done for everyday use.

The richest area for embroidered textiles in the subcontinent is that which straddles the border between India and Pakistan, and which includes Gujarat in India and Sindh in Pakistan. Neighbouring parts of Rajasthan in India and Baluchistan in Pakistan also contribute to the extraordinarily varied embroidery tradition in this region. Much of the embroidery is done by women from rural farming and herding communities, both Hindu and Muslim, and is mostly made for their own use, although some communities, notably the Mochis and the Meghwals, also embroider pieces to commission. The Mochis, originally leatherworkers, are perhaps the most renowned embroiderers in the subcontinent, and their extremely fine chain-stitch embroidery was formerly commissioned for prestigious pieces at the Mughal court (plates 22–6) and for export to Europe (plates 1–9), as well as for local Gujarati clients (plates 73–7). Their work in the Gujarati context is particularly associated with Kutch, where they made vibrantly coloured skirts, head-veils and wall hangings, including *pichhwai* for Krishna shrines, for several other communities as well as their own. Mochi communities were also to be found in other parts of Gujarat, where they produced

embroideries in similar designs but using other stitches than their traditional chain-stitch (plates 76, 77).

Several other communities in Kutch, especially in Banni, its remote, northernmost part, produce very fine embroideries, characterised by tiny stitches on silk or satin and the additional use of small mirrors (plates 78–86). Mirrors *(shisha)* are a feature of many types of western Indian embroidery, and are also sometimes used in embroidery by Banjara communities. Thought to have originated with the use of naturally ocurring mica found in the deserts of western India, mirror-work is now so widely used that mirror glass is specially manufactured for this purpose in local towns such as Kapadvanj in Gujarat. Chain-stitch is perhaps most frequently associated with Kutch embroidery, but other distinctive stitches also contribute. Notable among these is an interlacing-stitch (detail E, page 141), called *hurmitch* in Sindh where it is most prevalent, and *bavaliya* in Kutch, but which also corresponds to a stitch which appears in Armenian embroidery,[21] and which may have been brought to western India either directly from the Near East or by missionaries who had learnt it there.

Saurashtra (formerly called Kathiawar), the peninsula of Gujarat to the south of Kutch, is the source of a variety of embroidery types made by farming communities such as the Kathis (after whom the area was named), Mahajans (business communities; see plate 88), Kanbi (plate 90), Ahir and Rabari (plate 89). None of their work is as fine as that produced in Kutch, but is mainly in bold designs for decoration of garments, especially those associated with weddings, and for the home or livestock.[22]

Sindh, today in Pakistan, has one of the most varied embroidery traditions in the subcontinent, with the desert region of Tharparkar particularly rich in domestic embroidery. Amidst a huge variety of regional patterns and techniques, two major styles of embroidery are paramount: the *pakko* ('solid') and the *kachho* ('raw'), also called *soof*. *Pakko* style is characterised by thickly embroidered floral and leaf forms, of which communities like the Meghwar are the prime exponents (plates 94, 95), while *soof* embroidery is based on triangular and geometric forms which often incorporate stylised peacocks as well as flowers in their designs (plate 100). Urban styles using fine chain-stitch on silk originate from centres such as Hyderabad in central Sindh and Shikarpur in the north (plates 101, 102), while the state of Baluchistan also has an extremely rich tradition of finely embroidered garments (plates 111–14).[23]

Very different from the vibrantly coloured embroideries of western India are the utilitarian *kantha* of Bengal, which includes modern-day Bangladesh (plates 115–17). The *kantha*, like the closely related *sujni* from neighbouring Bihar, is traditionally made of the most humble materials – recycled cloth and thread from old saris and *dhotis* – but the embroidery used to decorate these layered cotton textiles is often extremely fine and the designs sophisticated, although the repertoire of stitches used is very small and confined to the simplest of running- and darning-stitches (detail I, page 143). *Kanthas* may be used as bedcovers, shawls or bags, depending on their size and thickness. Designs are often based on human figures and animals and scenes from local life such as temple cars (*rath*) in predominantly Hindu areas such as Jessore, or more abstract patterns in Muslim regions like Rajshahi. Central lotus medallions and corner *kalkas* ('paisley' or mango motifs) or tree forms are prominent features of many types (plates 115, 117), while others have simpler designs incorporating border patterns running the length of the field (plate 116). The purely abstract lotus designs (plate 117) are clearly linked to the auspicious *alpona* floor decorations made by women as a protective device at the threshold of their houses. Although traditionally a strictly utilitarian domestic product, the *kantha* has now re-emerged as an item of urban interior design, made from new rather than re-cycled materials (plate 118).

A very restricted range of stitches is also used, although to totally different effect, in the *phulkari* embroideries of the Panjab and other parts of north-west India and Pakistan (plates 120–30). While *phulkari* ('flower work') has come to be used as a general term for several types of embroidery from the Panjab, it is only correctly used for those with sparse motifs on a plain cotton ground. The shawls with densely embroidered geometric designs are called *bagh* ('garden') and are the most prestigious type of shawl (plates 120, 121). The *bagh* is traditionally started by a child's grandmother when it is born, in preparation for his or her wedding day, when the *bagh* will be draped round the bride as she is brought to her marital home. The *bagh* is embroidered in brilliant floss silk, which is worked from the back of the fabric in such a way that it is visible only on the front of the fabric. The *phulkari* from the eastern part of the Panjab (plates 122, 123), called *sainchi*, make use of human figures and animals as well as abstract motifs, while those from the western Panjab, today in Pakistan, are more likely to be fully geometric, with designs dominated by diamond

and chevron patterns (plate 120). *Phulkaris* using stitches other than the flat, light-reflective darning-stitch were traditionally found in areas like Rohtak (plate 125) and Hissar (plate 124), both today in the state of Haryana, but formerly in Panjab. The type of shawl with double running-stitch, visible on both sides, is known as a *chope* (plate 126) and is used, like all the *phulkari* types, during specific parts of the wedding ceremony. Also collected in Hissar in 1883 is an embroidered woollen shawl (plate 127) which is strongly reminiscent of the embroidered blankets of Bikaner, but with the unusual addition of distinctly *chope*-like designs around the edges.

The wide area in which the *phulkari* stitch was prevalent extended to the west and north of Panjab as well as south into Rajasthan. The colourful geometric embroideries of Swat (plates 128, 129) and Indus Kohistan (plates 130–32), today both in the North-West Frontier Province of Pakistan, also make use of the flat, floss-silk darning-stitch seen in the *baghs* of the Panjab. These, however, are also decorated with motifs associated with areas even further to the north, in Central Asia, such as the Y-shaped 'ram's horn' pattern often done in tiny cross-stitch rather than darning-stitch. The use of beads and metal decorations to embellish costume pieces is also characteristic of these northern embroideries.

Scattered over many parts of India, but especially associated with the southern Indian states of Andhra Pradesh and Karnataka and with Madhya Pradesh in central India, the itinerant Banjara people (also called Lambadi or other variants) have developed a striking embroidery style that is used mainly on ritual textiles, mats, bags and smaller accessories like head-pieces (see plates 133–37). The Banjaras' original home was probably Rajasthan, but their work as carriers for the Mughal armies took them all over India and they formed settlements throughout the country. Today they work mainly as road-builders, and many communities move around in search of work. Their embroideries reflect their mobile way of life, both in their function (multi-purpose bags and carrying-cloths feature prominently, rather than wall hangings or bedcovers) and in their sturdy construction and materials. Different Banjara communities have developed their own styles of embroidery, with those of Khandesh, on the Maharashtra/Madhya Pradesh borders, often featuring small, seed-like motifs and fine appliqué details (plates 133, 134), while those of the more southerly Deccan favour densely embroidered surfaces in

which the ground fabric is invisible (plate 137). A feature common to much Banjara embroidery is the use of cowrie shells as auspicious adornment.

The tribal groups of north-east India are from quite different ethnic groups from the rest of India, and are more closely linked to the peoples of Burma and Thailand with whom they share borders. While some have relatively rich traditions of weaving, embroidery in these regions is scarce, and often imitates local patterns in woven or other techniques (plate 139). The embroidered shawls made in Manipur for warriors of the Angami Naga tribe (plate 141) are clearly in the tribal tradition of textiles made by the Naga themselves, who do not practice embroidery, but who sometimes use painted designs of elephants and other animals to decorate their shawls. The splendid silk shawls worn by men of the Meitei (Vaishnavite Hindu) community in Manipur (plate 140),[24] on the other hand, echo designs from 'mainstream' north Indian textiles.

❧ Notes ❧

1. In the context of this book, 'India' is used to denote the country before the Partition of 1947, which included present-day India, Pakistan and Bangladesh. The majority of embroideries in this book date from before Partition, but where precise provenances are known, present-day designations are used (e.g. Dhaka, Bangladesh; Swat, Pakistan) regardless of the date of the piece.

2. One piece is in the Calico Museum of Textiles, Ahmedabad (no. 983, Irwin and Hall (1973), cat. 55, col. pl. 1), and the other is in the AEDTA collection, Paris (no. 2381, K. Riboud, ed. *In Quest of Themes and Skills – Asian textiles* (Bombay 1989), pp. 2–3).

3. A.C. Moule and P. Pelliot. *Description of the World* (London 1938), vol. 1, p. 420.

4. Duarte Barbosa. *Livro de Duarte Barbosa*, translated by M. Longworth Dames (London, Hakluyt Society 1918), vol. 1, p. 142.

5. A. Hamilton. *A New Account of the East Indies... being the remarks of Capt. Alexander Hamilton who spent his time there from 1688 to 1723*, 2 vols. (Edinburgh 1727), 1930 repr., vol. 1, p. 86.

6. This piece is almost certainly too late to be one of the Indian embroideries listed in the inventory of 1603 (see John Irwin. 'The Commercial Embroidery of Gujerat in the seventeenth century', *Journal of the Indian Society of Oriental Art* (1949), vol. XVII, pl. VII.) as it appears on stylistic grounds to date from the late 17th century. However, another embroidery at Hardwick, probably from Bengal, may be pre-1603 (see S.M. Levey. *An Elizabethan Inheritance: the Hardwick Hall Textiles* (London, National Trust 1998), p. 29: small detail only illustrated).

7. In the Museum of Fine Arts, Boston. Illustrated in J. Irwin. 'Origins of the "Oriental Style" in English Decorative Art', *Antiques* (Jan. 1959), pl. 13. Another embroidery of similar design is in the Burrell Collection, Glasgow.

8. See R. Crill. 'Nepalese embroidery: a new chronology', *Hali*, issue 44, 1989, pp. 30–35.

9. See note 6 above.

10. India Office Library, Court Book IV, f.135, quoted in Irwin and Hall (1973), p. 35.

11. E. Law. *History of Hampton Court*, II, 292. I am grateful to Clare Browne of the Department of Textiles and Dress at the Victoria and Albert Museum, London, for her comments on the Labours of Hercules as a subject for embroidery in the seventeenth century.

12. Abu'l-Fazl. 'Allami', *The A'in-i Akbari*, tr. H. Blochmann, 1873, (3rd edition, New Delhi, 1977), A'in 31, pp. 93–6.

13. F. Bernier. *Travels in the Mogul Empire AD 1656-1668*, ed. A. Constable, London, 1891, p. 259.

14. Much of the collections of the India Museum (including all its textiles) was amalgamated with the South Kensington Museum, later the Victoria and Albert, in 1879.

15. See J. Irwin. *The Kashmir Shawl*, London, HMSO, 1973, p. 3.

16. Illustrated in R. Crill. 'Embroidered Topography', *Hali* (1993), issue 67, fig. 5.

17. See Askari and Crill (1997), pp. 44–6.

18. Orders for the year 1681 included a request for '500 *mulmuls* [muslins] with fine needleworke flowers wrought with white'. Quoted in Paine (1989), p. 20.

19. *Ibid.*, pp. 7–11.

20. See G. Watt (1903), p. 385; Paine (1989), p. 26.

21. See A.O. Kasparian. *Armenian Needlelace and Embroidery* (1983), p. 8. I am grateful to Marianne Ellis for providing this reference.

22. For more details on the various communities in Saurashtra and their embroideries, see Gillow and Barnard (1991), pp. 58–63, and Nanavati *et al.* (1966), pp. 17–27.

23. See Askari and Crill (1997), pp. 15–43, 65–77, for further information on embroidery styles in Sindh and Baluchistan.

24. See Nilima Roy. *Art of Manipur* (New Delhi 1979), pl. 29.

⇒ *List of Plates* ⇐

19. Part of a bedcover
Cotton embroidered with *tussar* silk;
chain-stitch, back-stitch.
L. 120.5cm, w. 52cm.
Bengal, for the Portuguese market,
early 17th century.
Gift of the Hon. Mrs Denison.
IS 157-1953

20. Border of a bedcover
Cotton embroidered with *tussar* silk;
chain-stitch.
L. 152cm, w. (incl. border) 23cm.
Bengal, for the Portuguese market,
early 17th century.
T 6-1936

21. Cape
Linen embroidered with tussar silk;
chain-stitch.
L. (incl. fringe) 84cm, w. 154cm.
Bengal, for the Portuguese market,
early 17th century.
T 1016-1877

Mughal and Courtly Embroidery

22. Man's coat
Silk embroidered with silk thread;
chain-stitch.
L. 97cm.
Mughal, c.1620–30.
IM 18-1947

23. Tent hanging
Cotton ground, embroidered with floss
silk and silver-gilt-wrapped thread;
satin-stitch, brick-stitch, chain-stitch,
laid and couched work.
H. 181cm, w. 162cm.
Mughal, late 17th century.
IM 48-1928

24. Tent hanging
Cotton ground, quilted and
embroidered with silk; chain-stitch,
quilted with double running-stitch.
H. 172cm, w. 139cm.
Mughal, c.1700.
IM 62-1936

25. Hanging
Cotton embroidered with silk;
chain-stitch.
H. 117cm, w. 81.25cm.
Mughal, late 17th century.
Given by Miss F. J. Lefroy.
IS 168-1950

26. Floorspread
Cotton embroidered with silk;
chain-stitch.
L. 269cm, w. 203cm.
Mughal, c.1700.
Purchased by the Associates of the
Victoria and Albert Museum.
IS 34-1985

27. Man's sash (*patka*)
Cotton embroidered with floss silk and
gold-wrapped thread; satin-stitch.
w. 52.5cm.
Mughal, early 18th century.
IM 29-1936

28. Man's sash (*patka*)
Cotton embroidered with floss silk and
metal wire; satin-stitch.
L. 243cm, w. 56cm.
Mughal, early 18th century.
IM 26-1936

29. Fragment of a turban cloth
Cotton embroidered with floss silk;
chain-stitch.
w. 19.5cm.
Mughal, early 18th century.
IM 27-1936

30. Knuckle-pad cover
Cotton embroidered with silk;
chain-stitch.
H. 13cm, w. 13cm.
Rajasthan, probably Bundi or Jaipur,
18th century.
Given by Imre Schwaiger.
IM 107-1924

Later Urban Embroidery

31. Sash
Wool embroidered with woollen thread;
stem-stitch, satin-stitch, darning-stitch.
L. 260cm, w. 71cm.
Srinagar, Kashmir, c.1830.
Bequeathed by Mrs Marian Lewis.
501-1907

32. Shawl with map of Srinagar
Wool, embroidered with woollen thread;
darning-stitch, satin-stitch, stem-stitch.
L. 229cm, w. 198cm.
Srinagar, Kashmir, c.1860.
Given by Miss Estelle Fuller.
IS 31-1970

33. Semi-circular shawl
Wool, embroidered with woollen thread;
straight-stitches.
L. 168cm, w. 305cm.
Srinagar, Kashmir, c.1840–60.
IS 1-1949

34. Tablecover
Wool embroidered with woollen thread;
chain-stitch.
L. (incl. fringe) 200cm, w. 170cm.
Srinagar, Kashmir, c.1855.
0261 (IS)

35. Three caps
Wool, embroidered with woollen thread;
cotton embroidered with floss silk;
darning-stitch, chain-stitch, satin-stitch.
8078: L. 30.4cm, H. 12.7cm;
5763: diam. 18cm, H. 7.5cm;
8079: diam. 17cm, H. 8cm.
Srinagar, Kashmir (8078, 8079) and
Ludhiana, Punjab (5763), c.1855.
Left to right: 8078, 5763, 8079 (IS)

36. Scarf
Wool embroidered with floss silk;
satin-stitch.
L. (incl. fringe) 266cm, w. 83cm.
Delhi, c.1855.
0260 (IS)

37. Scarf
Cotton net embroidered with floss silk; chain-stitch.
L. (incl. fringe) 266cm, w. 50cm.
Delhi, *c.*1855.
4487 (IS)

38. *Pachisi* board
Wool embroidered with floss silk; satin-stitch.
L. 77cm, w. 77cm.
Sindh, *c.*1855.
4709 (IS)

39. Embroidered representation of the top of Shah Jahan's tomb
Silk embroidered with floss silk; satin-stitch.
L. 175cm, w. 50cm.
North India, probably Delhi, *c.*1840.
IS 34-1987

40. Coverlet (*rumal*)
Cotton embroidered with floss silk; double darning-stitch.
L. 80.5cm, w. 82.5cm.
Himachal Pradesh, probably Basohli, late 18th century.
IS 23-1983

41. Hanging depicting the battle of Kurukshetra
Cotton embroidered with floss silk; double darning-stitch.
L. 945cm, w. 76cm.
Chamba, Himachal Pradesh, *c.*1800.
Given by Gopal Singh, former Raja of Chamba.
1185-1883 (IS)

42. Coverlet (*rumal*)
Cotton embroidered with floss silk; double darning-stitch.
L. 63.5cm, w. 61cm.
Nurpur, Himachal Pradesh, *c.*1880.
1174-1883 (IS)

43. Coverlet (*rumal*)
Cotton embroidered with floss silk; double darning-stitch.
L. 86.3cm, w. 86cm.
Himachal Pradesh, probably Chamba or Kangra, early 20th century.
IS 26-1967

44. Length of dress fabric
Cotton embroidered with cotton thread with drawn thread work.
w. 84cm.
Dhaka, Bangladesh, *c.*1855.
0214 (IS)

45. Length of dress fabric
Cotton embroidered with cotton thread; chain-stitch.
L. 132cm, w. 74cm.
Gwalior, Madhya Pradesh, *c.*1855.
8838 (IS)

46. Handkerchief
Cotton embroidered with cotton and silk thread.
L. 42cm, w. 42cm.
Calcutta, West Bengal, mid-19th century.
0542 (IS)

47. Scarf
Cotton embroidered with cotton thread.
L. 94cm, w. 94cm.
Lucknow, Uttar Pradesh, *c.*1880.
981-1883 (IS)

48. Uncut borders for a garment
Cotton embroidered with cotton and *muga* silk thread.
L. 33cm, w. 40.1cm.
Lucknow, Uttar Pradesh, late 19th or early 20th century.
IS 58-1968

49. Length of dress fabric
Muga silk embroidered with cotton thread; satin-stitch, buttonhole-stitch, self-couching-stitch.
L. 116cm, w. 25.3cm.
Madras, Tamil Nadu, *c.*1855.
8730 (IS)

50. Bedcover (*raza'i*)
Cotton, quilted and wadded; back-stitch.
L. 227.5cm, w. 129.5cm.
Kashmir, *c.*1880.
1386-1883 (IS)

51. Bedcover
Cotton, quilted with cotton thread and wadded with blue cotton; back-stitch.
L. 211cm, w. 128cm.
Ahmedabad, Gujarat, *c.*1855.
5415 (IS)

52. Scarf
Cotton and *muga* silk, embroidered with *muga* silk thread; running-stitch, stem-stitch.
L. (incl. fringe) 116cm, w. 117cm.
Dhaka, Bangladesh, *c.*1855.
6038 (IS)

53. Coverlet
Cotton embroidered with *muga* silk thread; chain-stitch.
L. 84.5cm, w. 85cm.
Dhaka, Bangladesh, late 19th century.
Gift of Mr W. Marais.
IS 118-1965

54. Part of a man's sash (*patka*)
Cotton embroidered with silk thread; running-stitch.
L. 194cm, w. 58.5cm.
Bengal, probably Dhaka, *c.*1800.
Given by Mrs Mary Antrobus.
IM 33-1925

55. Parsee girl's shirt (*jubla*)
Silk embroidered with silk thread; cross-stitch.
L. 59.5cm, w. 58.5cm.
Gujarat, probably Surat, mid-19th century.
Gift of Mrs A.R. Ditmas.
IS 56-1957

56. Parsee girl's shirt (*jubla*)
Silk, embroidered with silk thread; satin-stitch.
L. 56cm, w. 53.5cm.
Surat, Gujarat, embroidered by Chinese embroiderers, *c.*1870.
1426a-1874

57. Parsee girl's shirt (*jubla*)
Silk embroidered with silk thread;
Chinese or Pekin knot-stitch.
L. 51cm, W. 51cm.
Surat, Gujarat, made by Chinese
embroiderers, late 19th century.
IS 167-1960

58. Border for a sari
Silk embroidered with silk thread;
Chinese or Pekin knot-stitch.
L. 100cm, W. 6.2cm.
Surat, Gujarat, made by Chinese
embroiderers for the Parsee market,
late 19th century.
IS 64-1981

59. Cover for a Jain manuscript
Silk embroidered with gold-wrapped
thread and sequins.
H. 16cm, W. 29.2cm.
Gujarat, late 19th century.
IS 20-1978

60. Turban band
Cotton ground with applied velvet,
embroidered with floss silk, with
embroidered and couched silver and
silver-gilt strips and sequins.
L. 64.5cm, W. 10.5cm.
Lucknow, Uttar Pradesh, c.1800.
IS 85-1988

61. *Huqqa* mat
Cotton ground, embroidered with floss
silk, with applied silver and silver-gilt
wire, sequins, pieces of beetle wing and
velvet.
Diam. (incl. fringe) 52cm.
Lucknow, Uttar Pradesh, early 19th
century.
IS 1-1999

62. Length of dress fabric
Woven strips of silver with silk wefts,
couched metal strips, embroidered
sequins, metal foil and pieces of beetle
wing.
L. 127cm, W. 53.5cm.
Madras, Tamil Nadu, c.1851.
753-1852

63. Tablecover
Silk embroidered with silk thread,
metal-wrapped thread, sequins and
beetle wings.
L. 111.5cm, W. 59.5cm.
North India, probably Delhi,
mid-19th century.
Given by Miss P. I. Pisani.
IS 142-1975

64. Dress piece
Cotton net with couched gold-wrapped
thread and twisted gold wire, embroi-
dered sequins and pieces of beetle wing.
L. 98cm, W. 78cm.
Hyderabad, Andhra Pradesh, c.1855.
4411 (IS)

65. Boy's shirt (*kurta*)
Silk with applied silver and silver-gilt
ribbon (*gota*).
L. 78cm, W. 136.5cm.
Bikaner, Rajasthan, c.1855.
05627 (IS)

66. Man's robe
Wool embroidered with silver and
silver-gilt wrapped thread; chain-stitch,
couching.
L. 134cm.
Lahore, c.1855.
0200 (IS)

67. Mat
Silk with an attached network of beads.
L. 28cm, W. 28cm.
Acquired in Darjeeling, West Bengal, but
possibly from Madras, mid-19th century.
06052a (IS)

68. Three hats
Cotton ground, stiffened with card and
cotton fabric, with an attached network
of beads.
0343, 0344: diam. 15cm, H. 7cm;
0345: diam. 17cm, H. 18cm.
Madras, Tamil Nadu, 1855.
Left to right: 0343, 0344, 0345 (IS)

**69. Door hanging (*toran*) with images
of Krishna**
Cotton ground, with an attached net-
work of Italian beads.
L. 113cm, W. 33cm.
Saurashtra, Gujarat, 20th century.
IS 11-1961

Folk and Tribal Embroidery

70. Wall hanging (*bhitiya*)
Cotton appliqué.
L. 1680cm, W. 248cm.
Saurashtra, Gujarat, 20th century.
Given by Mr and Mrs J. Burns.
IS 24-1994

71. Quilt (*ralli*)
Cotton, quilted and embroidered with
cotton; running-stitch, back-stitch.
L. 203cm, W. 163cm.
Sami community, Sindh, Pakistan,
20th century.
Given by Mrs Shireen Feroze Nana.
IS 4-1981

72. Quilt (*ralli*)
Cotton; running-stitch, appliqué.
L. 220cm, W 158cm.
Lower Sindh, Pakistan, 20th century.
Given by Mrs Shireen Feroze Nana.
IS 1-1981

73. Skirt length
Silk satin embroidered with silk thread;
chain-stitch.
L. 78.5cm, W. 246cm.
Mochi community, Kutch, Gujarat,
late 19th or early 20th century.
Circ. 307-1912

74. Skirt length
Silk satin embroidered with silk thread;
chain-stitch.
L. 68.5cm, W. 228.5cm.
Mochi community, Kutch, Gujarat,
early 20th century.
Given by Lady Ratan Tata.
IM 254-1920

75. Skirt
Silk satin embroidered with silk thread;
chain-stitch.
L. 91.5cm, w. 201cm.
Mochi community, Kutch, Gujarat,
early 20th century.
Given by Lady Ratan Tata.
IM 246-1920

76. Wall hanging (*chakla*)
Silk embroidered with floss silk;
herringbone-stitch, chain-stitch, fly-
stitch.
L. 70cm, w. 63.5cm.
Mochi community, Saurashtra, Gujarat,
early 20th century.
Given by Lady Ratan Tata.
IM 276-1920

77. Wall hanging (*chakla*)
Silk embroidered with floss silk; chain-
stitch, double chain-stitch, back-stitch.
L. 70cm, w. 66cm.
Mochi community, Saurashtra, Gujarat,
early 20th century.
Given by Lady Ratan Tata.
IM 274-1920

78. Woman's dress (*aba*)
Silk satin embroidered with silk thread
and mirrors; chain-stitch, buttonhole-
stitch, interlacing-stitch.
L. 110cm, w. 99cm.
Jat community, Banni, Kutch, Gujarat,
mid-19th century.
4559 (IS)

79. Woman's dress (*aba*)
Silk satin emboidered with silk thread
and mirrors; chain-stitch, buttonhole-
stitch, back-stitch.
L. 117cm, w. 112cm.
Muslim community, probably Memon,
Banni, Kutch, Gujarat, early 20th
century.
Given by Lady Ratan Tata.
IM 232-1920

80. Skirt length
Silk satin embroidered with silk thread
and mirrors; chain-stitch, buttonhole-
stitch, cross-stitch, close herringbone-
stitch.
L. 56cm, w. 218.5cm.
Muslim community, Banni, Kutch,
Gujarat, early 20th century.
Given by Lady Ratan Tata.
IM 252-1920

81. Woman's trousers (*ezar*)
Silk satin embroidered with silk thread
and mirrors; herringbone-stitch, cross-
stich, buttonhole-stitch, chain-stitch.
L. 91.5cm, w. (at waist) 84cm.
Muslim community, Banni, Kutch,
Gujarat, early 20th century.
Given by Lady Ratan Tata.
IM 239-1920

82. Woman's headcover (*odhni*)
Silk satin, embroidered with silk thread
and mirrors; chain-stitch, herringbone-
stitch.
L. 84cm, w. 72.5cm.
Lohana community, Banni, Kutch,
Gujarat, first half of the 20th century.
Given by Miss A. R. Ditmas.
IS 57-1957

83. Skirt
Silk satin embroidered with silk thread;
satin-stitch (field), chain-stitch (border).
L. 201cm, w. 86.5cm.
Bansali community, Kutch, Gujarat,
c.1880.
2304-1883 (IS)

84. Skirt fabric
Silk embroidered with floss silk; chain-
stitch, interlacing-stitch, herringbone-
stitch.
L. 81cm, w. 183cm.
Lohana community, Banni, Kutch,
Gujarat, early 20th century.
Given by Lady Ratan Tata.
IM 253-1920

85. Woman's headcover (*odhni*)
Silk embroidered with silk thread;
eye-stitch.
L. 197cm, w. 156cm.
Kutch, Gujarat, early 20th century.
Given by Miss M. D. Cra'ster.
IS 13-1990

86. Woman's headcover (*odhni*)
Silk satin embroidered with silk thread;
chain-stitch, herringbone-stitch,
buttonhole-stitch, running-stitch.
L. 167.5cm, w. 218.5cm.
Lohana community, Banni, Kutch,
Gujarat, early 20th century.
Given by Lady Ratan Tata.
IM 266-1920

**87. Part of a hanging for a shrine
(*pichhwai*)**
Cotton, embroidered with silk thread;
chain-stitch.
L. 158cm, w. 151cm.
Saurashtra, Gujarat, late 19th century.
IS 40-1977

88. Door hanging (*toran*)
Cotton ground, embroidered with floss
silk thread and mirrors, with applied
tie-dyed silk; satin-stitch, herringbone-
stitch, chain-stitch.
L. 117cm, w. 71cm.
Mahajan community, Saurashtra,
Gujarat, early 20th century.
IS 136-1960

89. Door hanging (*toran*)
Jute embroidered with wool;
chain-stitch.
L. 185cm, w. 46cm.
Rabari community, Saurashtra, Gujarat,
20th century.
IS 54-1981

**90. Wall hanging with image of
Ganesha (*Ganesh sthapana*)**
Cotton embroidered with silk;
herringbone-stitch, chain-stitch.
L. 66cm, w. 52cm.
Kanbi community, Saurashtra, Gujarat,
mid-20th century.
IS 18-1967

91. Hanging for the side of a bed (*kil*)
Cotton embroidered with floss silk;
herringbone-stitch, running-stitch.
L. 65cm, w. 140cm.
Ahir community, Morvi, Saurashtra,
Gujarat, mid-20th century.
IS 39-1977

92. Part of a pillow cover (*oshikun*)
Cotton embroidered with cotton thread;
herringbone-stitch, interlacing-stitch,
chain-stitch, running-stitch.
L. 100cm, w. 53cm.
Morvi, Saurashtra, Gujarat,
early 20th century.
IS 32-1977

93. Three children's hats
Cotton ground, covered with silk,
embroidered with silk; chain-stitch,
herringbone-stitch, running-stitch;
cotton appliqué.
IS 145-1960: L. 45.5 cm;
IS 28-1967: L. 22 cm;
IS 56-1981: L. 23 cm.
Gujarat (IS 145-1960; IS 56-1981) and
Bihar (IS 28-1967), 20th century.
Left to right: IS 145-1960; IS 56-1981;
IS 28-1967

94. Man's wedding shawl (*malir* or *doshalo*)
Cotton, block-printed and embroidered
with silk; chain-stitch, satin-stitch,
cross-stitch, buttonhole-stitch,
interlacing-stitch.
L. 267.5cm, w. 107cm.
Meghwar community, Tharparkar,
Sindh, Pakistan, 20th century.
Given by Mrs Shireen Feroze Nana.
IS 7-1981

95. Child's dress
Cotton ground, embroidered with silk;
buttonhole-stitch, open chain-stitch, fly-
stitch, herringbone-stitch, cretan-stitch.
L. 48cm, w. 49.5cm.
Meghwar community, Tharparkar,
Sindh, Pakistan, mid-20th century.
Given by Mrs M. Wiggington.
IS 33-1957

96. Skirt fabric
Cotton embroidered with silk; button-
hole-stitch, cross-stitch.
L. 75cm, w. (as sewn) 273cm (total length
of cloth 546cm).
Memon or Lohana community,
Tharparkar, Sindh, Pakistan, or Banni,
Kutch, Gujarat, mid-20th century.
Given by Mrs Shireen Feroze Nana.
IS 6-1981

97. Woman's shawl (*abochhini*)
Cotton embroidered with silk; 'Sindhi
stitch': radiating stitches with
buttonhole-stitch, open chain-stitch,
couching.
L. 205cm, w. 137cm.
Meghwar or Lohana Community,
Tharparkar, Sindh, Pakistan,
mid-20th century.
Given by Mrs Shireen Feroze Nana.
IS 8-1981

98. Man's wedding scarf (*bokano*)
Cotton embroidered with silk; open
chain-stitch, 'Sindhi stitch': radiating
stitches with buttonhole-stitch, Roman
stitch over laid thread.
L. 206cm, w. 55.5cm.
Tharparkar, Sindh, Pakistan,
early 20th century.
Given by Mrs Shireen Feroze Nana.
IS 13-1981

99. Woman's shawl (*abochhini*)
Cotton embroidered with silk; 'Sindhi
stitch', surface satin-stitch, buttonhole-
stitch, couching.
L. 185cm, w. 148cm.
Tharparkar, Sindh, Pakistan,
early 20th century.
Given by Mrs Shireen Feroze Nana.
IS 10-1981

100. Man's wedding scarf (*bokano*)
Cotton embroidered with silk;
satin-stitch, double running-stitch,
interlacing-stitch, hem-stitch.
L. 176cm, w. 62.5cm.
Sodha Rajput or Suthar community,
Sindh, Pakistan, 20th century.
Given by Mrs Shireen Feroze Nana.
IS 14-1981

101. Boy's shirt
Silk embroidered with silk; back-stitch,
running-stitch, buttonhole-stitch.
L. 83cm, w. (across sleeves) 110cm.
Shikarpur, Sindh, Pakistan,
early 20th century.
IS 58-1981

102. Skirt length
Silk embroidered with silk; chain-stitch.
L. 404cm, w. 77.5cm.
Hyderabad, Sindh, Pakistan, late 19th or
early 20th century.
Given by Lady Ratan Tata.
IM 278-1920

103. Panel for a blouse (*choli*)
Silk, embroidered with silk;
herringbone-stitch, open chain-stitch
'Sindhi stitch', Cretan-stitch.
L. 45.5cm, w. 74cm.
Probably from Sindh, Pakistan,
early 20th century.
Given by Miss Hellene Walton.
IS 27-1957

104. Panel for a blouse (*choli*)
Silk embroidered with silk; chain-stitch,
cross-stitch.
L. 30.5cm, w. 35.5cm.
Sindh, Pakistan, early 20th century.
IS 158-1960

105. Woman's bodice (*choli*)
Cotton embroidered with silk;
herringbone-stitch, buttonhole-stitch,
interlacing-stitch, chain-stitch.
L. 43cm, w. 77.5cm.
Bansali Community, Kutch, Gujarat,
early 20th century.
Given by Miss A. R. Ditmas.
IS 55-1957

106. Woman's tunic (*cholo*)
Cotton and silk embroidered with silk.
L. 85cm, w. 101cm.
Thano Bula Khan, Sindh, Pakistan,
mid-20th century.
IS 15-1974

107. Child's dress
Silk embroidered with floss silk; open
chain-stitch, Roman-stitch, 'Sindhi
stitch': radiating stitches with
buttonhole-stitch.
L. 58.5cm, w. 53.5cm.
Probably Badin, Sindh, Pakistan, *c*.1900.
49-1908

108. Child's dress
Silk embroidered with floss silk; chain-
stitch, 'Sindhi stitch': radiating stitches
with buttonhole-stitch.
L. 54.5cm, w. 58.5cm.
Probably Badin, Sindh, Pakistan,
early 20th century.
IS 55-1962

109. Woman's shawl (*abochhini*)
Cotton embroidered with floss silk;
chain-stitch, 'Sindhi stitch': radiating
stitches with buttonhole-stitch.
L. 194cm, w. 131cm.
Sindh, Pakistan, mid-20th century.
Given by Mrs Eley and Mrs G. L. Warren.
IS 82-1958

110. Woman's shawl (*abochhini*)
Silk embroidered with floss silk; chain-
stitch, 'Sindhi stitch': radiating stitches
with buttonhole-stitch.
L. 201cm, w. 134.5cm.
Badin, Sindh, Pakistan, early 20th
century.
Given by Miss Hellene Watson.
IS 19-1957

111. Woman's dress (*pashk*)
Silk embroidered with silk and gold
thread; chain-stitch, interlacing-stitch,
cross-stitch, satin-stitch, herringbone-
stitch.
L. 126cm, w. 50cm.
Nal or Khuzdar, Baluchistan, Pakistan,
late 19th or early 20th century.
Given by Mrs D. E. Hogg.
IS 14-1971

112. Woman's dress (*pashk*)
Silk embroidered with silk thread;
interlacing-stitch, herringbone-stitch,
cross-stitch, chain-stitch, satin-stitch.
L. 131cm, w. 50cm.
Kalat, Baluchistan, Pakistan, late 19th or
early 20th century.
Given by Mrs Anna Whitehead.
IS 33-1969

113. Woman's dress (*pashk*)
Silk embroidered with silk thread;
surface satin-stitch.
L. 125cm, w. 45cm.
Probably from Quetta, Baluchistan,
Pakistan, late 19th or early 20th century.
T.251-1923

114. Gunbelt (detail)
Leather embroidered with silk thread;
chain-stitch, buttonhole-stitch.
L. 143cm.
Sibi, Baluchistan, Pakistan, late 19th
century.
1-1900

115. Bedcover (*kantha*)
Cotton, quilted and embroidered
with cotton thread; running-stitch,
back-stitch.
L. 193cm, w. 127cm.
Jessore District, Bangladesh,
early 20th century.
IS 22-1983

116. Bedcover (*kantha*)
Cotton, quilted and embroidered with
cotton thread; running-stitch, pattern
darning-stitch.
L. 166cm, w. 114cm.
Faridpur or Jessore District, Bangladesh,
late 19th or early 20th century.
IS 62-1981

**117. Wrapper (*bostani*) or seating mat
(*ashon*)**
Cotton, quilted and embroidered with
cotton thread; running-stitch, pattern
darning-stitch, satin-stitch, buttonhole-
stitch.
L. 71cm, w. 69cm.
Bangladesh, early 20th century.
IS 61-1981

118. Coverlet
Cotton, quilted and embroidered with
cotton thread; running-stitch.
L. 57cm, w. 57cm.
Calcutta, West Bengal, 1996.
IS 13-1996

119. Child's dress
Cotton embroidered with silk thread;
chain-stitch, pattern darning-stitch,
knot-stitch, buttonhole-stitch.
L. 51cm, w. 63.5cm.
Dharbanga District, Bihar,
mid-20th century.
IS 6-1961

120. Woman's headcover (*bagh*)
Cotton embroidered with floss silk;
surface darning-stitch.
L. 203cm, w. 122cm.
Western Panjab, early 20th century.
IS 4-1961

121. Woman's headcover (*bagh*)
Cotton embroidered with floss silk;
surface darning-stitch.
L. 237cm, w. 123cm.
Western Panjab, mid-20th century.
IS 28-1983

122. Woman's headcover (*chadar*)
Cotton embroidered with floss silk;
surface darning-stitch.
L. 228cm, w. 144cm.
Eastern Panjab, mid-20th century.
IS 34-1970

123. Woman's headcover (*chadar*)
Cotton embroidered with floss silk;
surface darning-stitch.
L. 222cm, w. 146cm.
Eastern Panjab, early 20th century.
IS 24-1983

124. Skirt
Cotton embroidered with floss silk;
surface darning-stitch.
L. 94cm, w. (at hem) 404cm.
Hissar, Haryana, *c*.1880.
1823-1883 (IS)

125. Woman's headcover
Cotton embroidered with floss silk,
with added mirrors; satin-stitch, surface
darning-stitch.
L. 213cm, w. 137cm.
Rohtak, Haryana, *c.*1880.
1842-1883 (IS)

126. Part of a woman's headcover
(*chope*)
Cotton embroidered with floss silk;
double running-stitch.
L. 66cm, w. 57cm.
Panjab, early 20th century.
Given by Dr C. S. Chan Sandhu.
IS 91-1985

127. Shawl
Wool embroidered with woollen thread;
cross-stitch, double running-stitch,
satin-stitch.
L. 195.5cm, w. 134.5cm.
Hissar, Haryana, *c.*1880.
1839-1883 (IS)

128. Coverlet (*rumal*)
Cotton embroidered with floss silk;
surface darning-stitch.
L. 71cm, w. 71.5cm.
Swat Valley, Pakistan, *c.*1935.
Given by Major E. H. Cobb.
IM 37-1938

129. Woman's shirt
Cotton embroidered with floss silk;
surface darning-stitch.
L. 84cm, w. 148cm.
Swat Valley, Pakistan, mid-20th century.
IS 40-1979

130. Woman's shawl
Cotton embroidered with floss silk with
added beads; surface darning-stitch.
L. 146cm, w. 204cm.
Indus Kohistan, Pakistan,
mid-20th century.
IS 2-1997

131. Child's jacket
Cotton embroidered with silk, with
applied beads, zip fasteners; cross-stitch.
L. 40cm, w. 37cm.
Indus Kohistan, Pakistan,
mid-20th century.
IS 32-1996

132. Woman's shirt (*kurta*)
Cotton, embroidered with silk, with
added beads, sequins; chain-stitch.
L. 98cm, w. 156cm.
Indus Kohistan, Pakistan, second half of
the 20th century.
IS 3-1997

133. Coverlet (*rumal*)
Cotton, appliquéd and embroidered
with silk, with added cowrie shells.
L. 43.5cm, w. 41cm.
Banjara community, Central India,
probably Khandesh, 20th century.
IS 476-1993

134. Neck piece (*galla*)
Cotton, embroidered with silk with
added cowrie shells; running-stitch,
straight-stitch worked on the diagonal.
L. 35.5cm, w. 26cm.
Banjara community, Central India,
probably Maharashtra, 20th century.
IS 477-1993

135. Bag for bread (*khalechi*)
(opened out)
Cotton, embroidered with cotton thread;
Florentine-stitch, tent-stitch, a variation
of surface satin-stitch with additional
central ridge.
L. 58cm, w. 63cm.
Banjara community, probably from
Maharashtra, 20th century.
IS 168-1984

136. Mat (*asana*)
Cotton, embroidered with cotton thread;
running-stitch, interlacing-stitch.
L. 77.5cm, w. 74cm.
Banjara community, Central India,
mid-20th century.
IS 169-1984

137. Bag
Cotton, embroidered with cotton, with
added cowrie shells; chain-stitch, satin-
stitch, close herringbone-stitch.
L. (open) 60cm, w. 36cm.
Banjara community, probably
Karnataka, 20th century.
IS 474-1993

138. Woman's blouse
Cotton embroidered with silk; eye-stitch,
double running-stitch.
L. 31cm, w. 88cm.
Dharwar, Karnataka, mid-19th century.
8249 (IS)

139. Jacket
Cotton, embroidered with wool and
cotton; pattern darning-stitch.
L. 38cm, w. 42cm.
Assam, early 20th century.
IM 49a-1939

140. Man's shawl
Silk, embroidered with floss silk; chain-
stitch, roman filling-stitch.
L. (incl. fringe) 326cm, w. 141cm.
Manipur, mid-19th century.
0190 (IS)

141. Man's shawl
Cotton, embroidered with floss silk;
Romanian couching, Roman stitch.
L. 185cm, w. 125.5cm.
Manipur for use by Eastern Angami
Nagas, *c.*1940.
IS 165-1989

The Plates

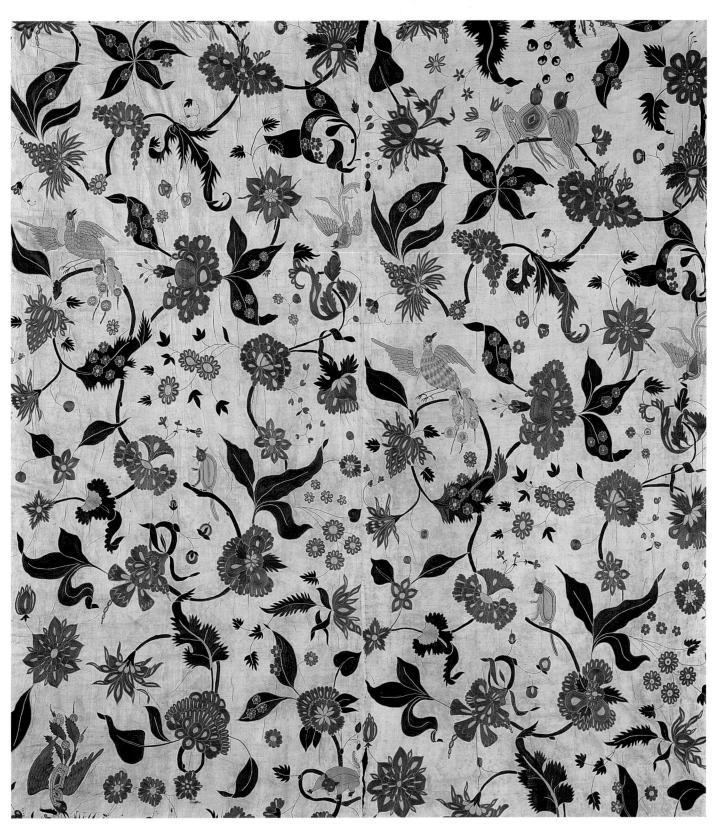

1. Bed or wall hanging

Gujarat, for the English market, *c.*1700.

IS 155-1953

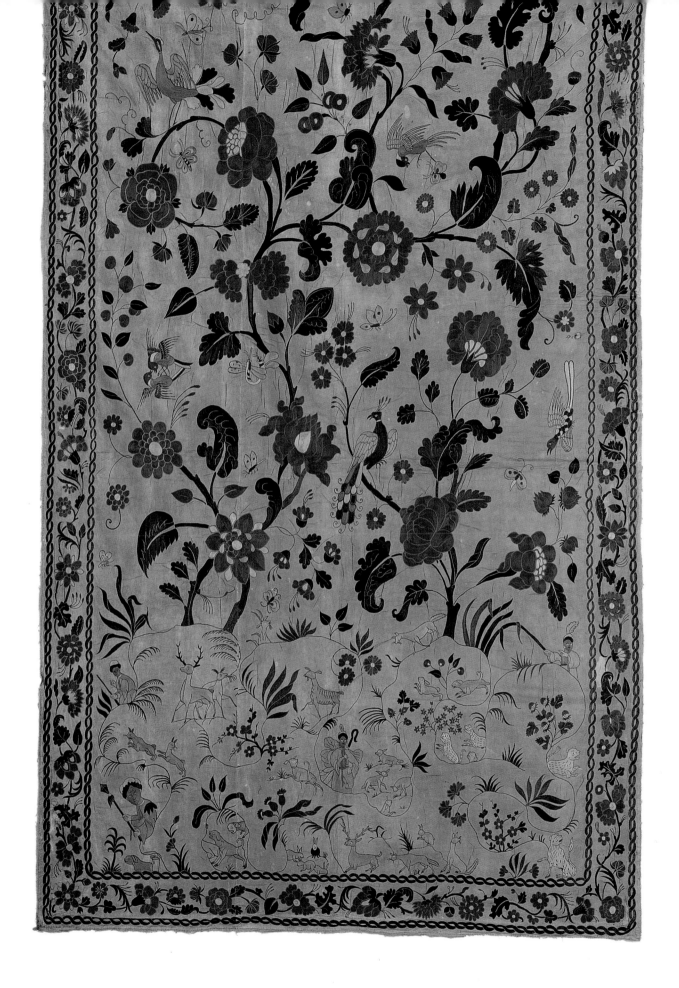

2. Bed or wall hanging

Gujarat, for the English market, late 17th century.

IS 152-1953

3. *(opposite)* **Length of dress or furnishing fabric**

Gujarat, for the European market, *c.*1710.

T 20-1947

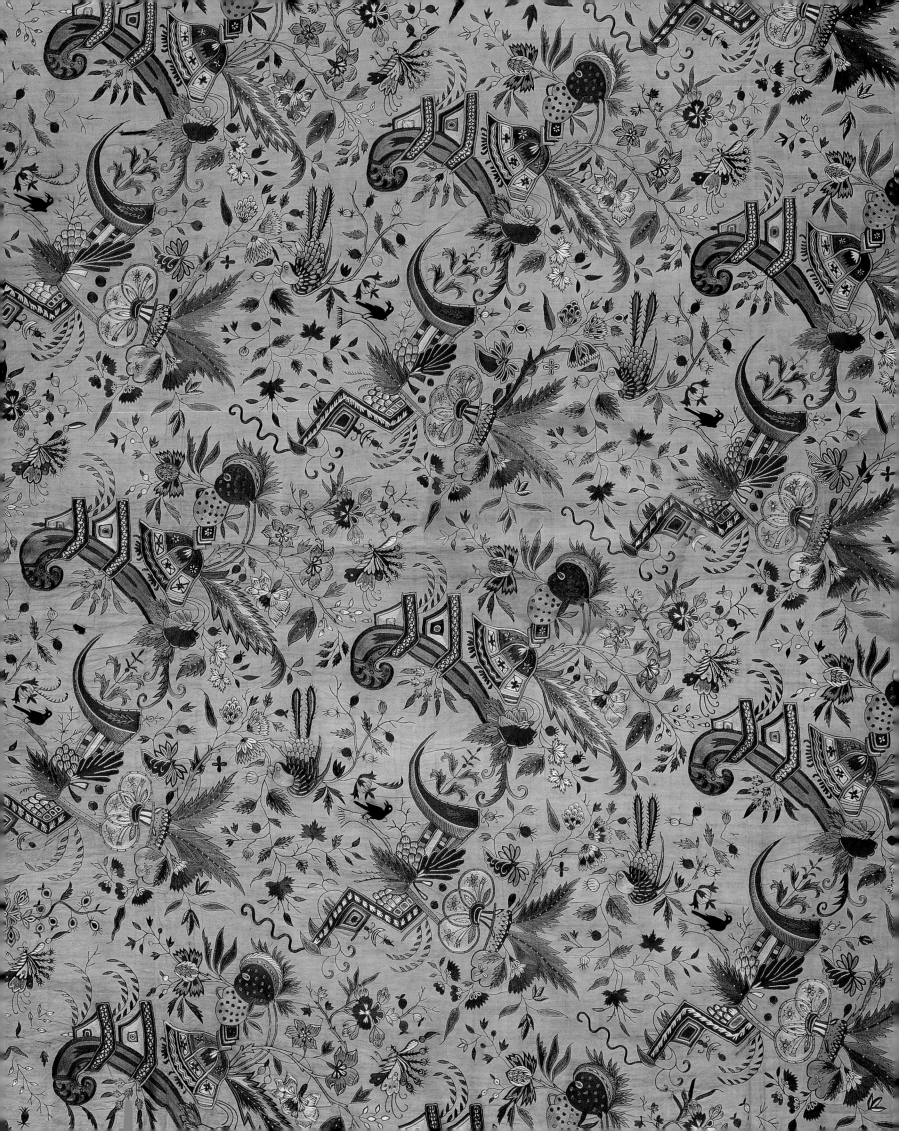

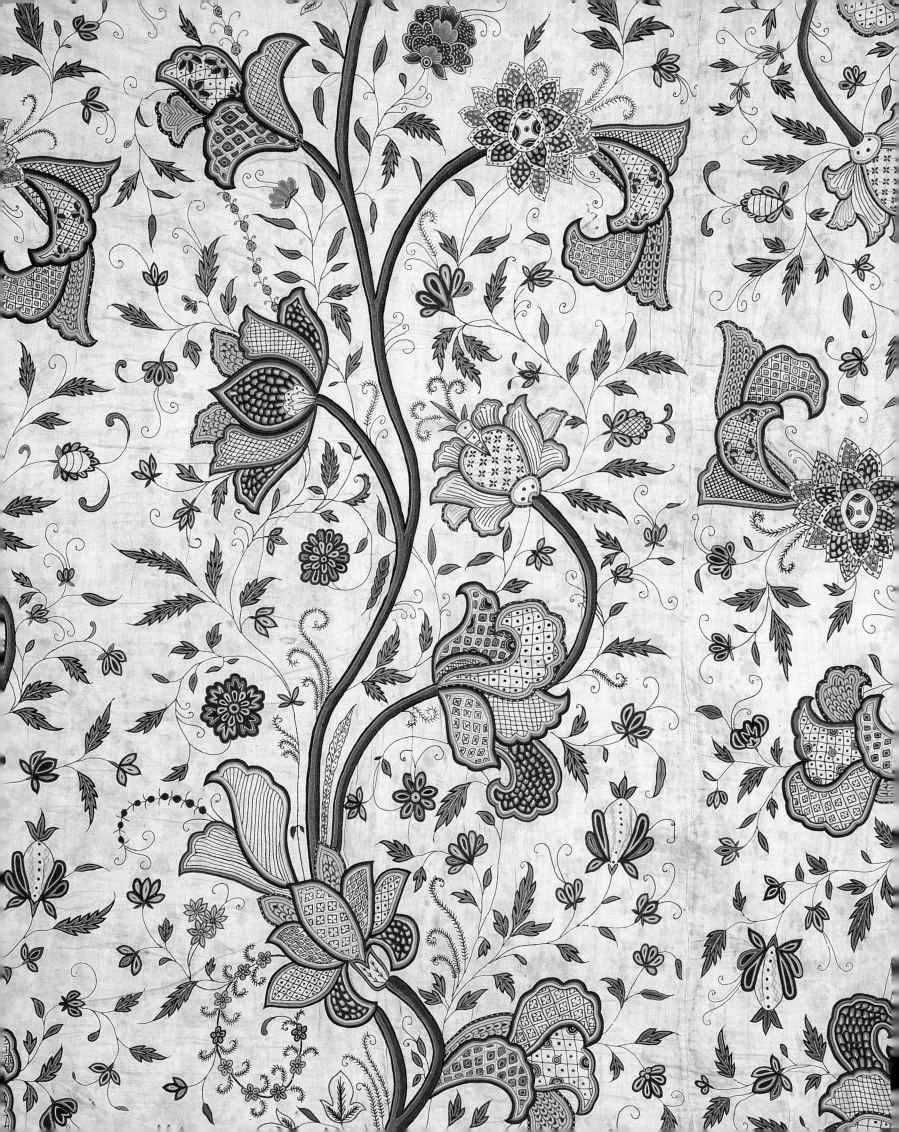

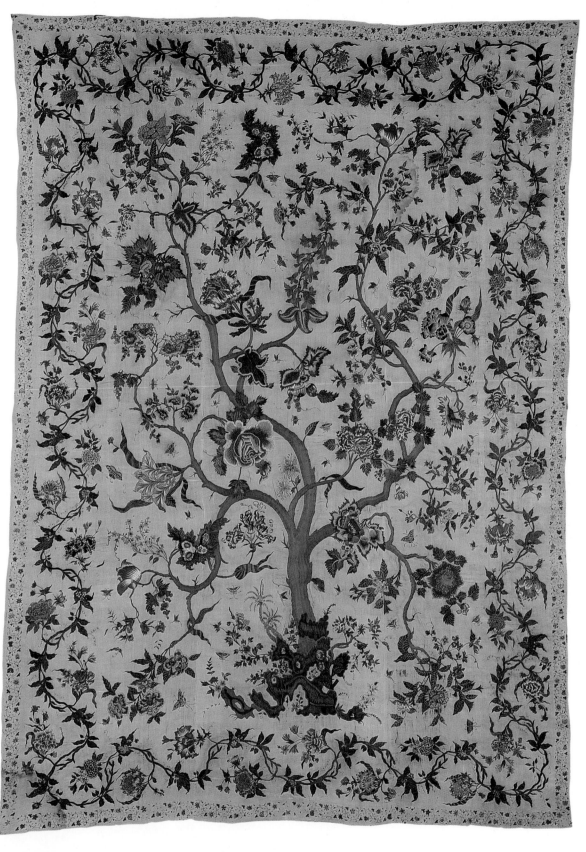

4. *(opposite)* **Length of furnishing fabric**
Gujarat, for the European market, early 18th century.
IS 298-1951

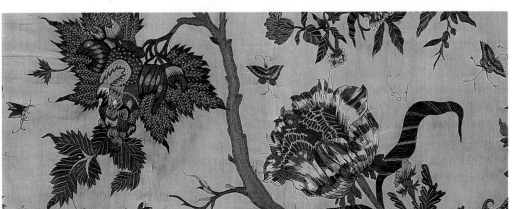

5. *(above; detail left)* **Palampore**
Gujarat, for the European market, *c.* 1700–20.
IS 29-1889

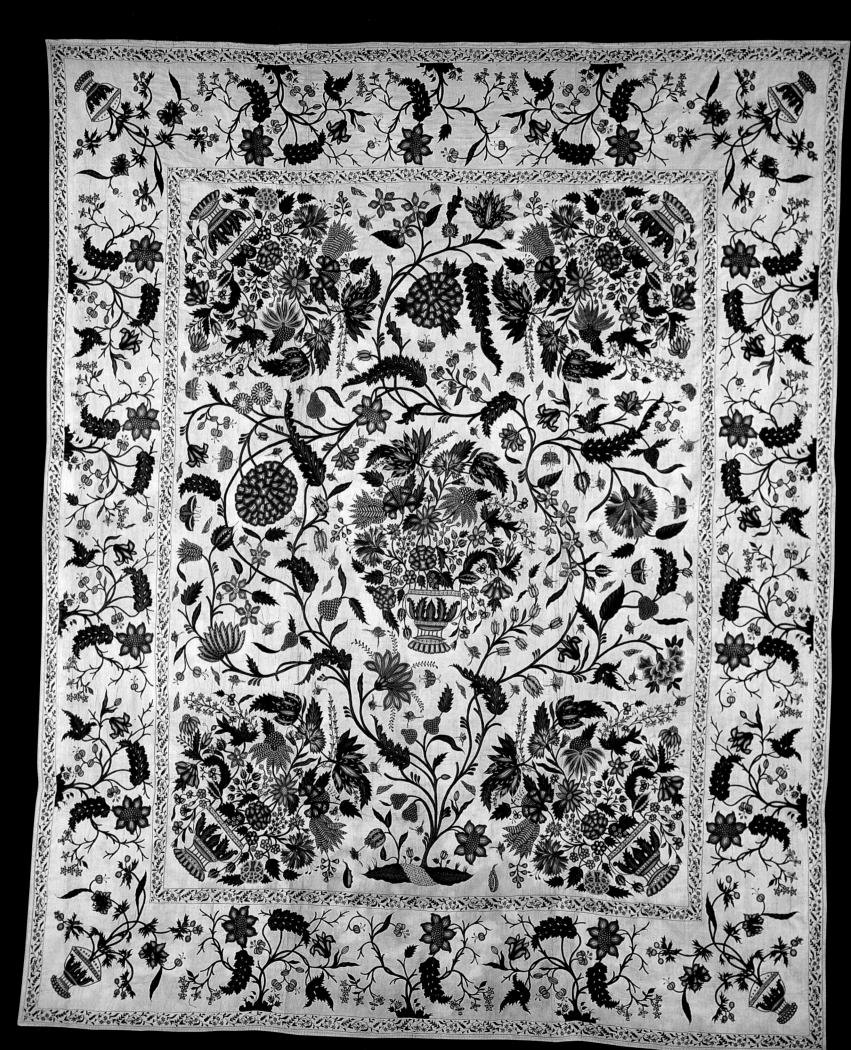

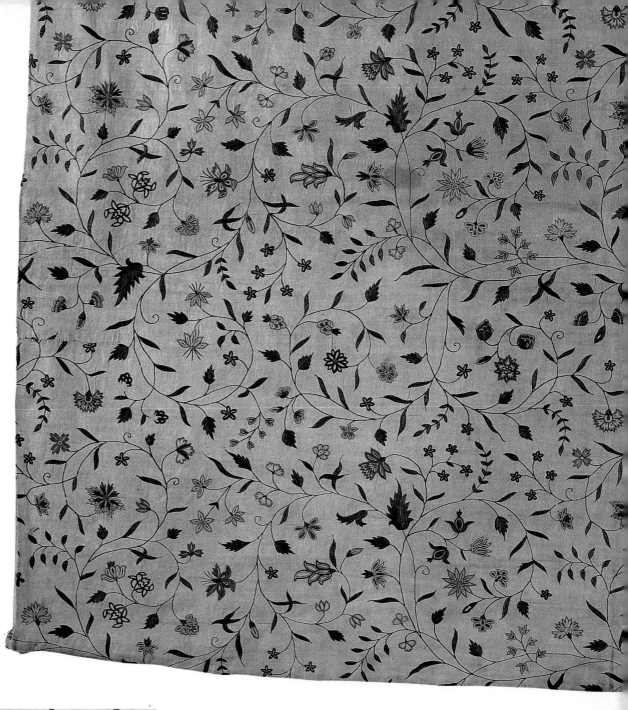

6. *(opposite)* **Palampore**
Gujarat, for the European
(Dutch?) market, 1725–40.
IM 13-1930

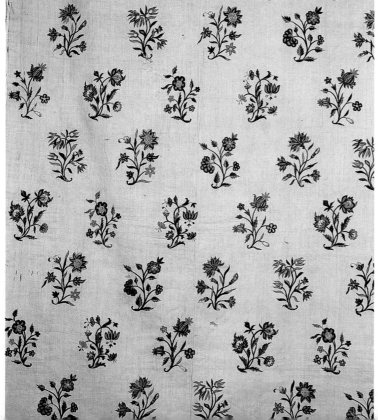

7. *(above)* **Fragment of dress or furnishing fabric**
Gujarat, for the European market, early 18th century.
IS 78-1955

8. Length of furnishing fabric
Gujarat, for the European market,
early 18th century.
IS 141-1954

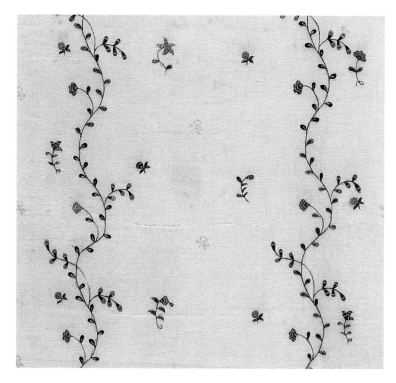

9. *(left)* **Length of dress fabric**
Probably Gujarat for the English market, late 18th/early 19th century.
Circ. 329-1925

10. *(above)* **Length of dress fabric**
North India, for the European market, late 18th/early 19th century.
IS 130-1984

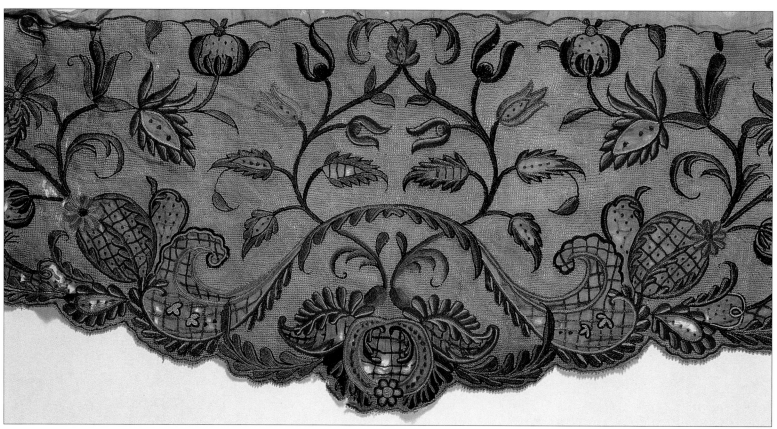

11. Decorative ruffle for a sleeve
Gujarat, for the European market, *c.*1760.
T 122-1956

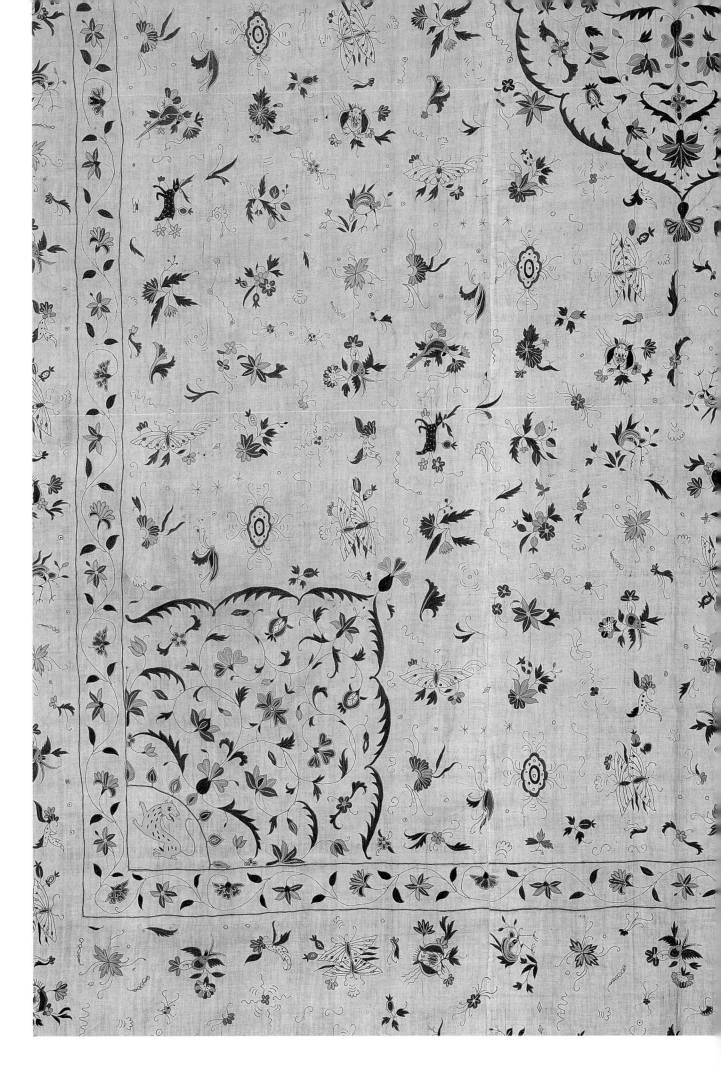

**12. Floorspread
or bedspread**
Gujarat, probably for
the European market,
early 18th century.
T 52-1914

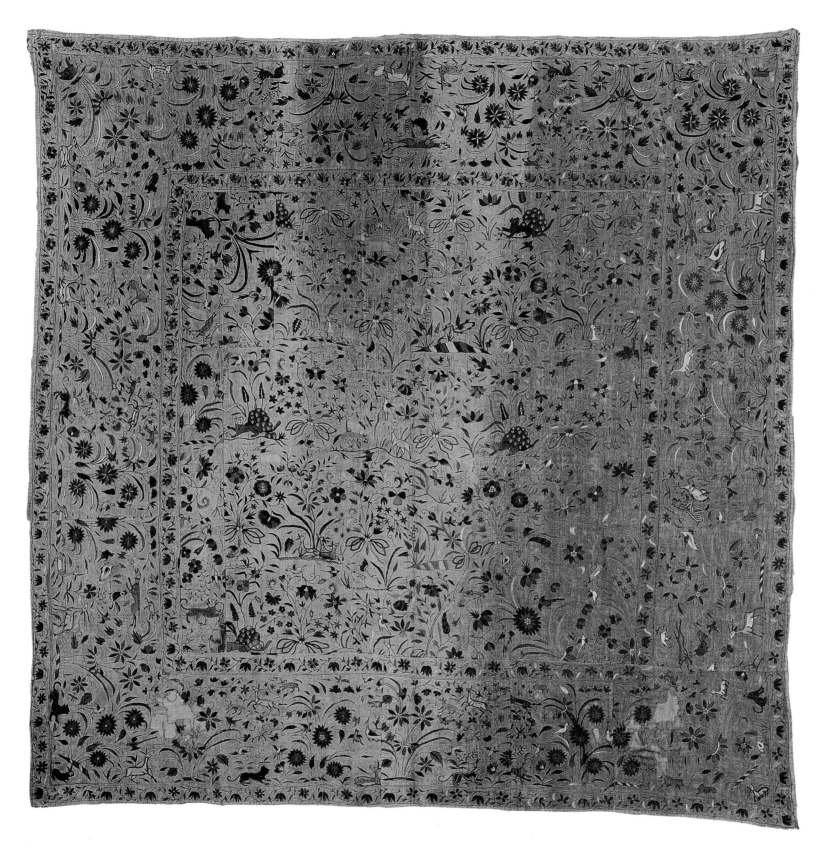

13. Floorspread
Western India, *c.*1725–50.
257-1899

14. *(opposite)* **Bedcover or wall hanging**
Probably Northern India for the Dutch market,
mid-18th century.
IM 165-1910

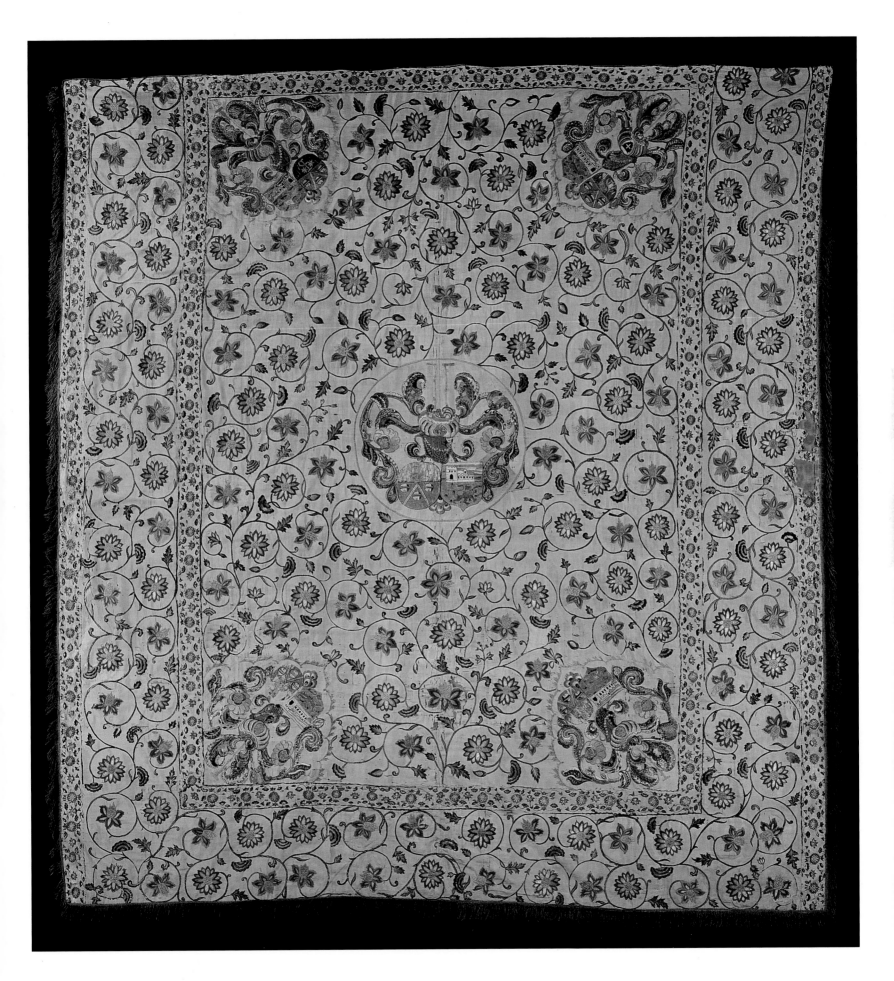

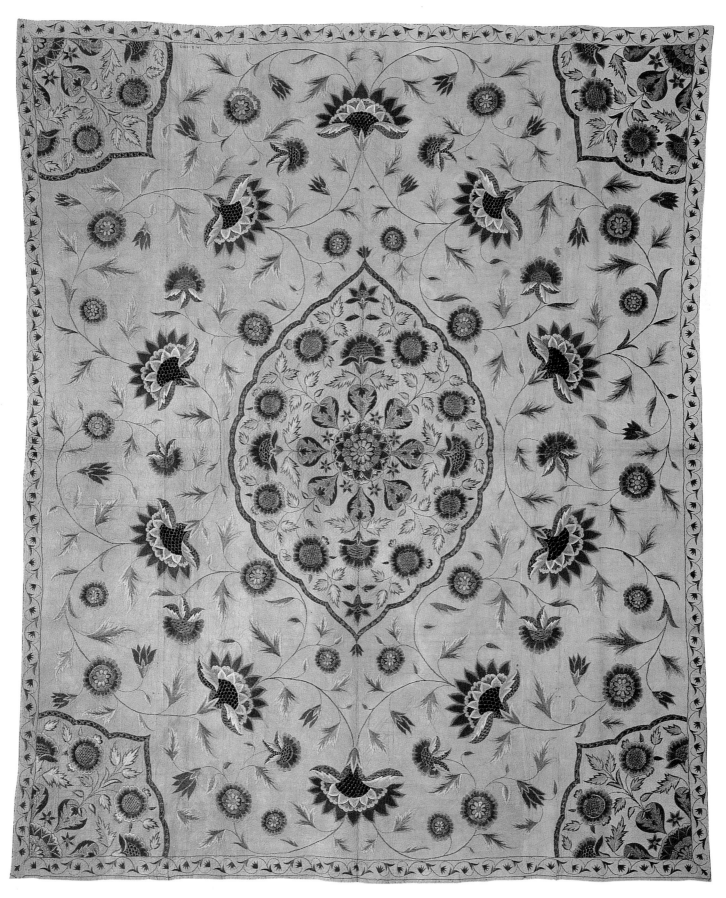

15. Floorspread

Probably Deccan, mid-18th century.

IM 2-1912

16. *(opposite)* **Floorspread**

Deccan, mid-18th century.

783-1864

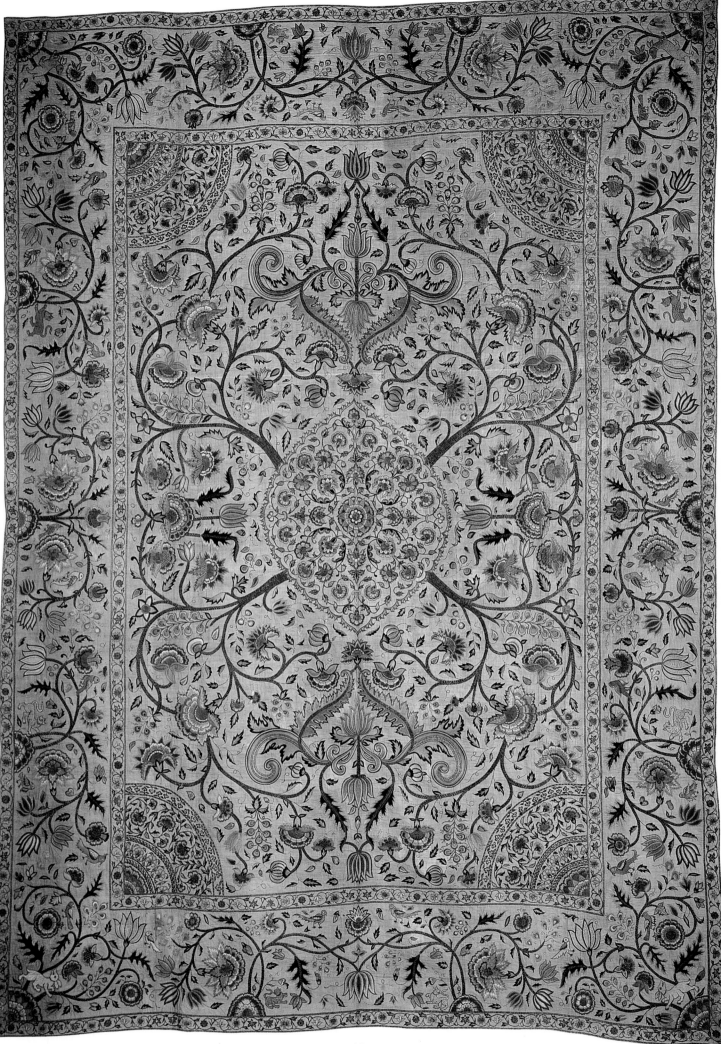

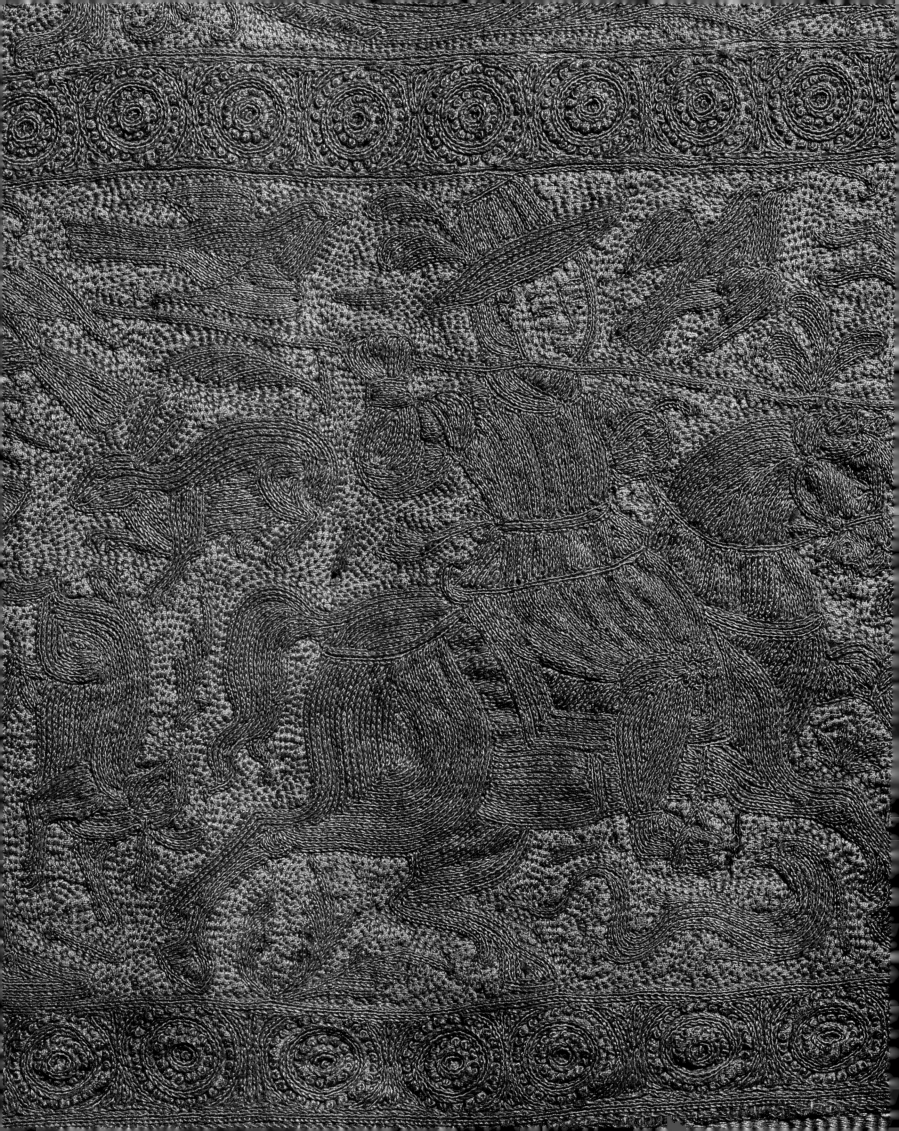

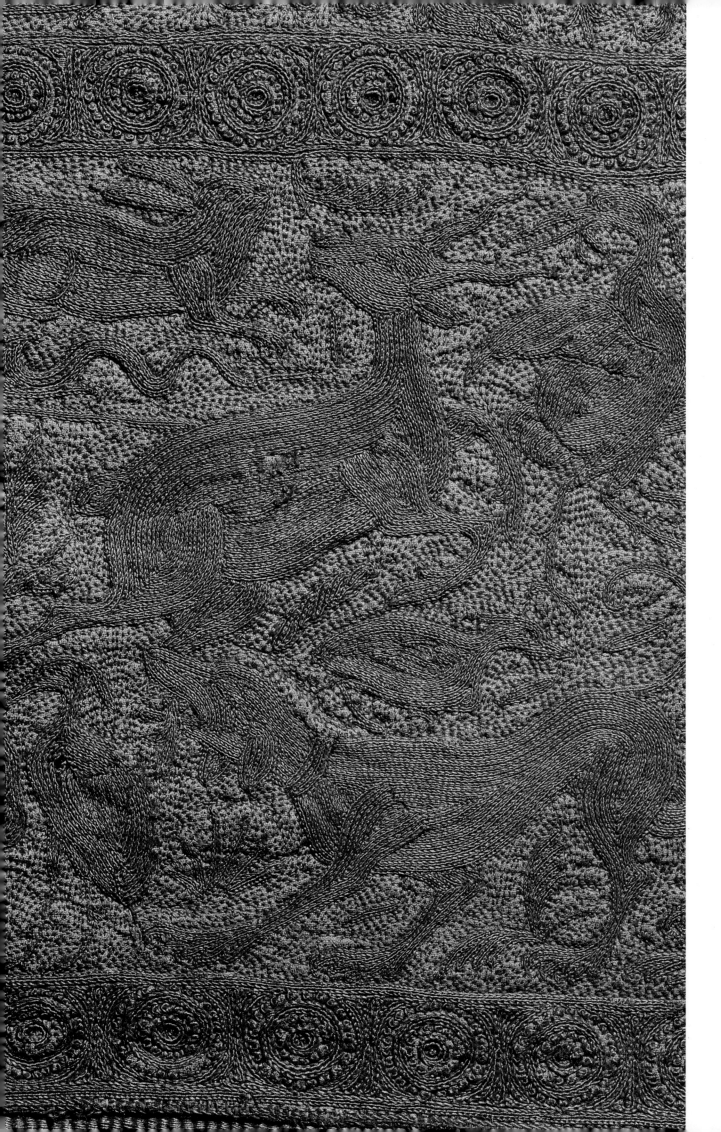

17. Bedcover (detail)
Bengal, for the
Portuguese market,
*c.*1600.
616-1886

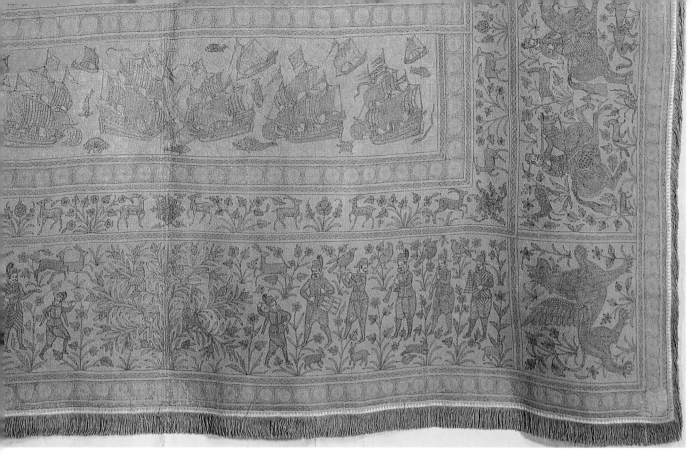

18. Bedcover (detail)
Probably Bengal for
the Portuguese market,
early 17th century.
T 438-1882

19. *(below)* **Part of
a bedcover**
Bengal, for the
Portuguese market,
early 17th century.
IS 157-1953

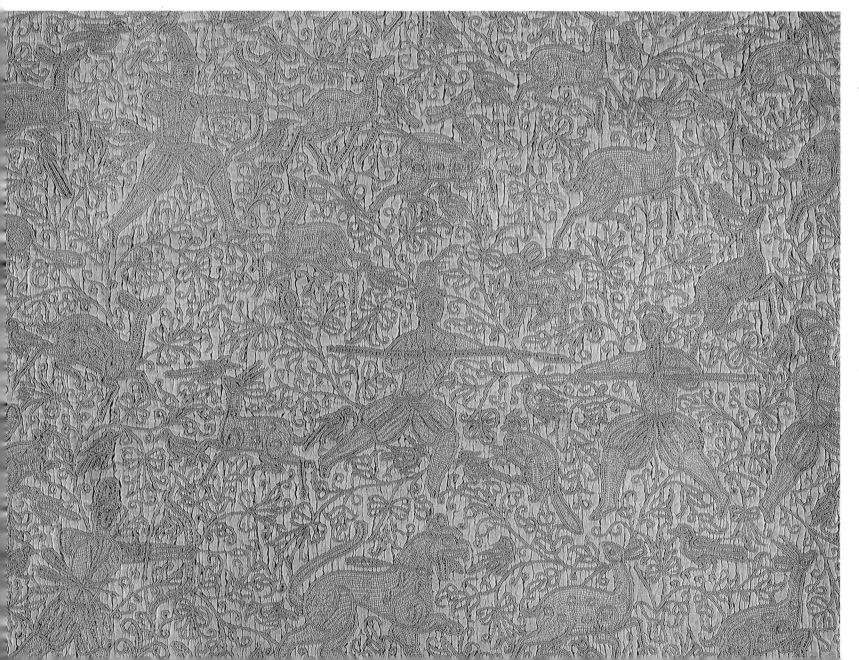

**20. Border of a
bedcover** (detail)
Bengal, for the
Portuguese market,
early 17th century.
T 6-1936

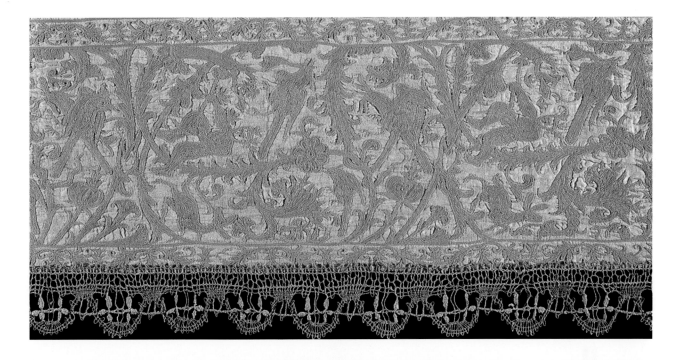

21. *(below)* **Cape**
(detail)
Bengal for the
Portuguese market,
early 17th century.
T 1016-1877

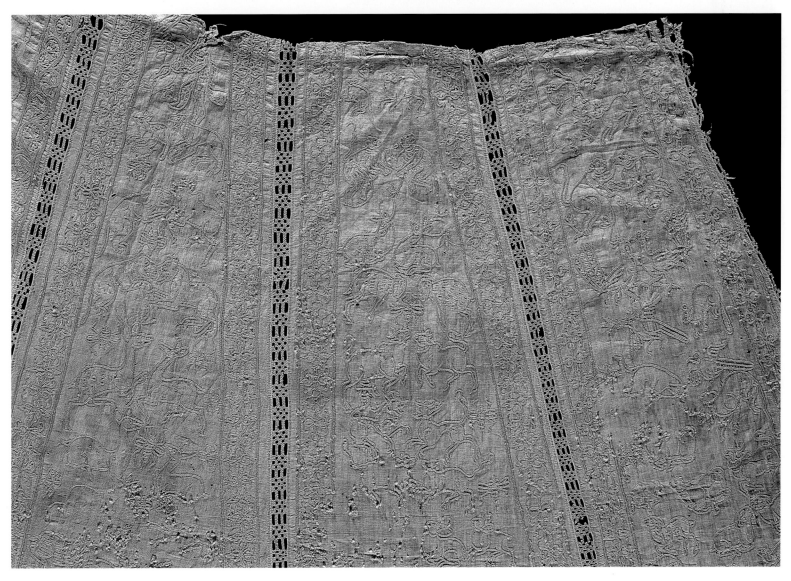

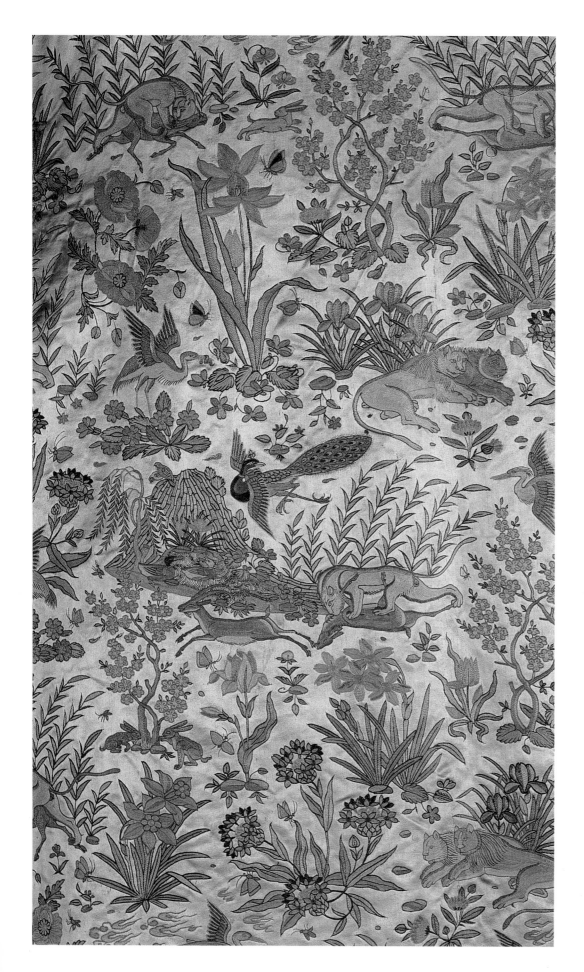

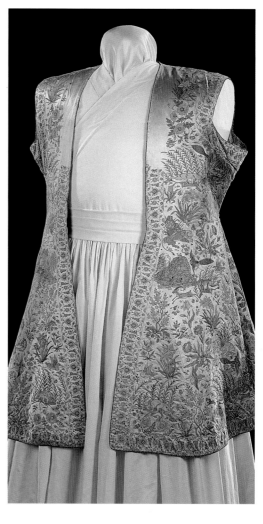

22. *(above; detail left)* **Man's coat**
Mughal, *c.*1620–30.
IM 18-1947

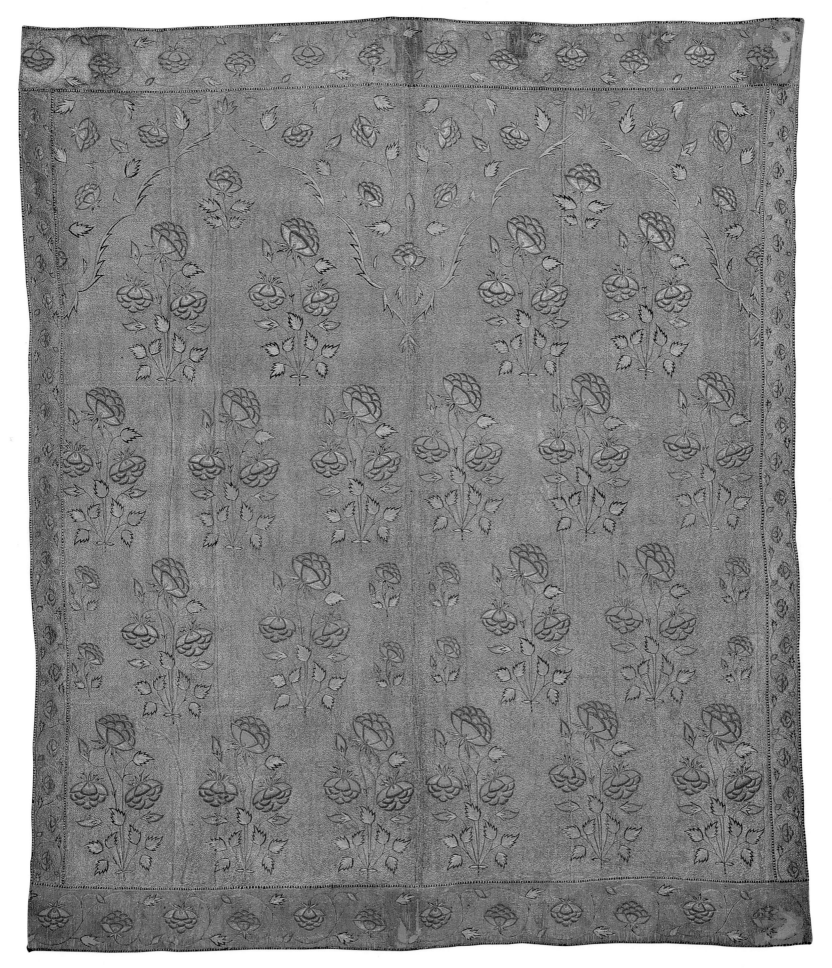

23. Tent hanging
Mughal, late 17th century.
IM 48-1928

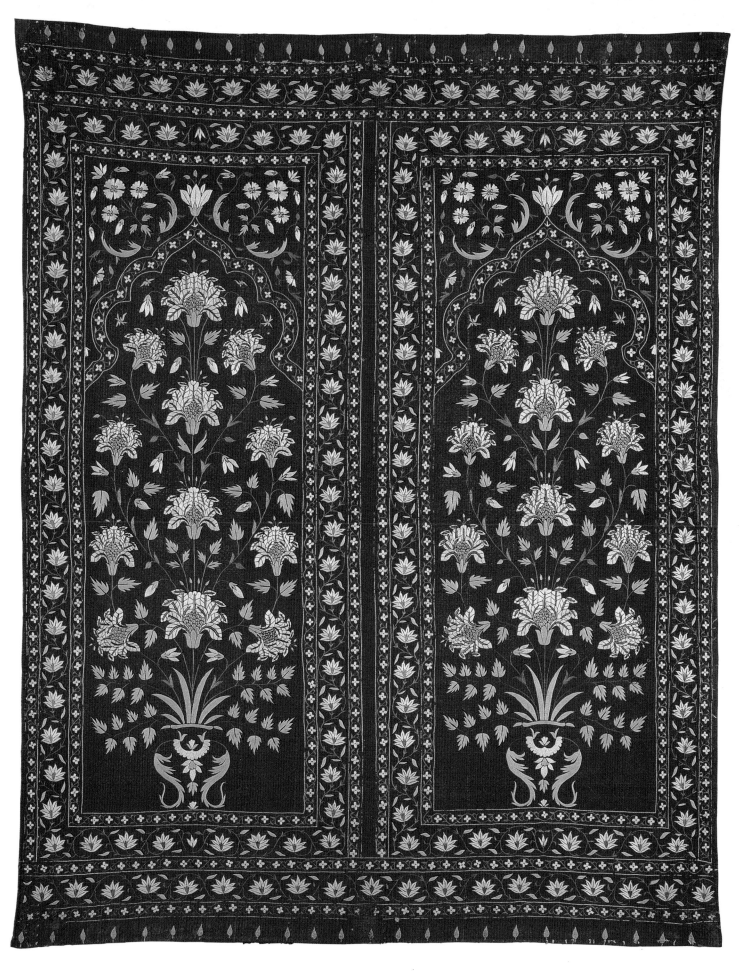

24. Tent hanging
Mughal, *c.*1700.
IM 62-1936

25. *(opposite)* **Hanging**
Mughal, late 17th century.
IS 168-1950

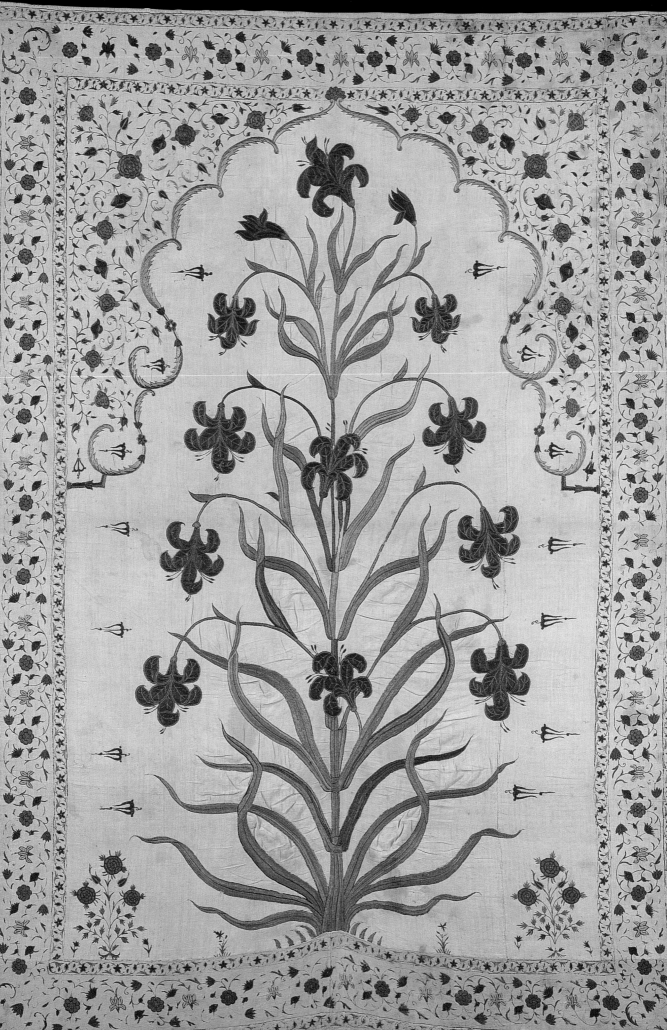

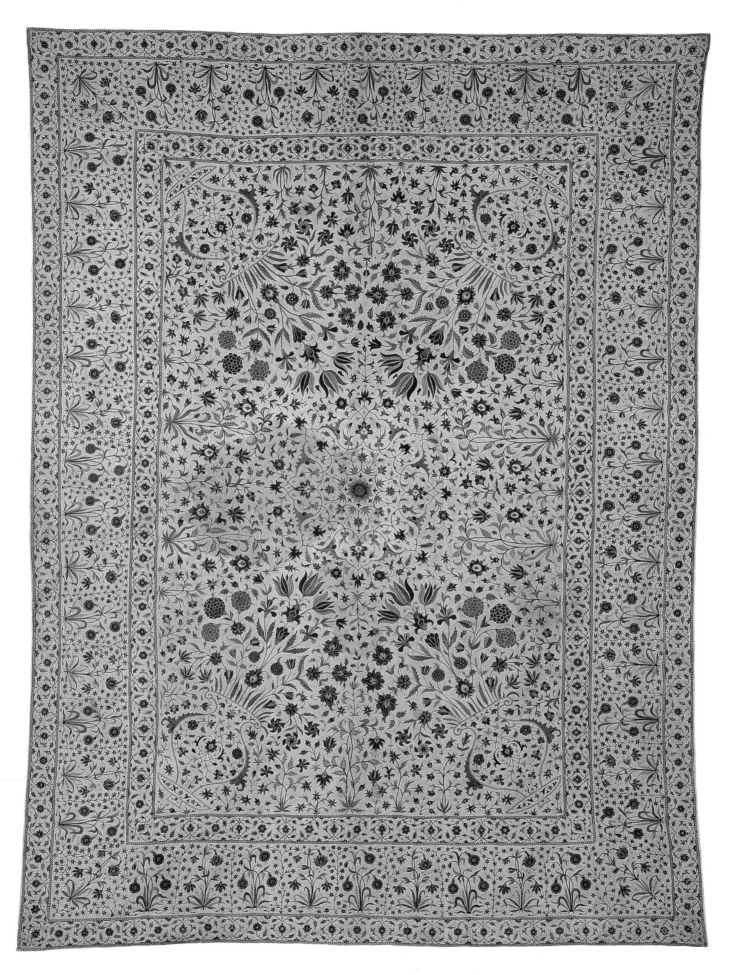

26. Floorspread

Mughal, *c*.1700.

IS 34-1985

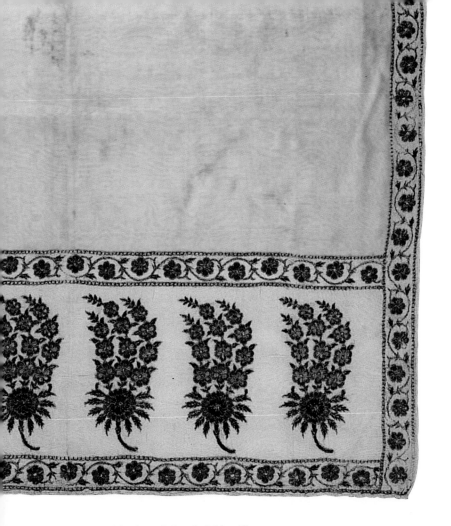

27. Man's sash (*patka*) (detail)
Mughal, early 18th century.
IM 29-1936

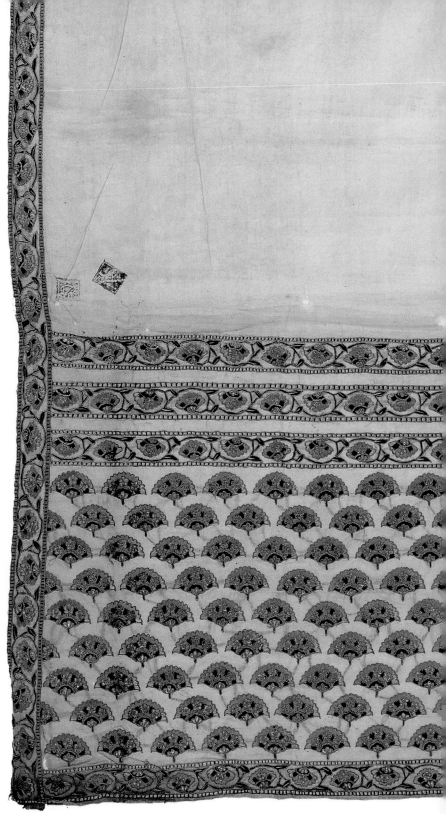

28. Man's sash (*patka*) (detail)
Mughal, early 18th century.
IM 26-1936

29. Fragment of a turban cloth (detail)
Mughal, early 18th century.
IM 27-1936

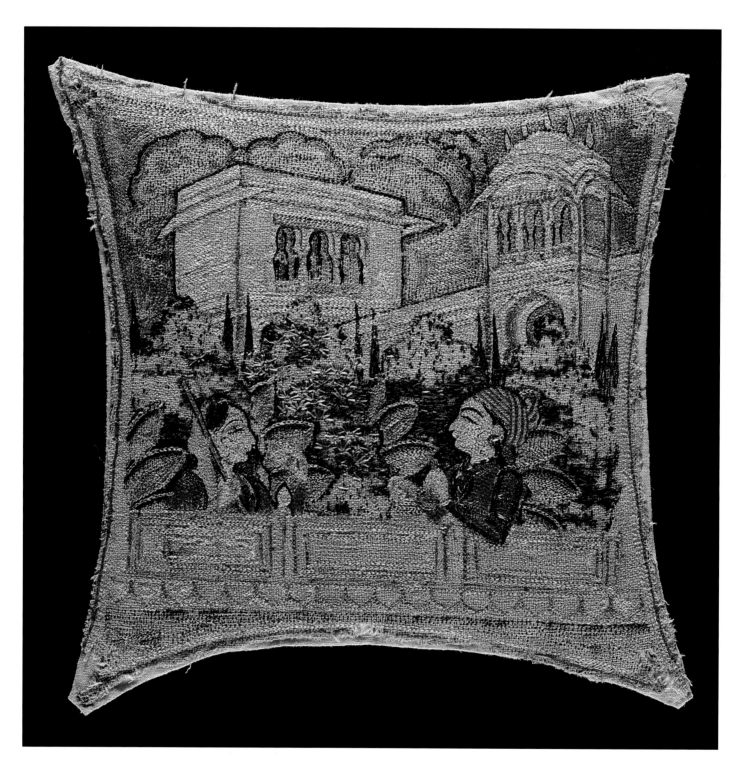

30. Knuckle-pad cover
Rajasthan, probably Bundi or Jaipur,
18th century.
IM 107-1924

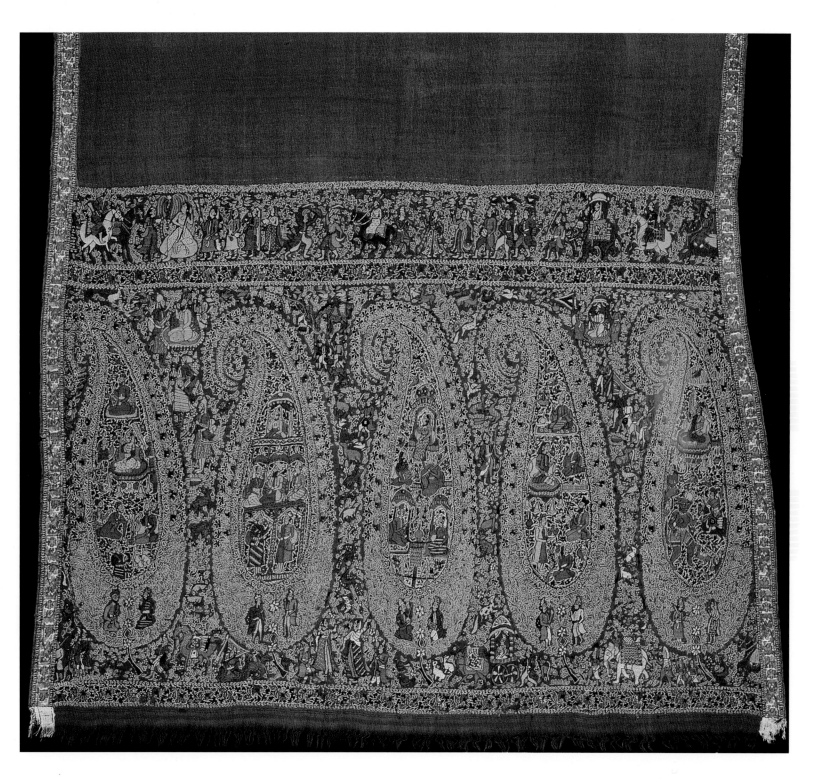

31. Sash
Srinagar, Kashmir, *c.* 1830.
501-1907

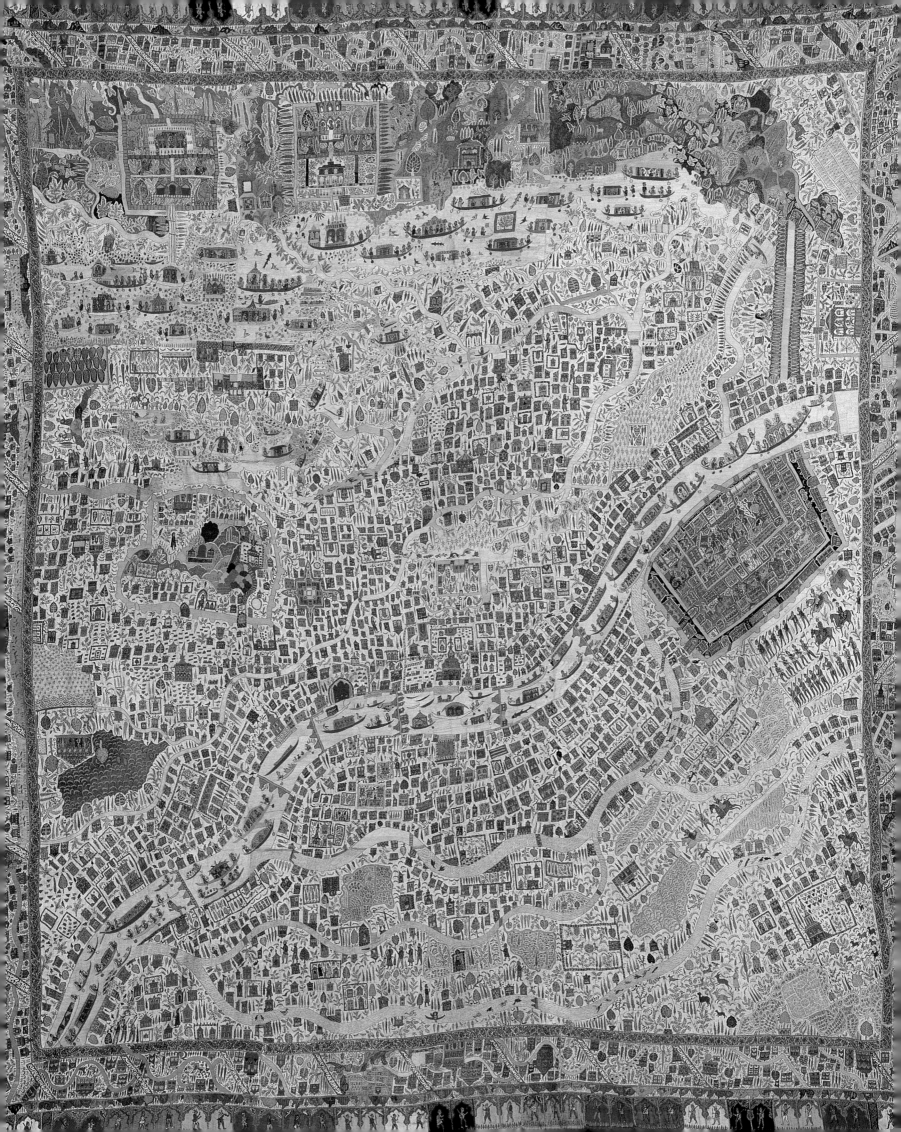

32. *(opposite; detail right)* **Shawl with map of Srinagar**
Srinagar, Kashmir, *c.*1860.
IS 31-1970

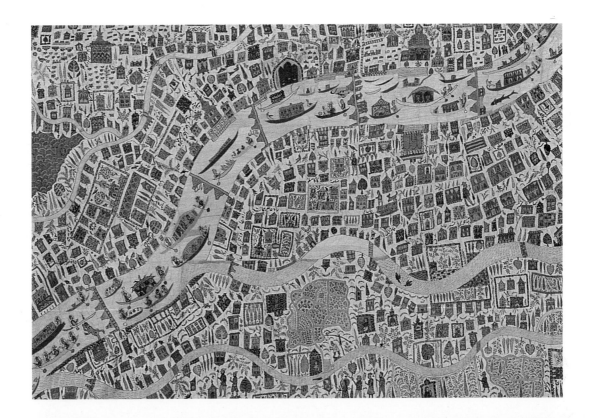

33. *(below)* **Semi-circular shawl**
Srinagar, Kashmir, *c.*1840–60.
IS 1-1949

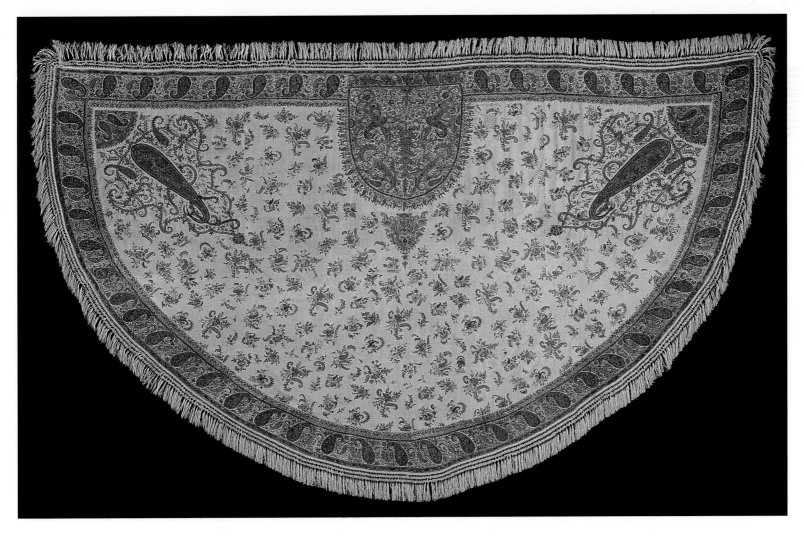

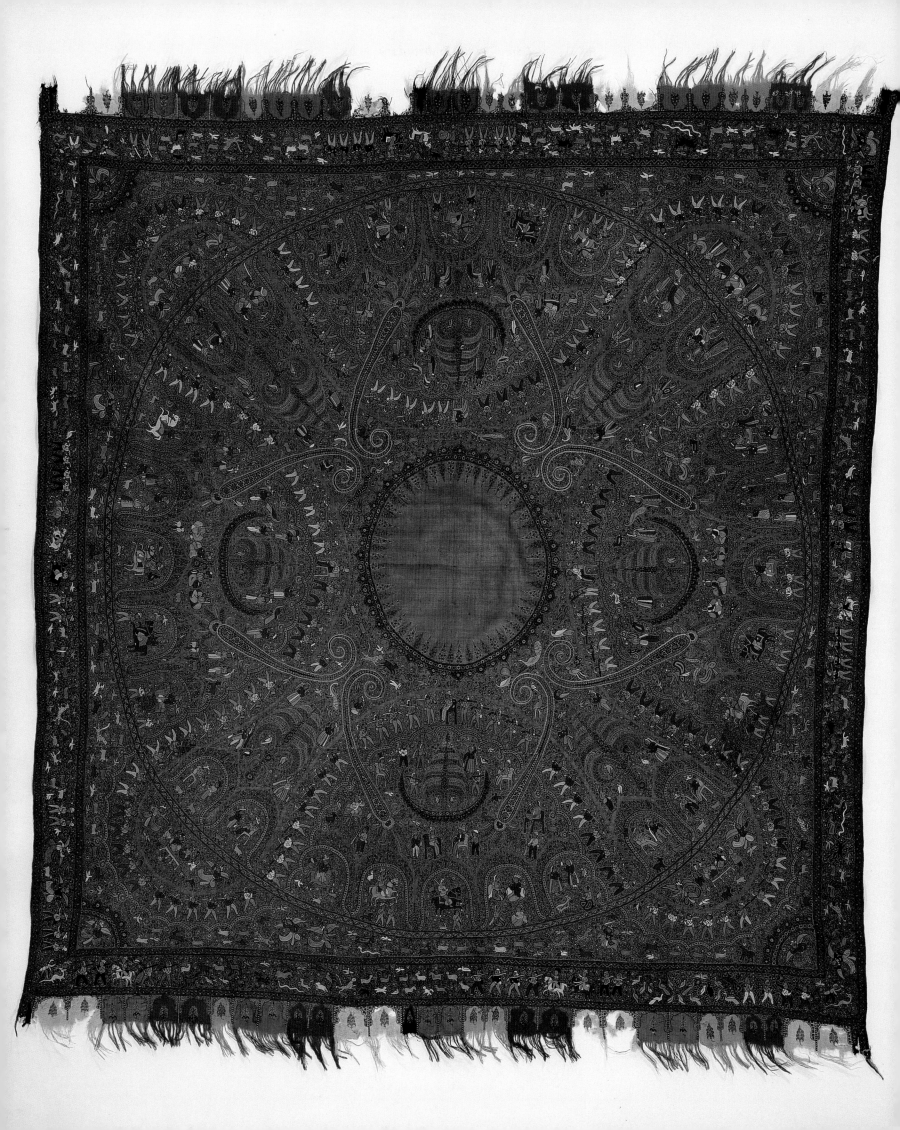

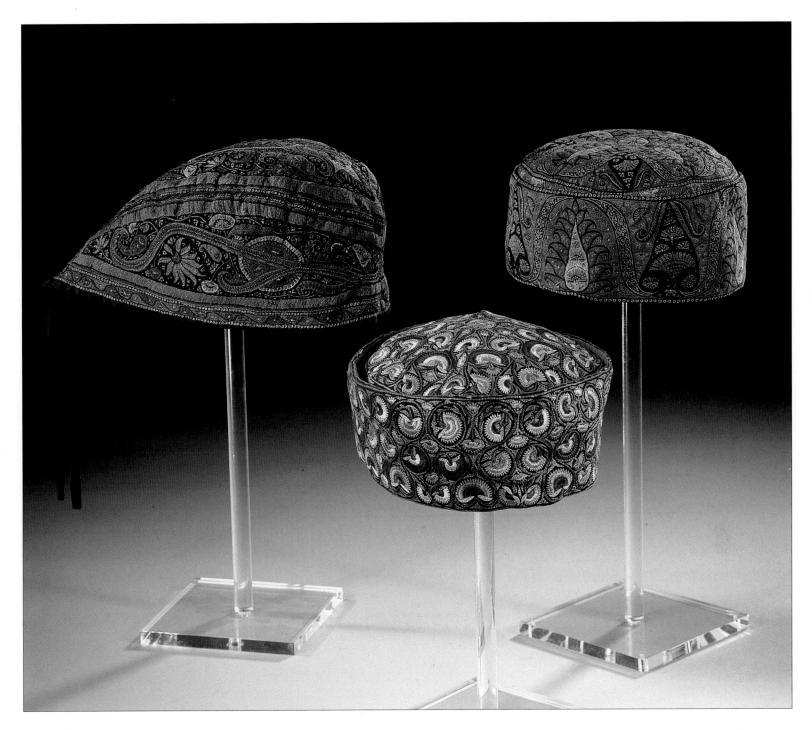

35. Three caps
Srinagar, Kashmir *(left and right)*,
Ludhiana, Punjab *(centre)*, *c.*1855.
Left to right: 8078 (IS), 5763 (IS), 8079 (IS)

34. *(opposite)* **Tablecover**
Srinagar, Kashmir, *c.*1855.
0261 (IS)

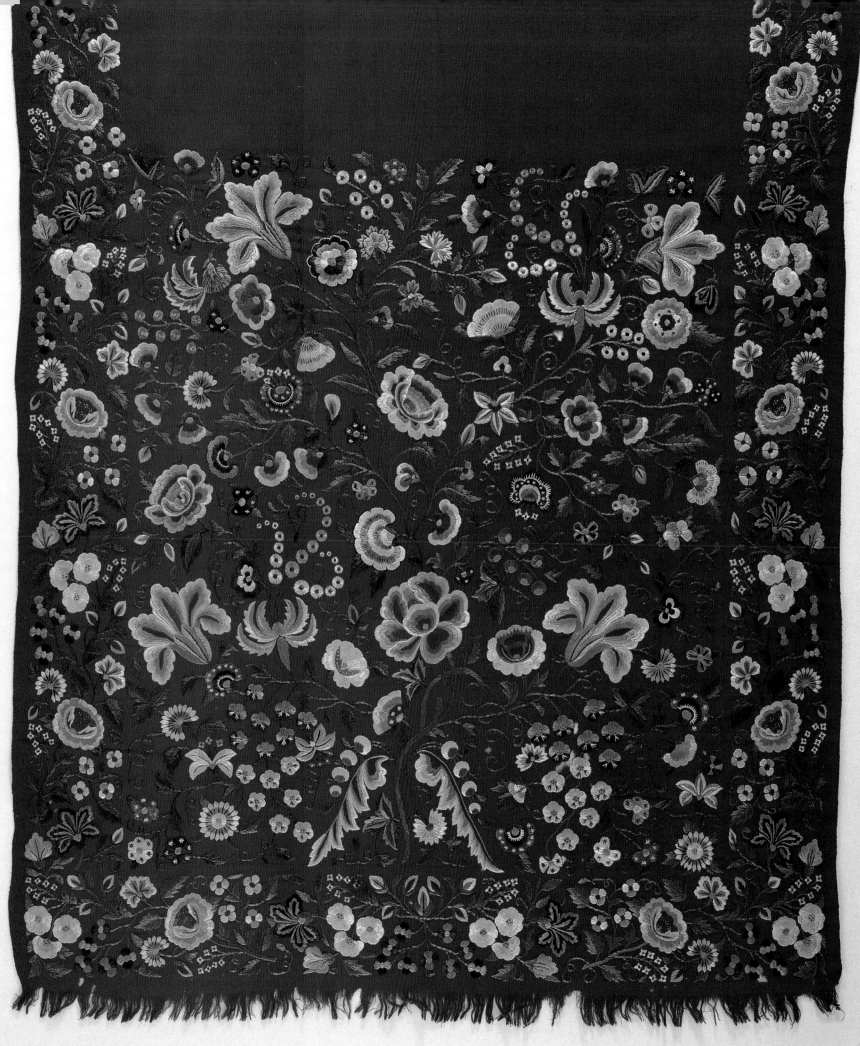

36. Scarf (detail)

Delhi, *c.*1855.

0260 (IS)

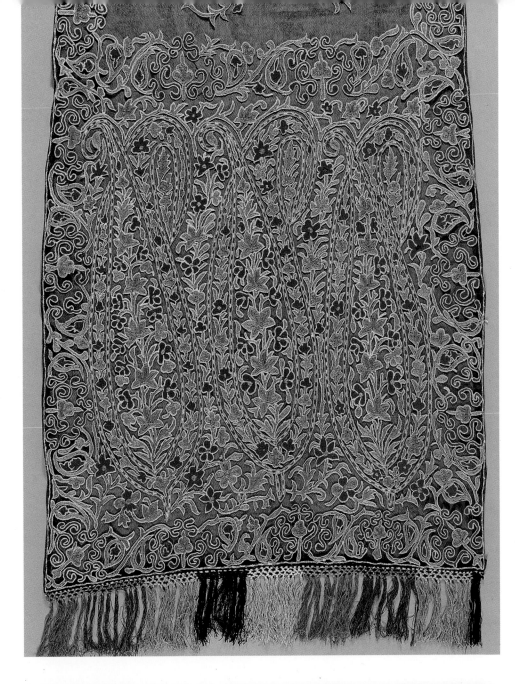

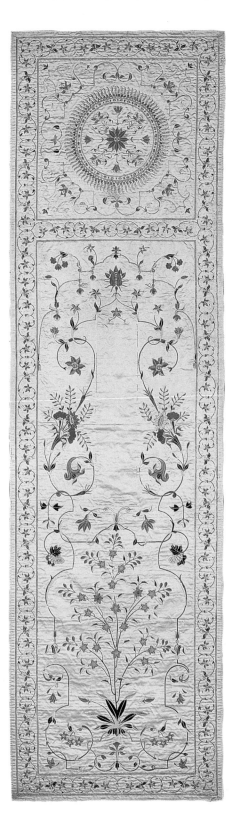

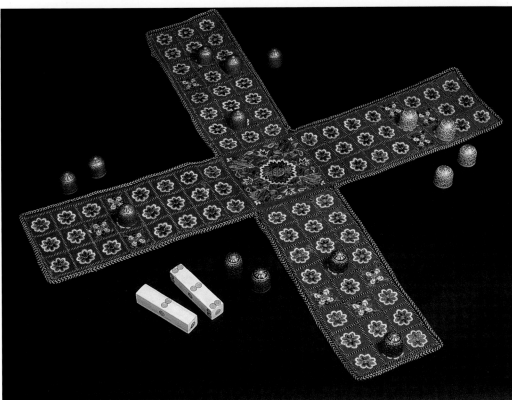

37. *(above left)* **Scarf** (detail)
Delhi, *c*.1855.
4487 (IS)

38. *(left)* *Pachisi* **board**
Sindh, *c*.1855.
4709 (IS)

39. *(above)* **Embroidered representation
of the top of Shah Jahan's tomb**
North India, probably Delhi, *c*.1840.
IS 34-1987

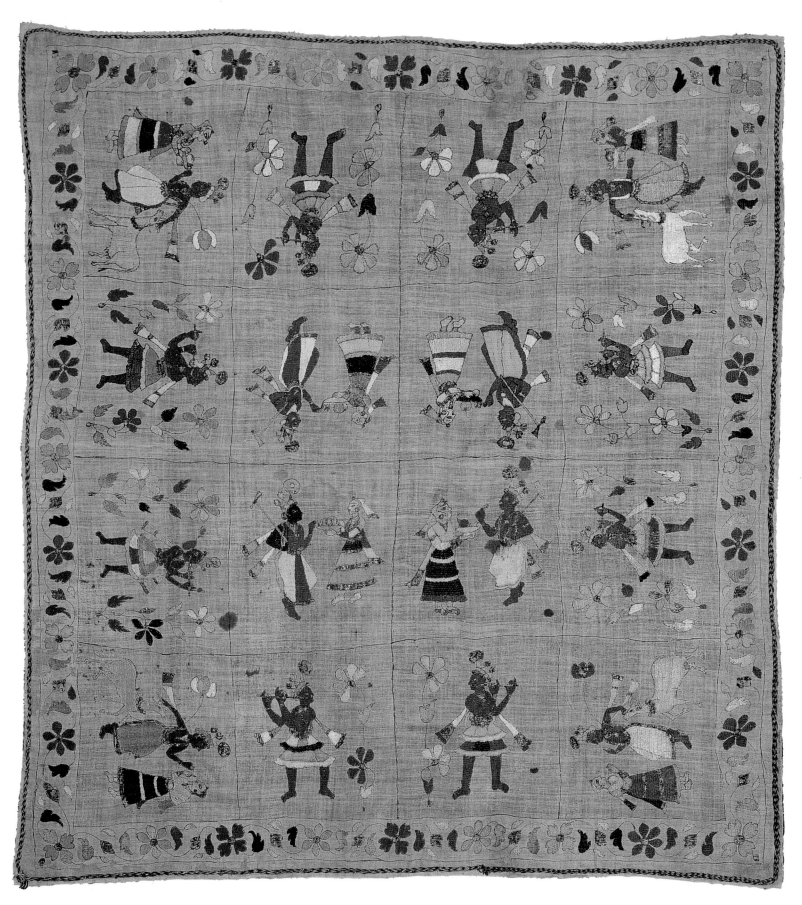

40. Coverlet (*rumal*)
Himachal Pradesh, probably Basohli, late 18th century.
IS 23-1983

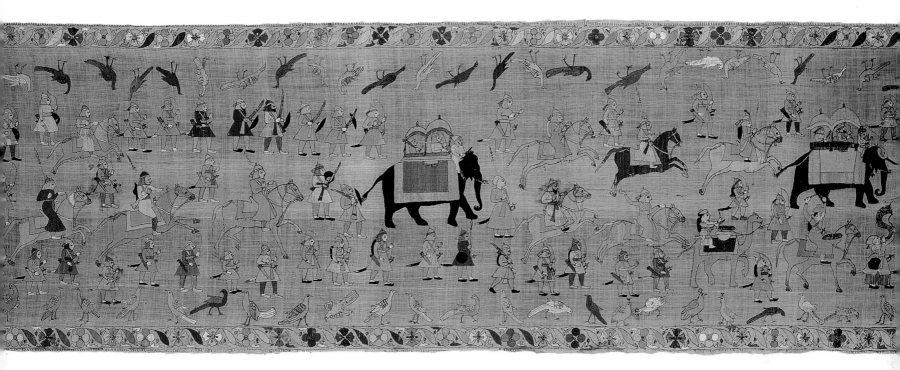

41. Hanging depicting the battle of Kurukshetra (detail)
Chamba, Himachal Pradesh, *c.*1800.
1185-1883 (IS)

42. Coverlet (*rumal*)
Nurpur, Himachal Pradesh, *c.*1880.
1174-1883 (IS)

43. Coverlet (*rumal*)
Himachal Pradesh, probably Chamba or Kangra, early 20th century.
IS 26-1967

44. Length of dress fabric (detail)
Dhaka, Bangladesh, *c.*1855.
0214 (IS)

45. Length of dress fabric (detail)
Gwalior, Madhya Pradesh, *c.*1855.
8838 (IS)

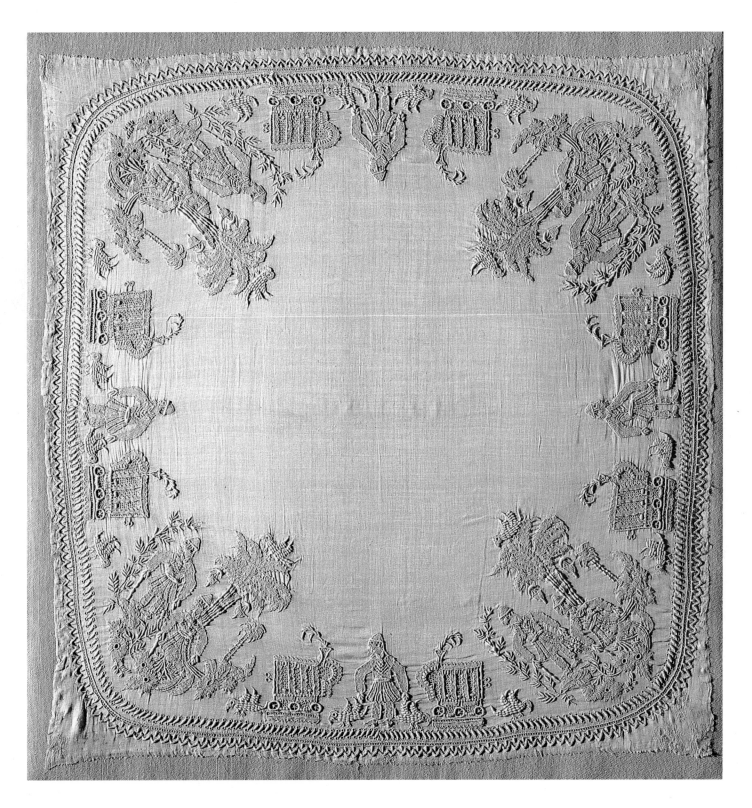

46. Handkerchief
Calcutta, West Bengal, mid-19th century.
0542 (IS)

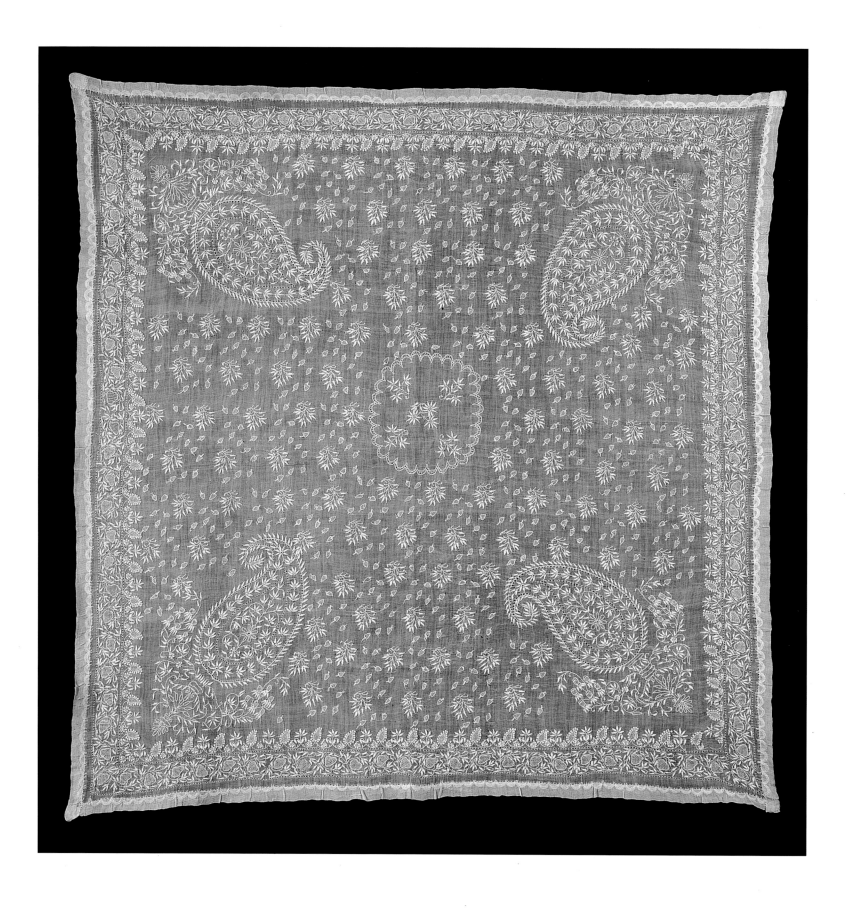

47. Scarf
Lucknow, Uttar Pradesh, *c.*1880.
981-1883 (is)

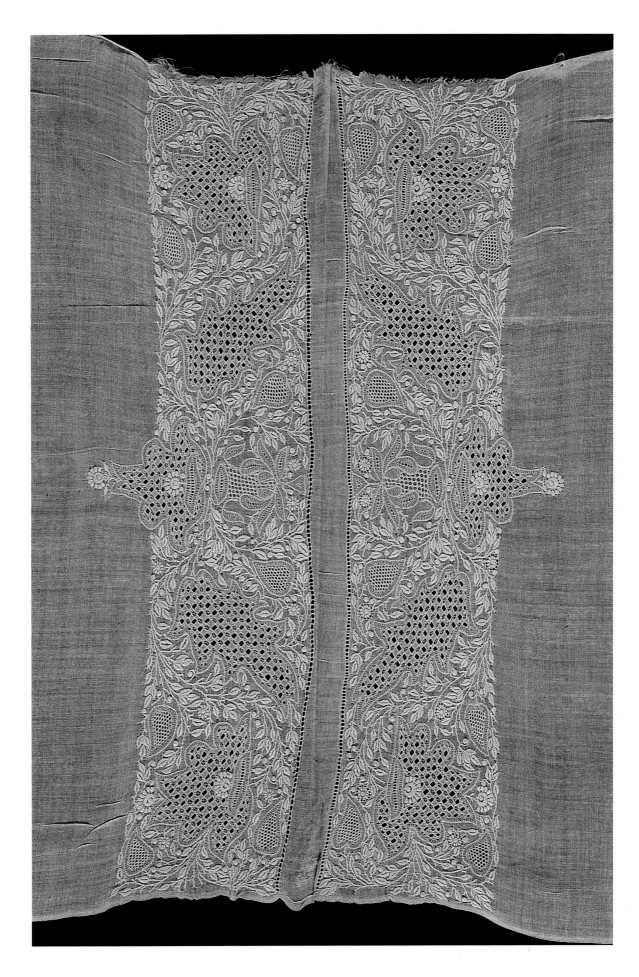

**48. Uncut borders for
a garment**
Lucknow, Uttar Pradesh,
late 19th or early 20th century.
IS 58-1968

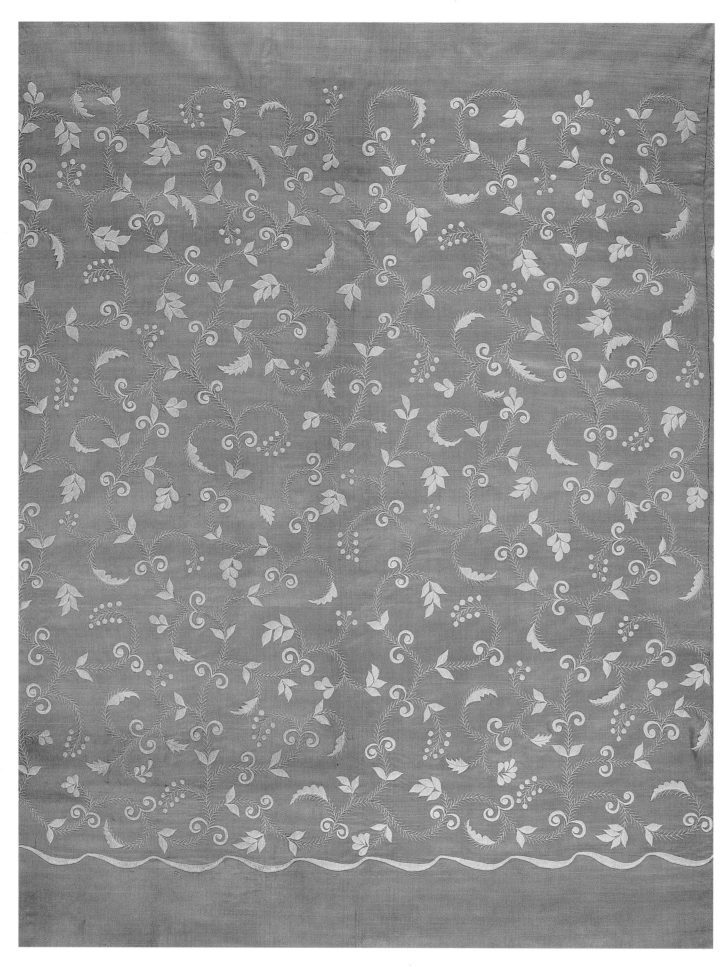

49. Length of dress fabric (detail)
Madras, Tamil Nadu, *c.*1855.
8730 (IS)

50. *(opposite)* **Bedcover (*raza'i*)** (detail)
Kashmir, *c.*1880.
1386-1883 (IS)

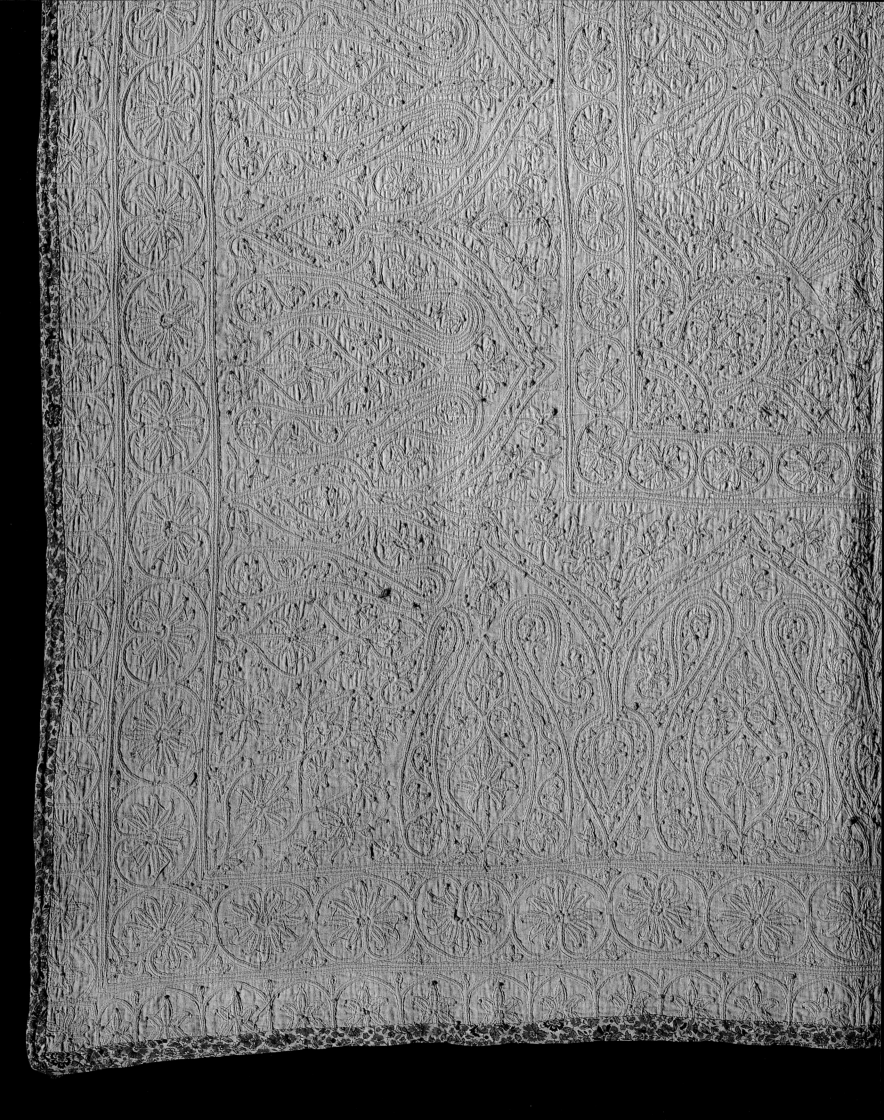

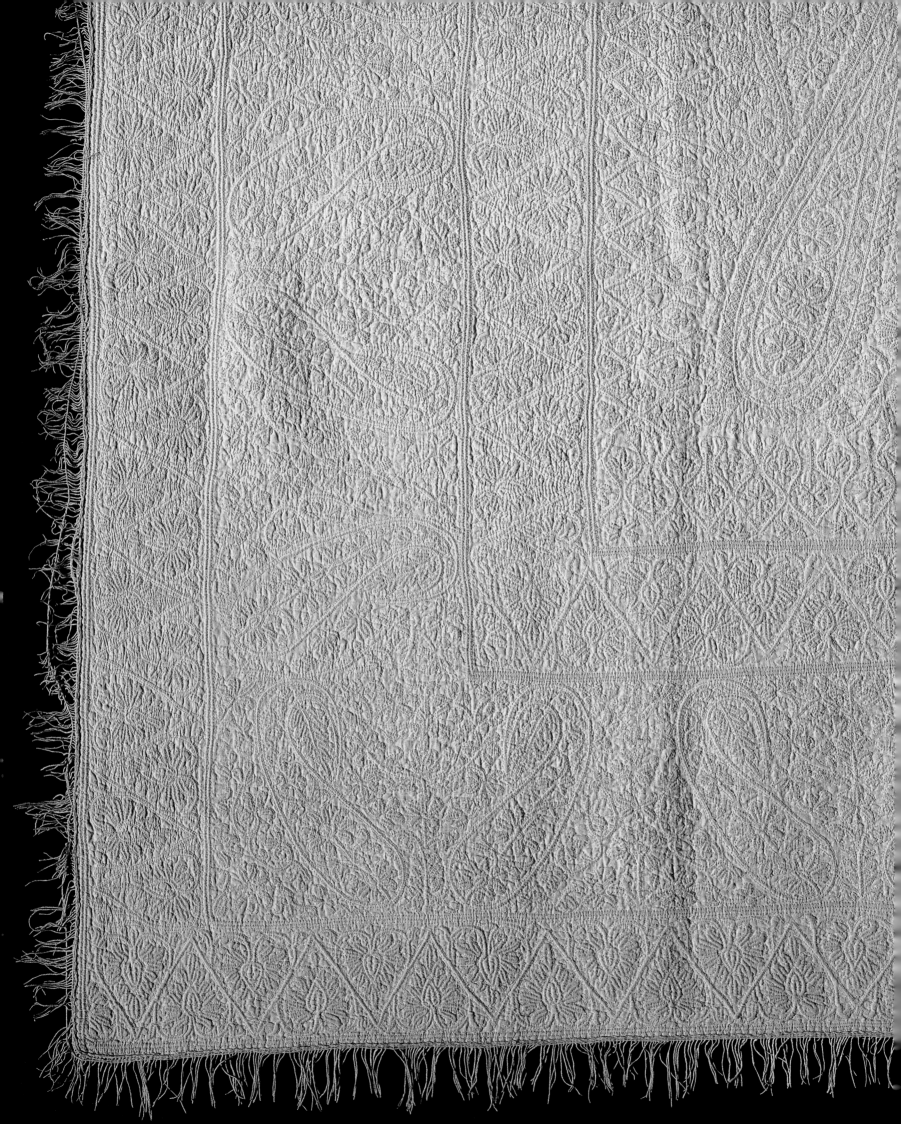

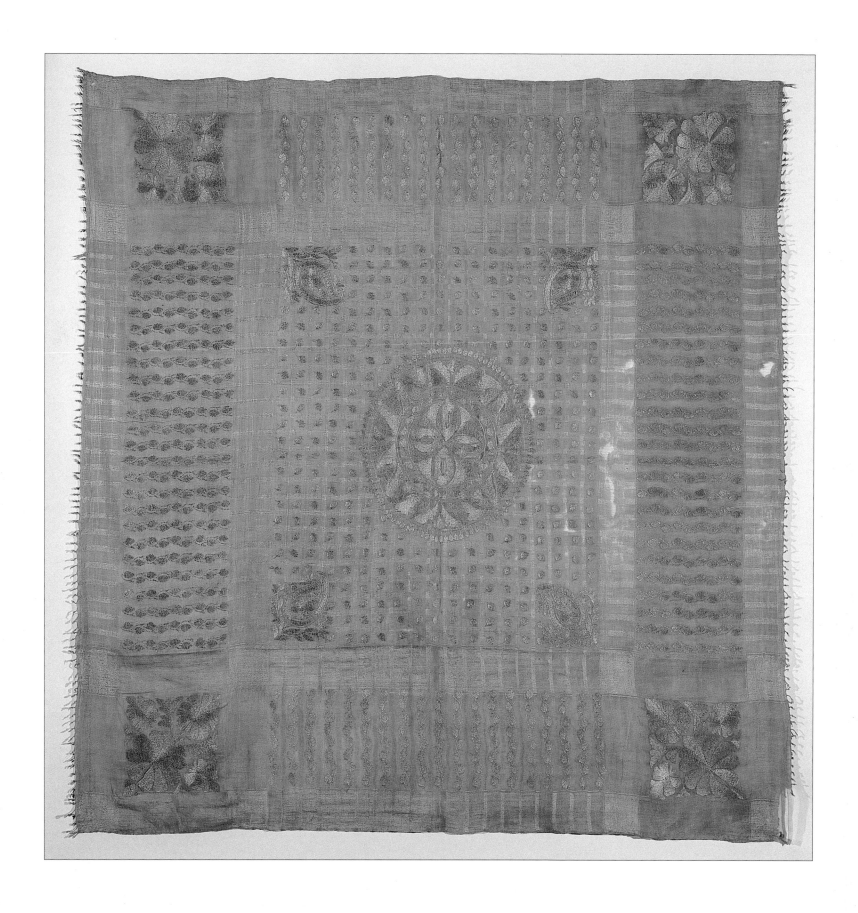

51. *(opposite)* **Bedcover** (detail)
Ahmedabad, Gujarat, *c.*1855.
5415 (IS)

52. Scarf
Dhaka, Bangladesh, *c.*1855.
6038 (IS)

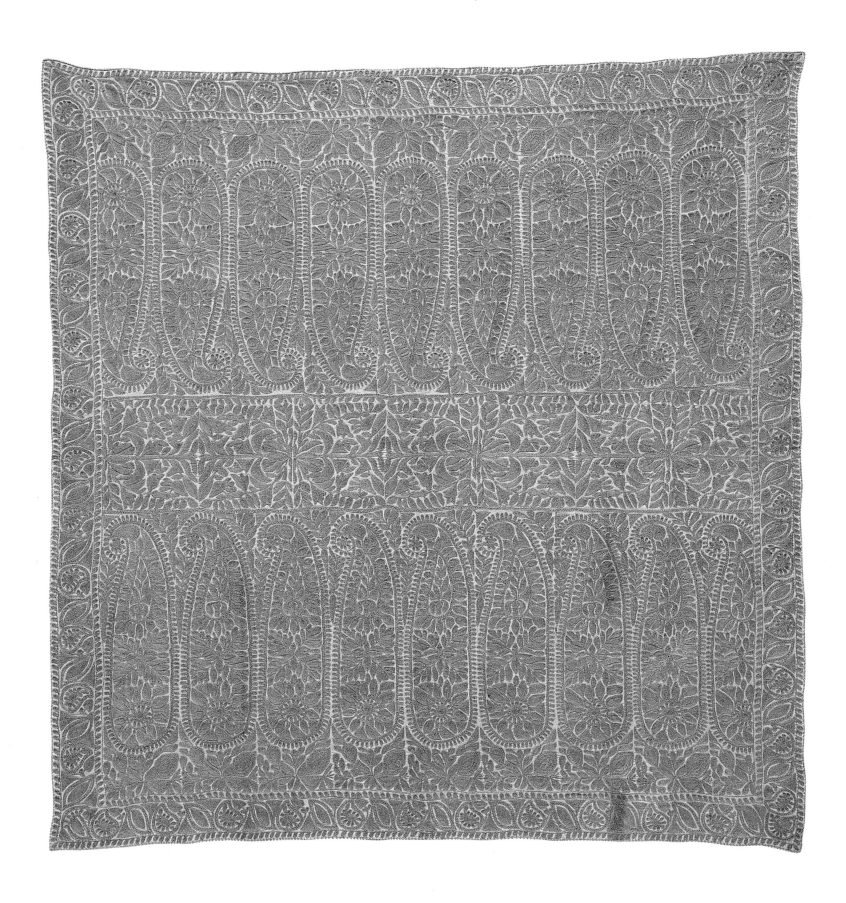

53. Coverlet
Dhaka, Bangladesh, late 19th century.
IS 118-1965

54. (*opposite*) **Part of a man's sash (*patka*)**
Bengal, probably Dhaka, *c.*1800.
IM 33-1925

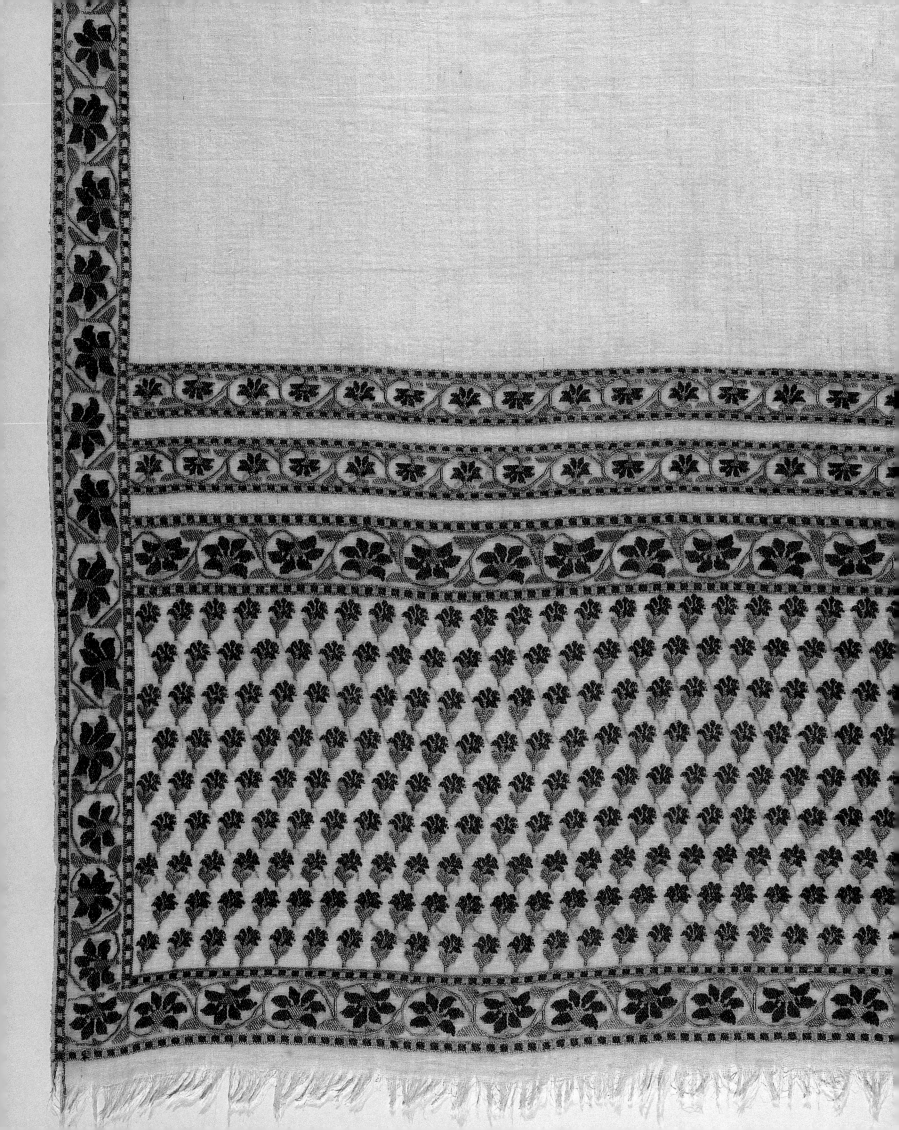

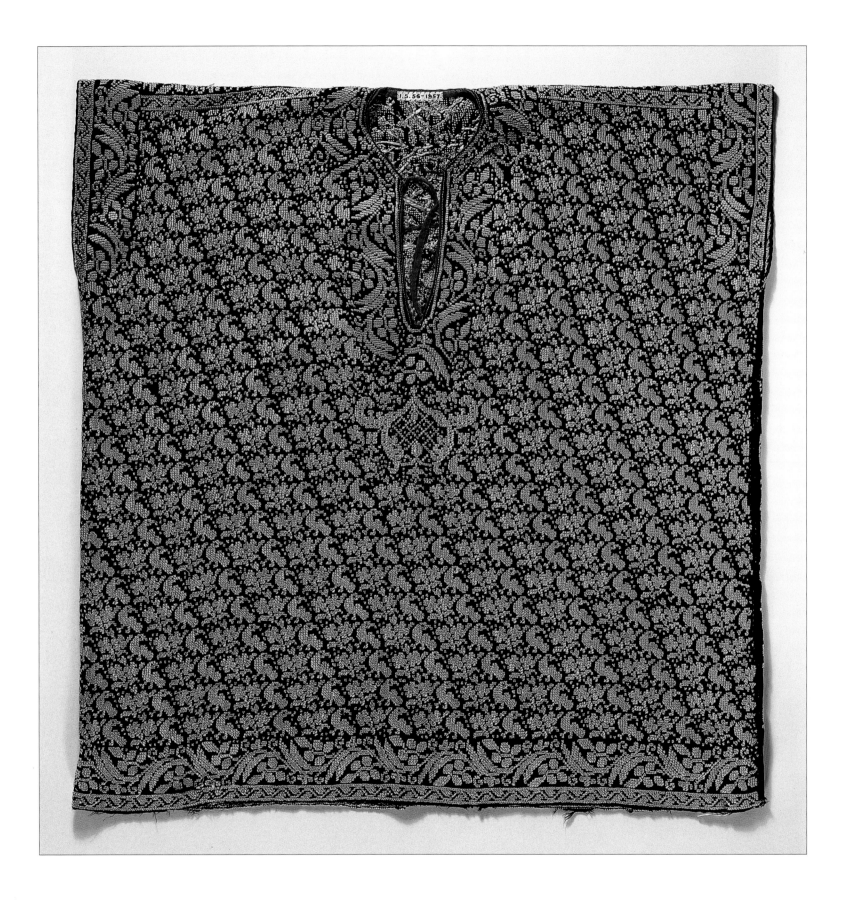

55. Parsee girl's shirt (*jubla*)
Gujarat, probably Surat, mid-19th century.
IS 56-1957

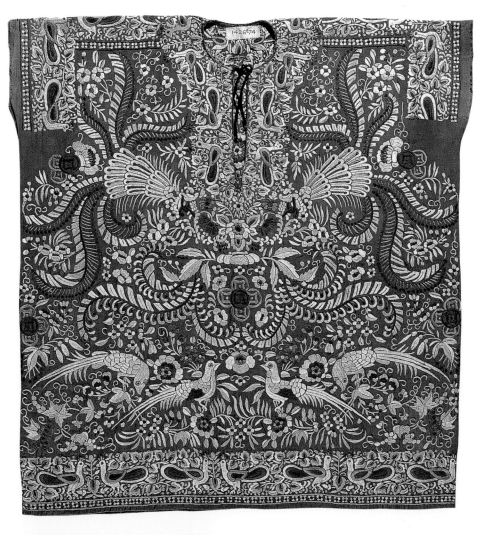

56. Parsee girl's shirt (*jubla*)
Surat, Gujarat, *c.*1870.
1426a-1874

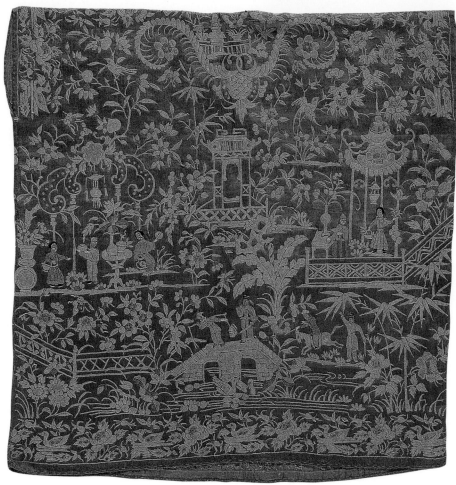

57. Parsee girl's shirt (*jubla*)
Surat, Gujarat, late 19th century.
IS 167-1960

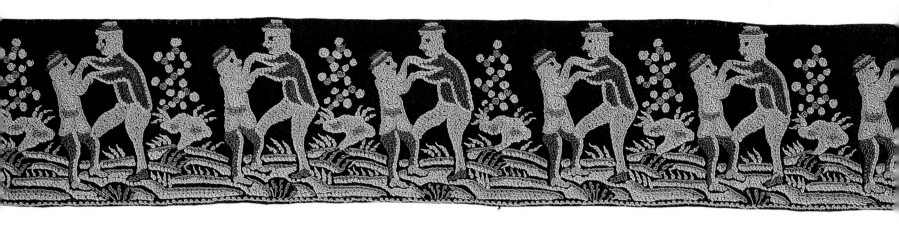

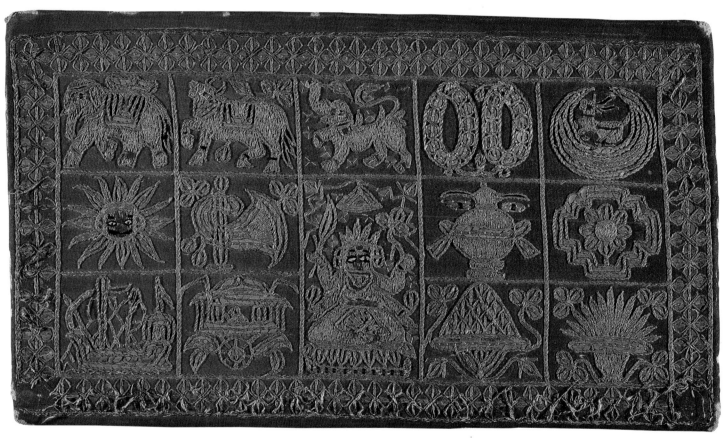

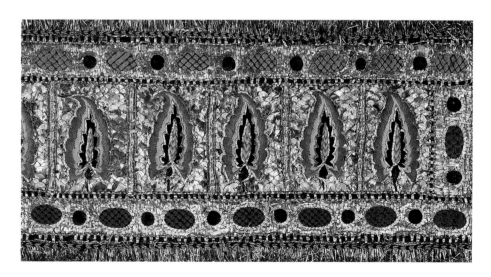

58. *(top)* **Border for a sari** (detail)
Surat, Gujarat, late 19th century.
IS 64-1981

59. *(centre)* **Cover for a Jain manuscript**
Gujarat, late 19th century.
IS 20-1978

60. *(left)* **Turban band** (detail)
Lucknow, Uttar Pradesh, *c.*1800.
IS 85-1988

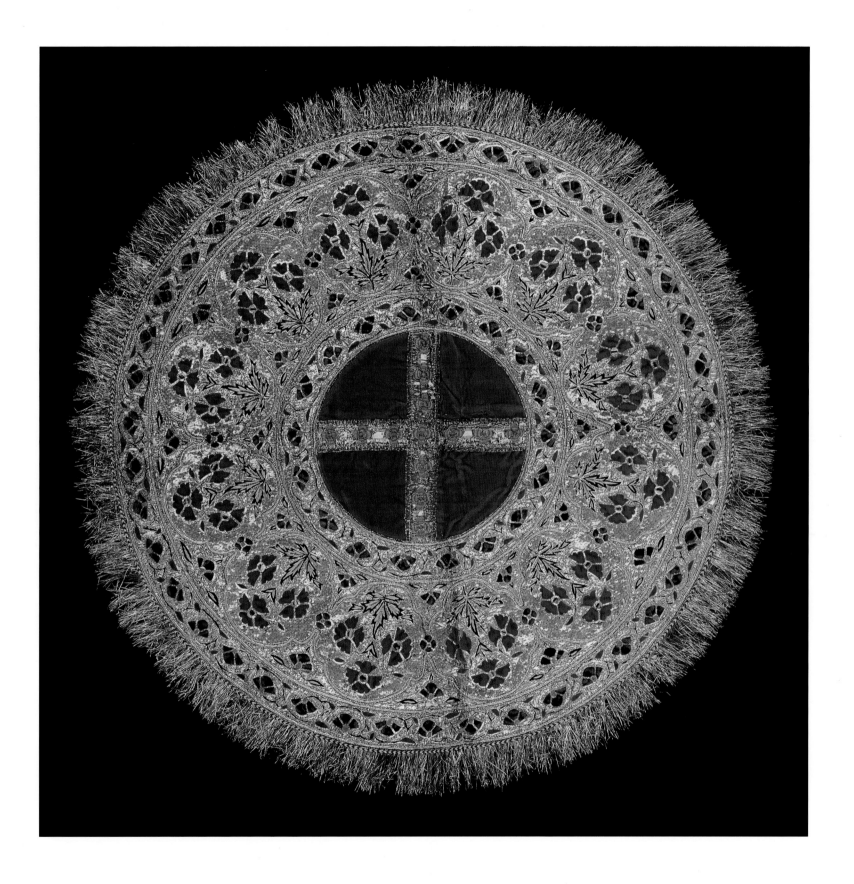

61. *Huqqa* mat
Lucknow, Uttar Pradesh, early 19th century.
IS 1-1999

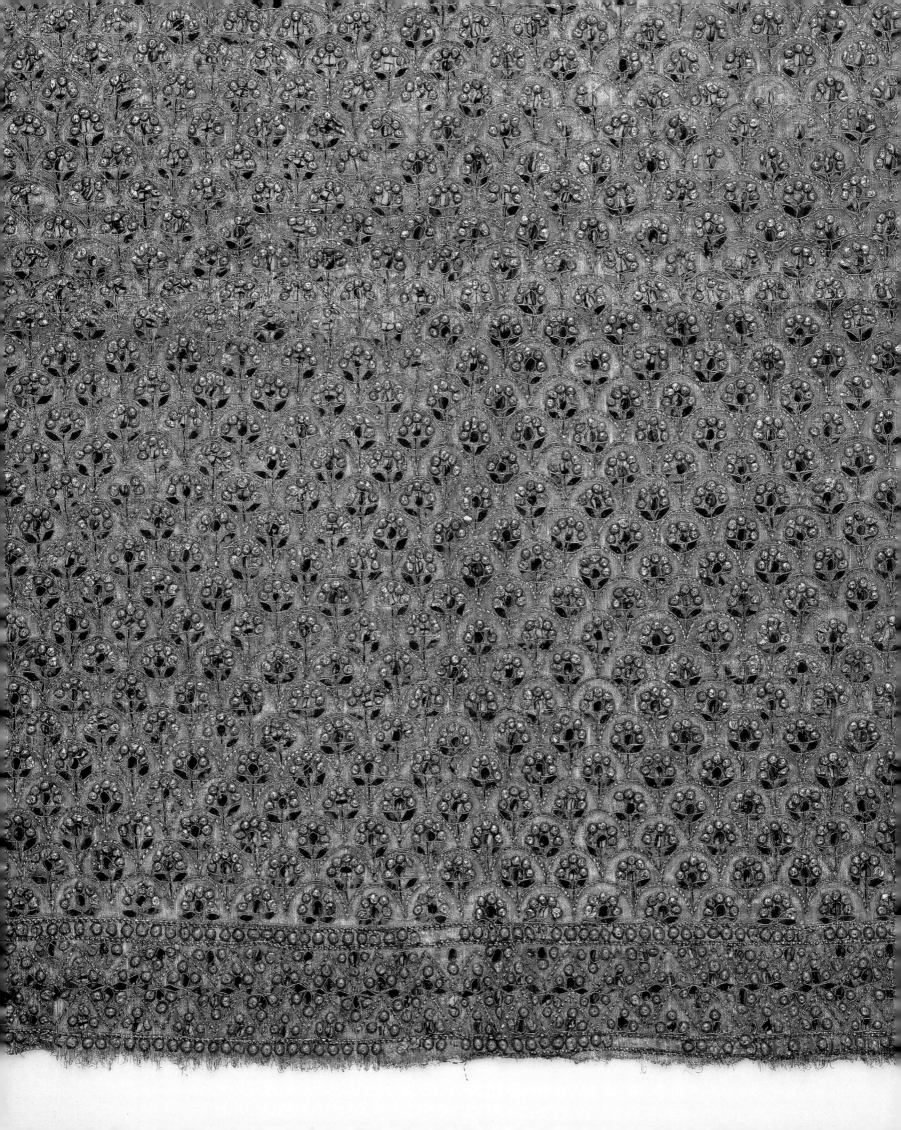

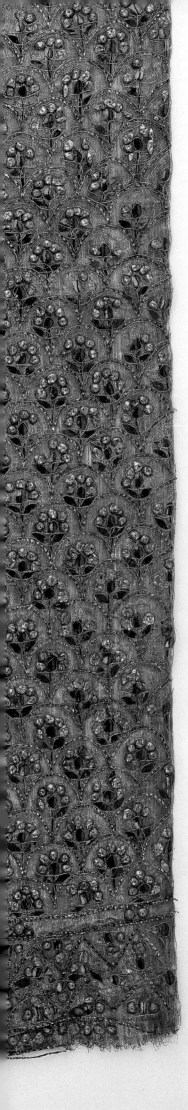

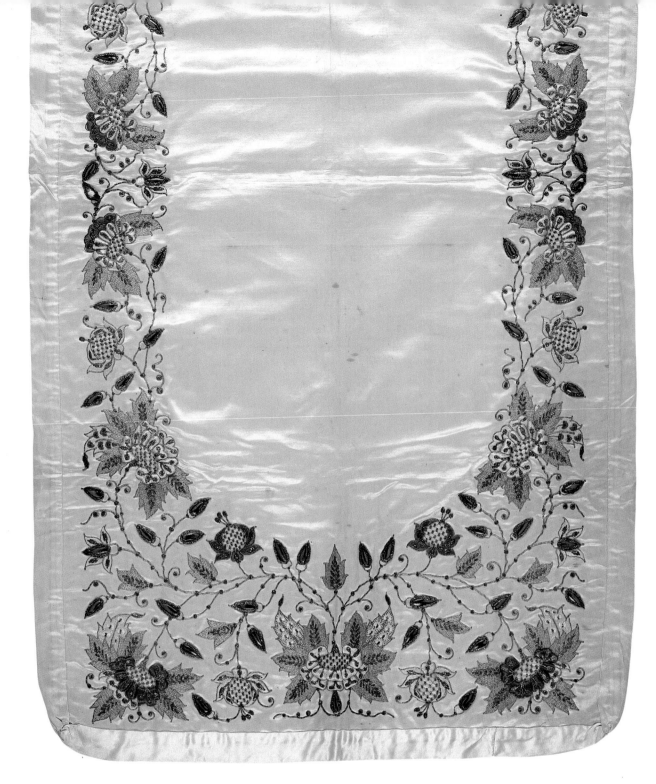

63. Tablecover (detail)
North India, probably Delhi, mid-19th century.
IS 142-1975

62. Length of dress fabric (detail)
Madras, Tamil Nadu, c.1851.
753-1852

64. Dress piece (detail)
Hyderabad, Andhra Pradesh, *c.*1855.
4411 (IS)

65. Boy's shirt (*kurta*)
Bikaner, Rajasthan, *c.*1855.
05627 (IS)

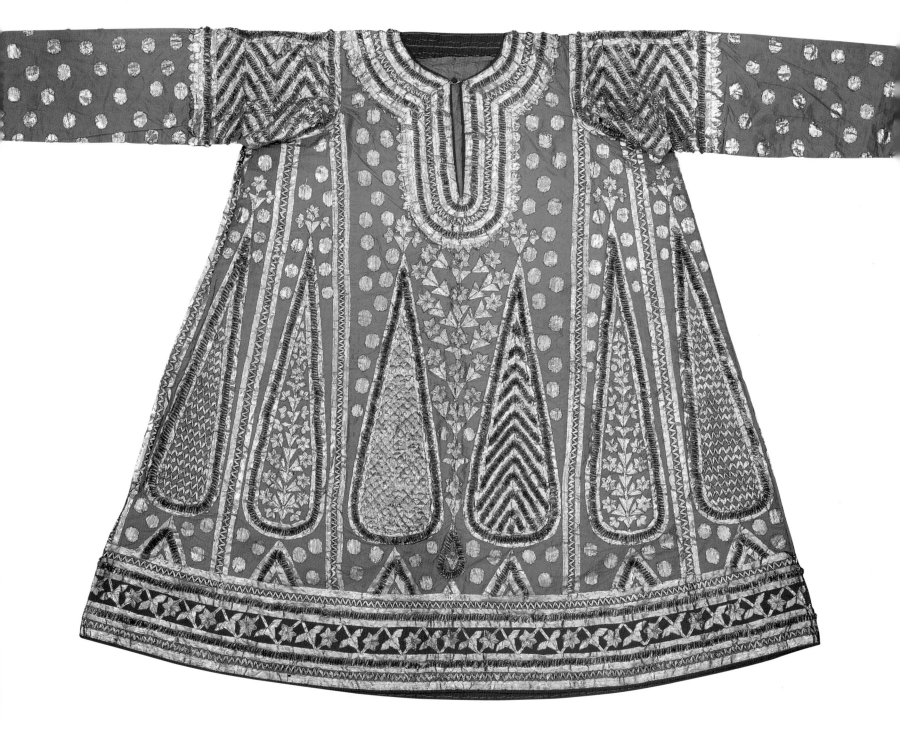

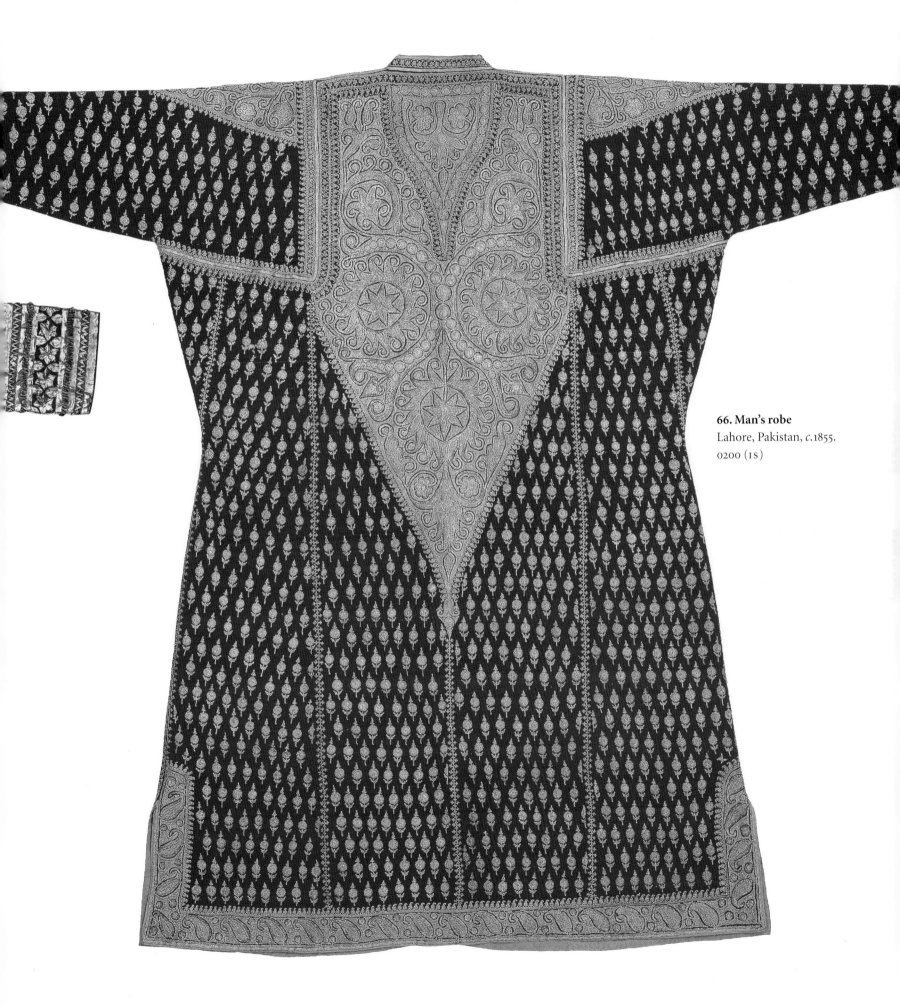

66. Man's robe
Lahore, Pakistan, *c.*1855.
0200 (IS)

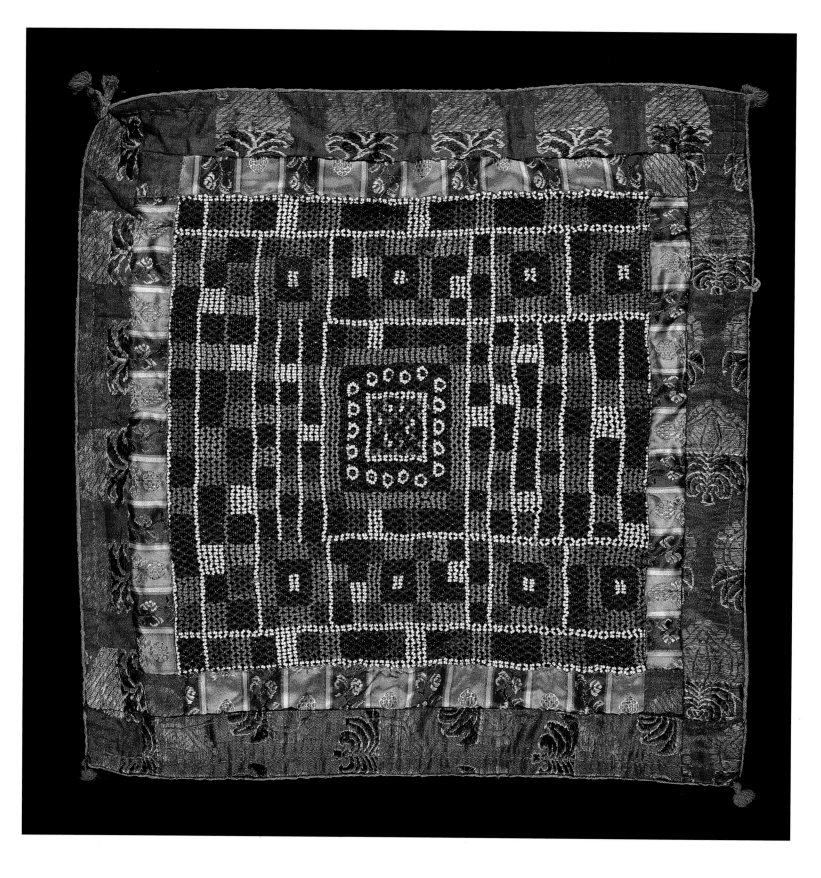

67. Mat
Possibly from Madras, mid-19th century.
06052a (IS)

69. (*opposite bottom*)
Door hanging (*toran*) (detail)
Saurashtra, Gujarat, 20th century.
IS 11-1961

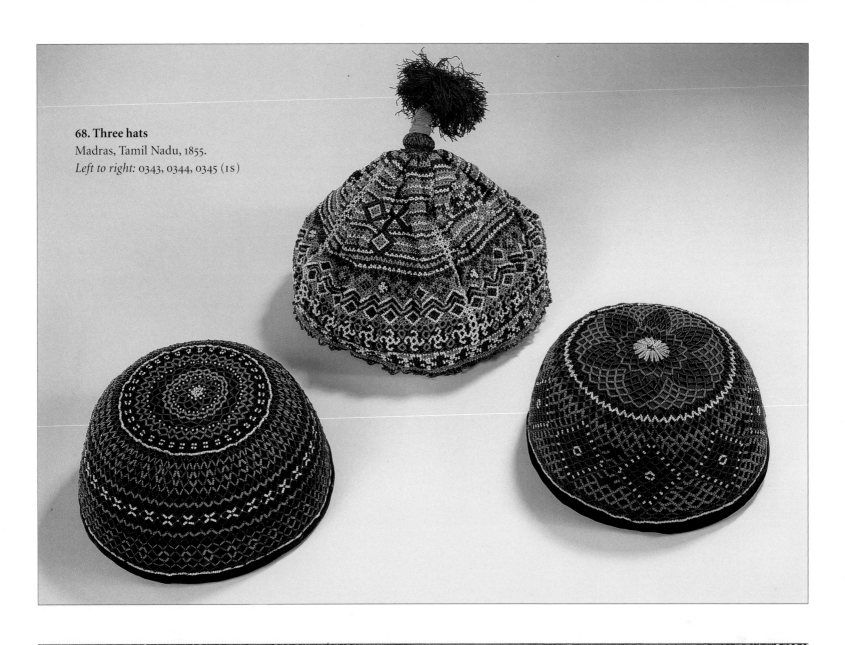

68. Three hats
Madras, Tamil Nadu, 1855.
Left to right: 0343, 0344, 0345 (IS)

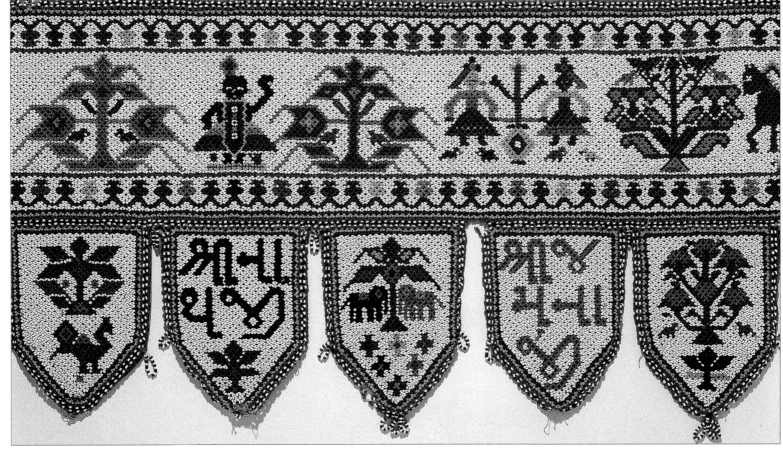

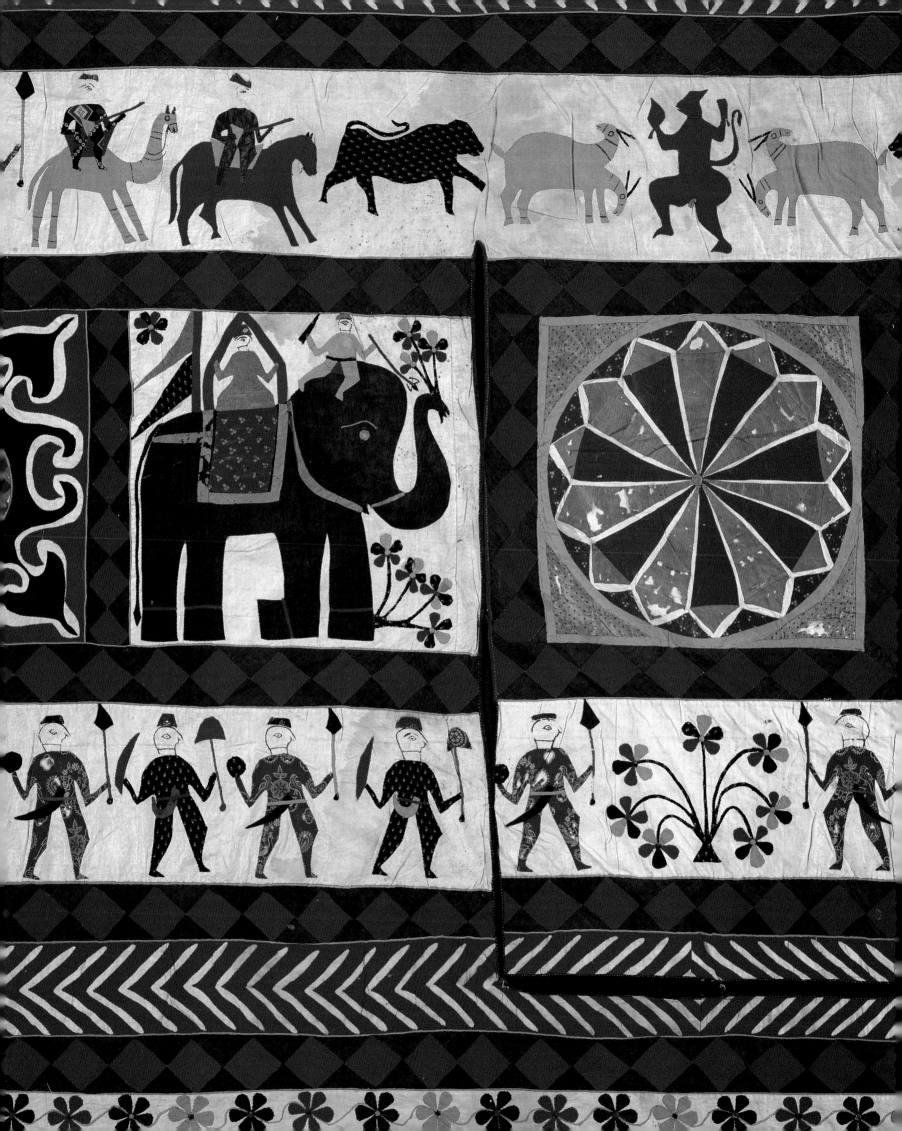

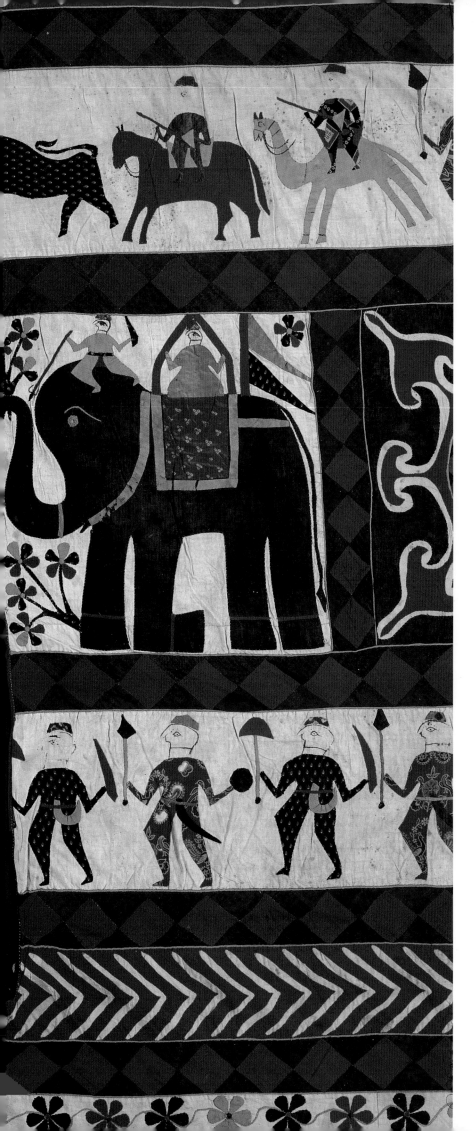

Folk and Tribal
❧ Embroidery ❧

70. Wall hanging (*bhitiya*) (details)
Saurashtra, Gujarat, 20th century.
IS 24-1994

79

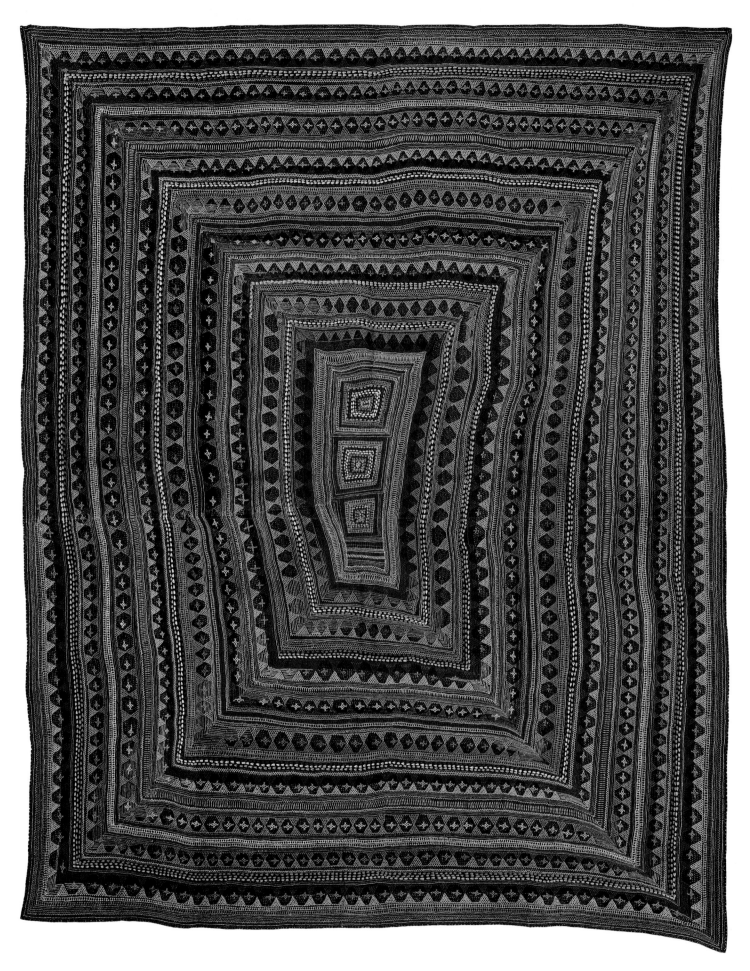

71. Quilt (*ralli*)
Sami community, Sindh, Pakistan, 20th century.
IS 4-1981

72. *(opposite)* **Quilt (*ralli*)**
Sindh, Pakistan, 20th century.
IS 1-1981

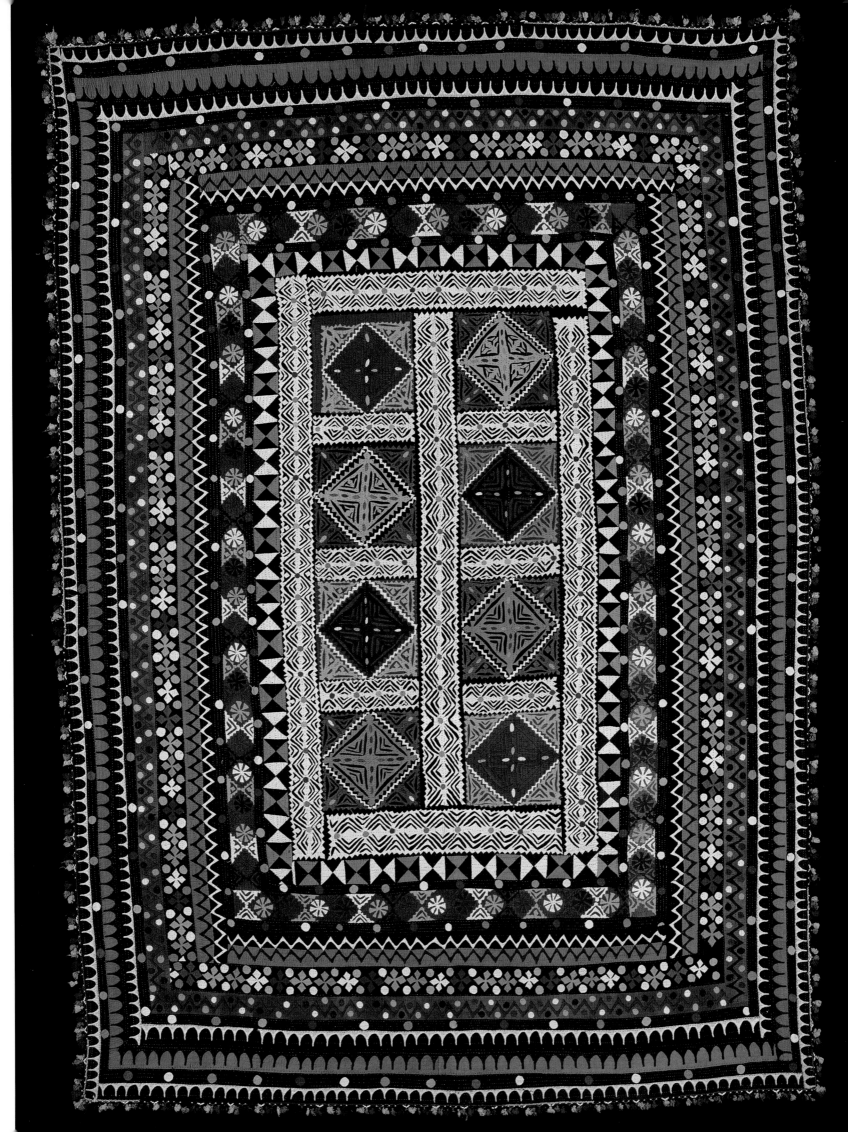

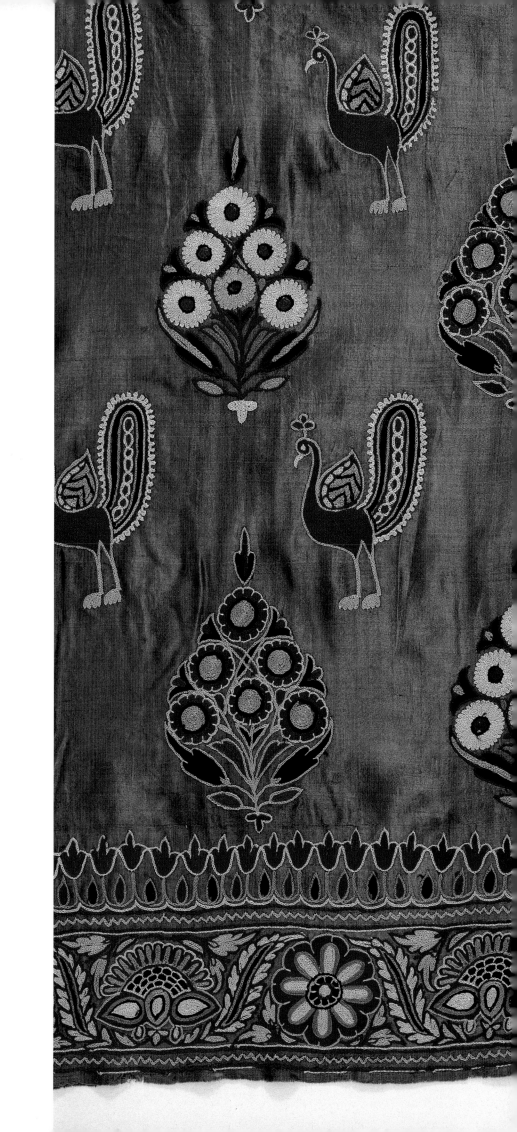

73. Skirt length (detail)
Kutch, Gujarat, late 19th or early 20th century.
Circ. 307-1912

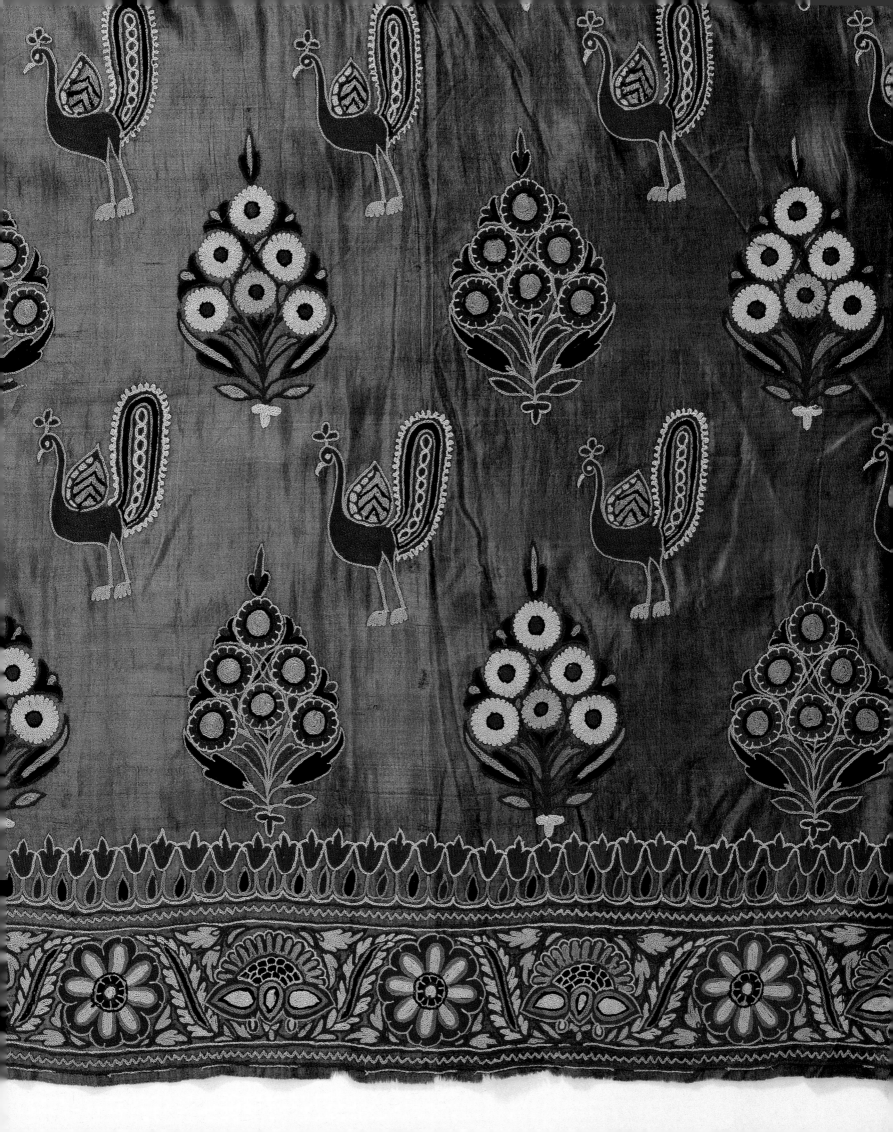

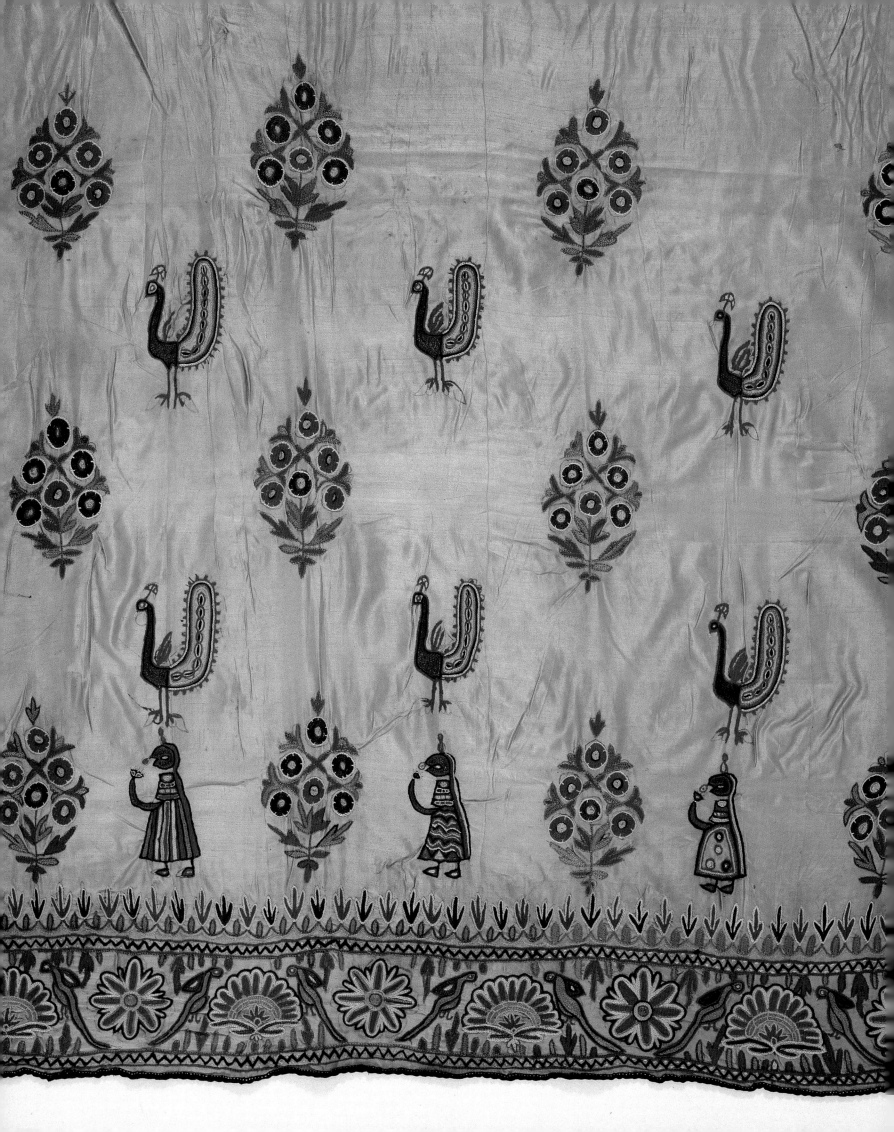

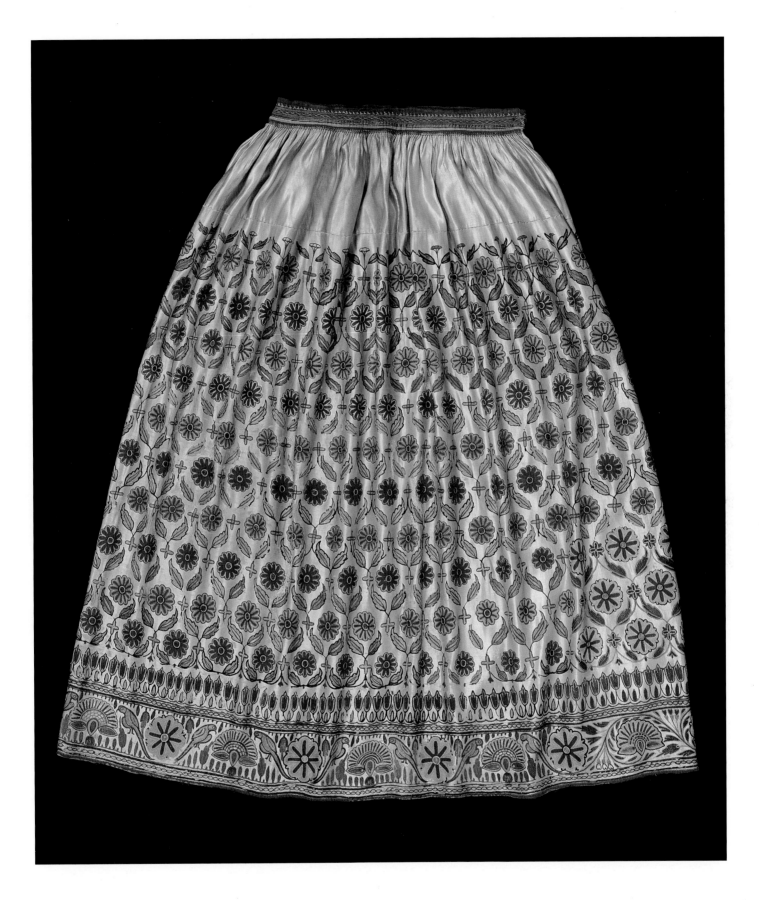

74. *(opposite)* **Skirt length** (detail)
Kutch, Gujarat, early 20th century.
IM 254-1920

75. Skirt
Kutch, Gujarat, early 20th century.
IM 246-1920

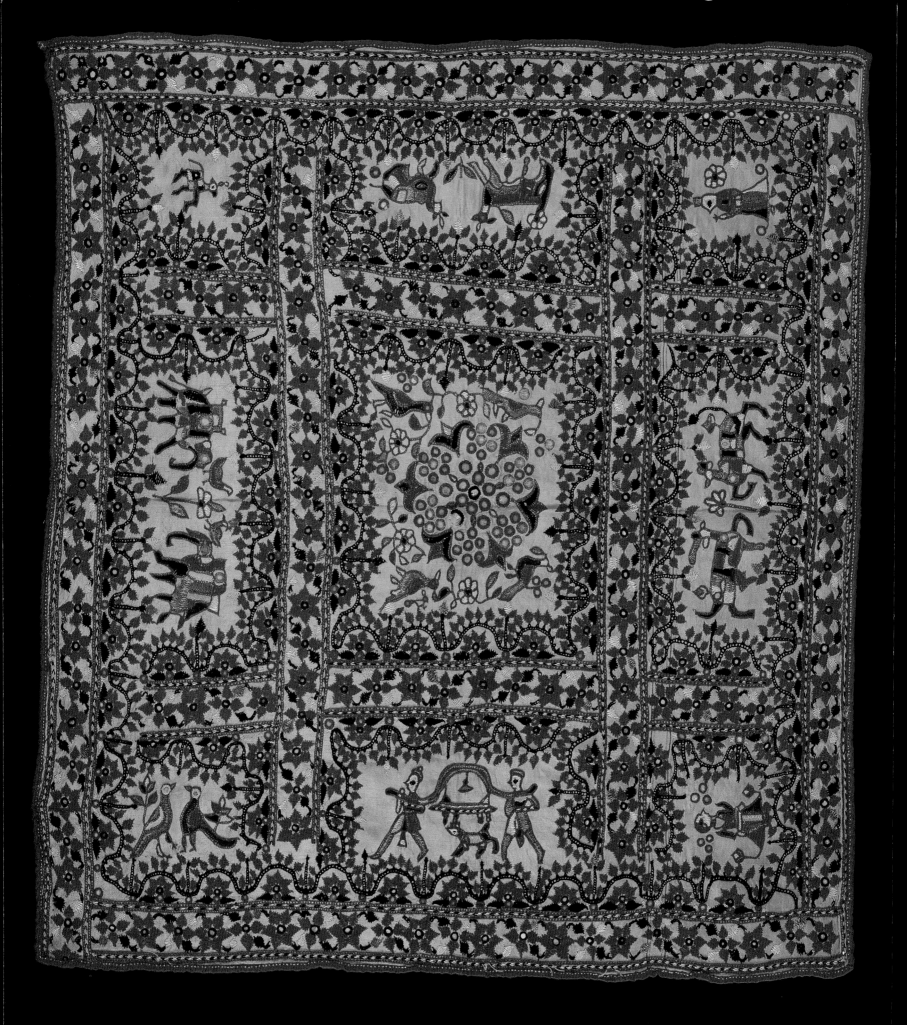

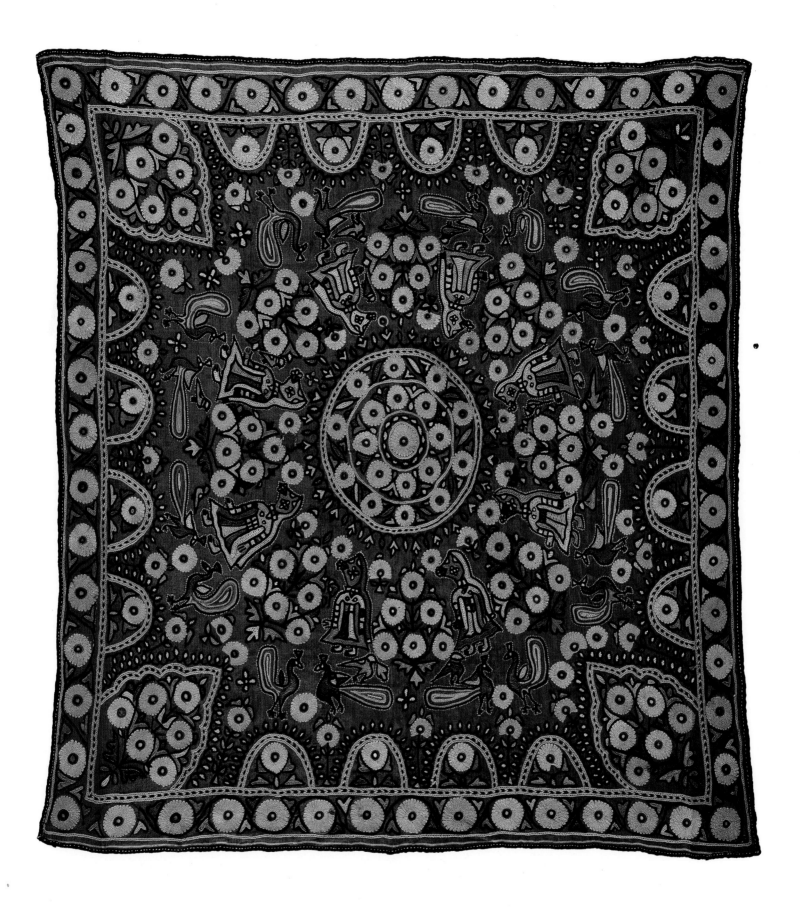

76. *(opposite)* **Wall hanging (*chakla*)**
Saurashtra, Gujarat, early 20th century.
IM 276-1920

77. Wall hanging (*chakla*)
Saurashtra, Gujarat, early 20th century.
IM 274-1920

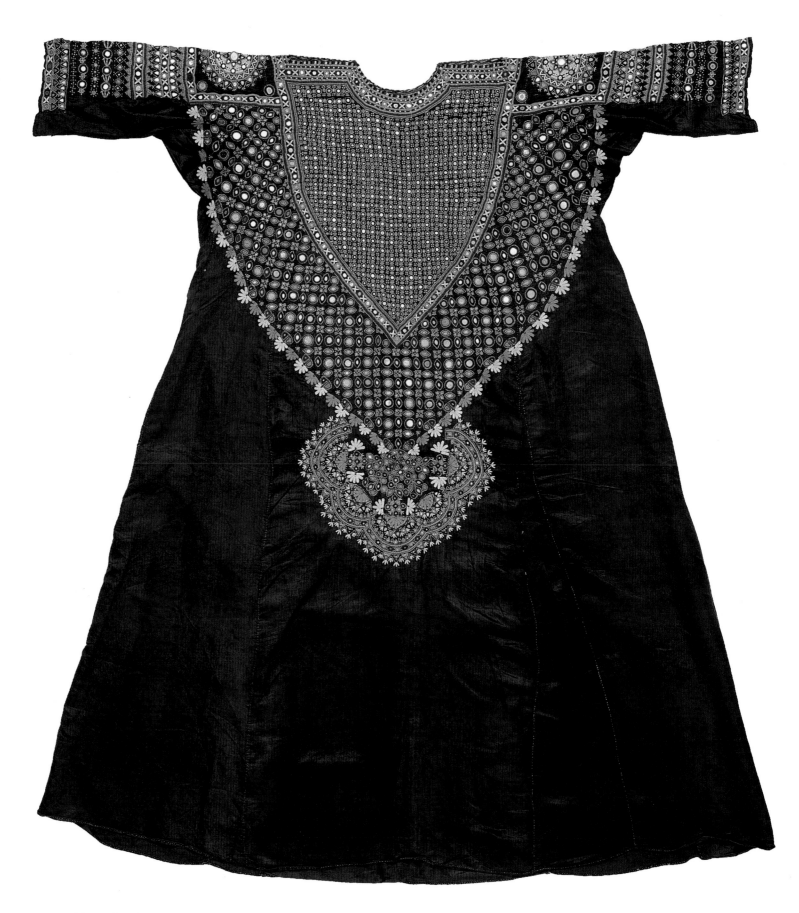

78. *(above; detail opposite)* **Woman's dress (aba)**
Kutch, Gujarat, mid-19th century.
4559 (IS)

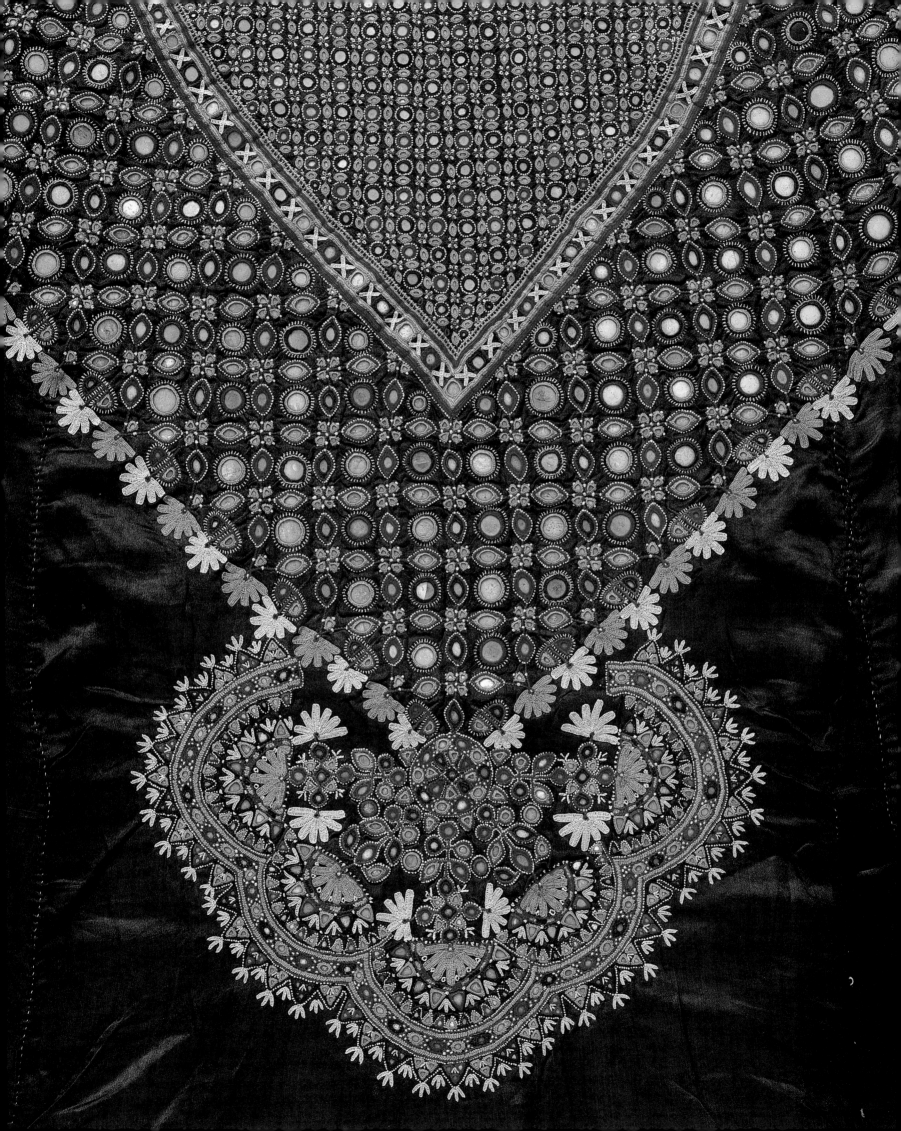

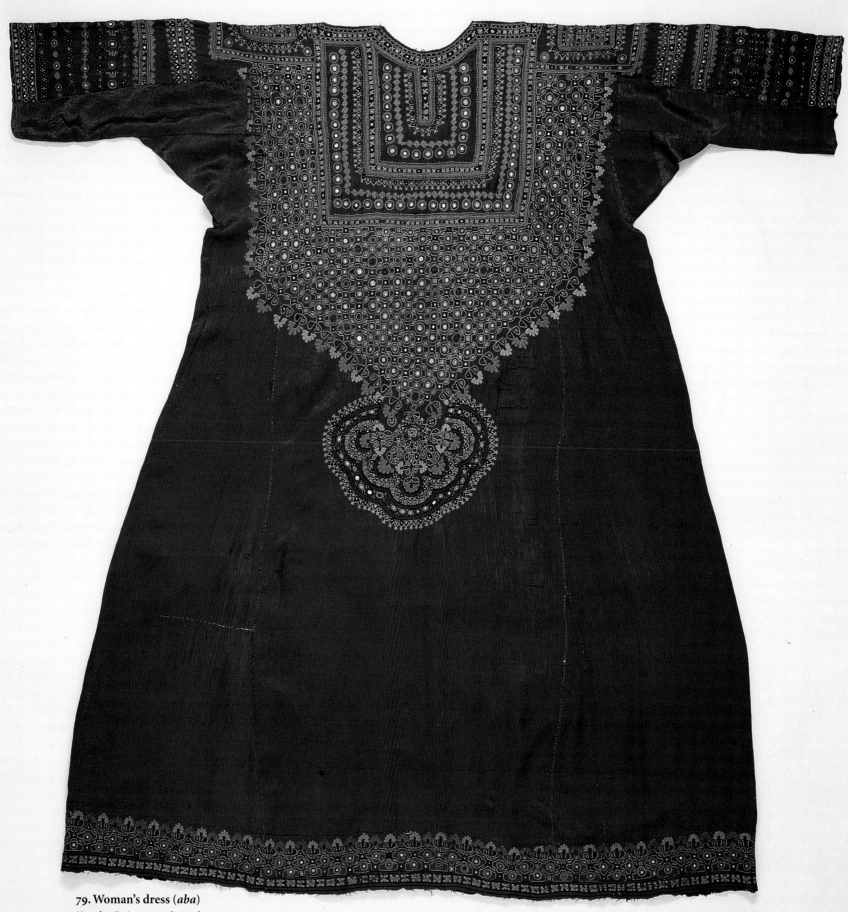

79. Woman's dress (*aba*)
Kutch, Gujarat, early 20th century.
IM 232-1920

80. Skirt length (detail)
Kutch, Gujarat, early 20th century.
IM 252-1920

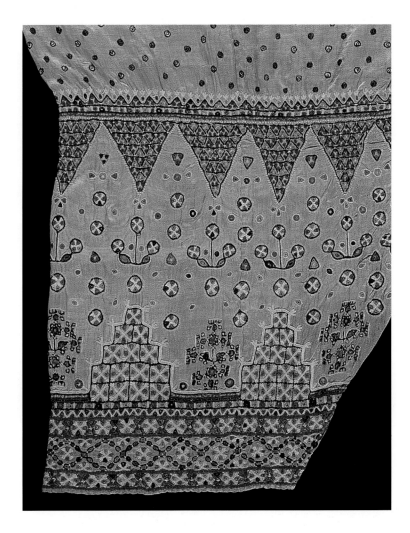

81. Woman's trousers (*ezar*) (detail)
Kutch, Gujarat, early 20th century.
IM 239-1920

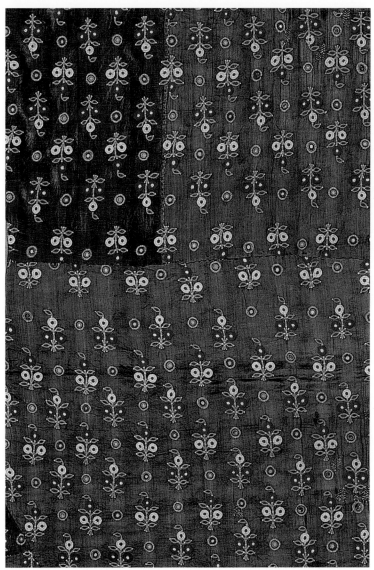

82. Woman's headcover (*odhni*) (detail)
Kutch, Gujarat, early 20th century.
IS 57-1957

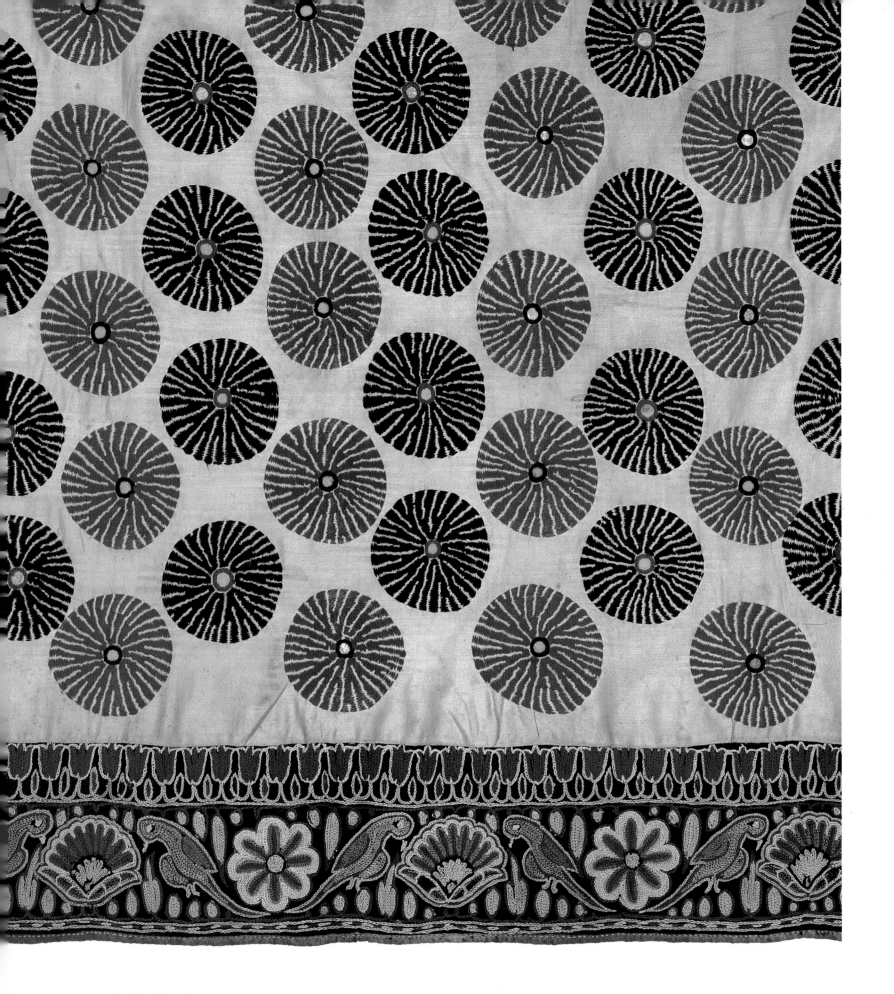

83. Skirt (detail)
Kutch, Gujarat, *c.*1880.
2304-1883 (IS)

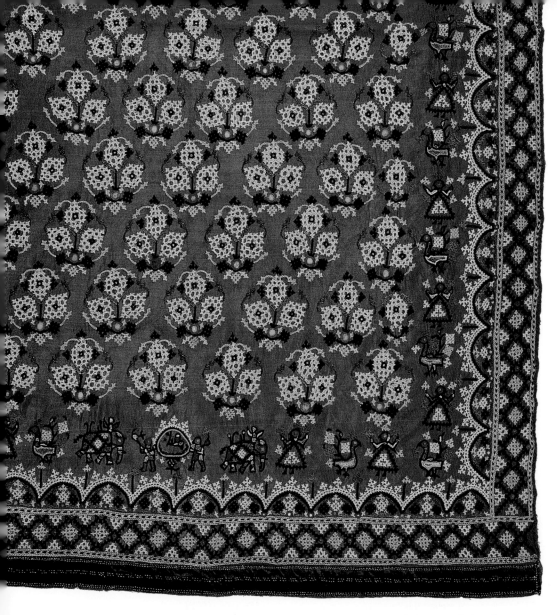

84. *(above)* **Skirt fabric** (detail)
Kutch, Gujarat, early 20th century.
IM 253-1920

85. *(right)* **Woman's headcover**
(***odhni***) (detail)
Kutch, Gujarat, early 20th century.
IS 13-1990

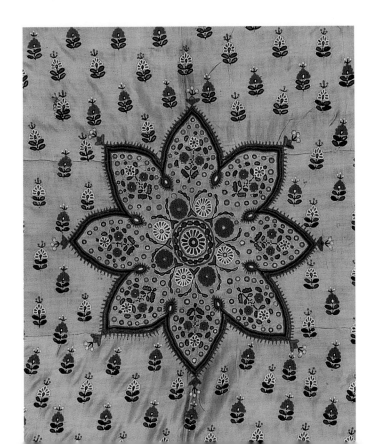

86. Woman's headcover (*odhni*) (detail)
Kutch, Gujarat, early 20th century.
IM 266-1920

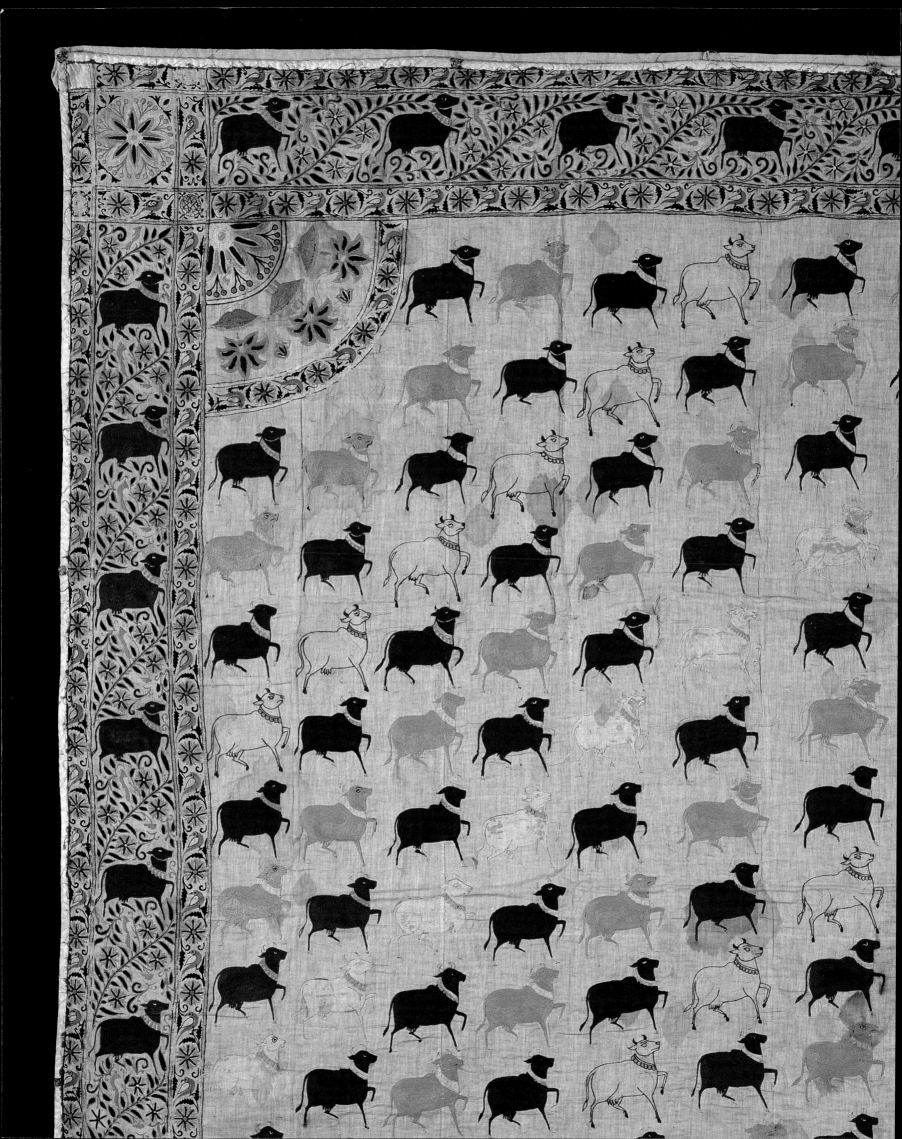

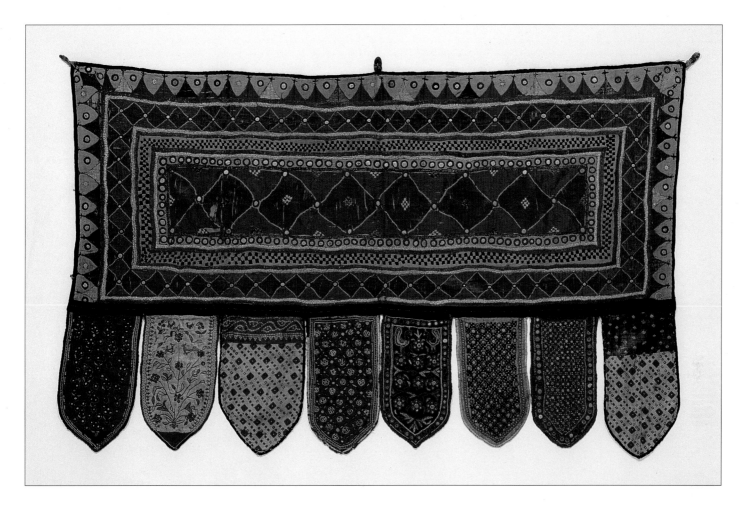

87. *(opposite)* **Part of a hanging for a shrine (*pichhwai*)**
Saurashtra, Gujarat, late 19th century.
IS 40-1977

88. *(above)* **Door hanging (*toran*)**
Saurashtra, Gujarat, early 20th century.
IS 136-1960

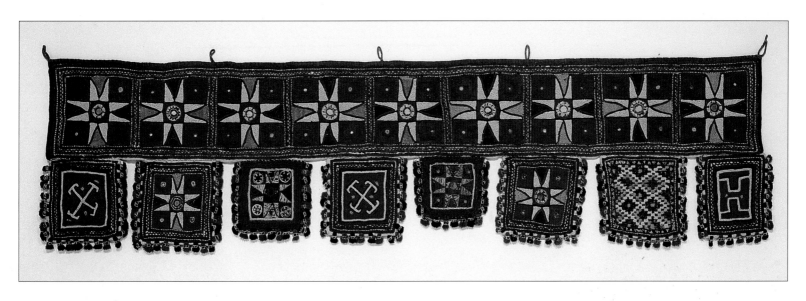

89. Door hanging (*toran*)
Saurashtra, Gujarat, 20th century.
IS 54-1981

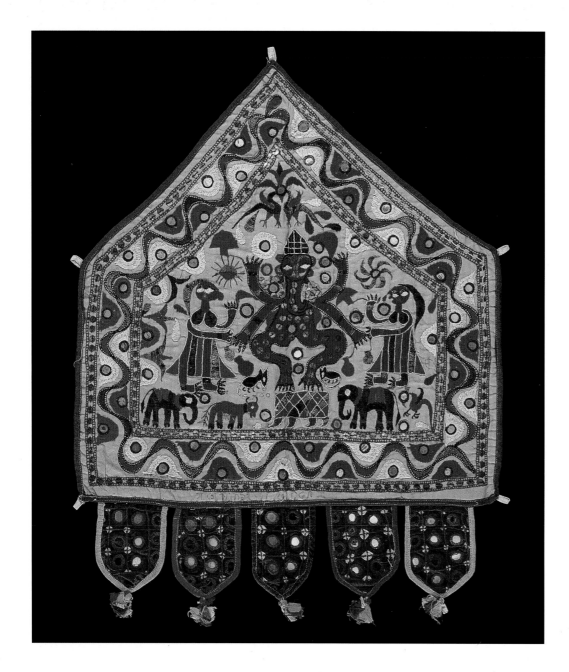

90. *(left)* **Wall hanging with image of Ganesha (*Ganesh sthapana*)** Saurashtra, Gujarat, mid-20th century. IS 18-1967

91. *(below)* **Hanging for the side of a bed (*kil*)** Saurashtra, Gujarat, mid-20th century. IS 39-1977

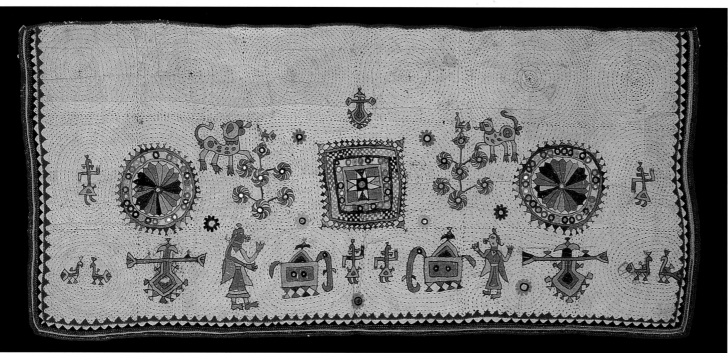

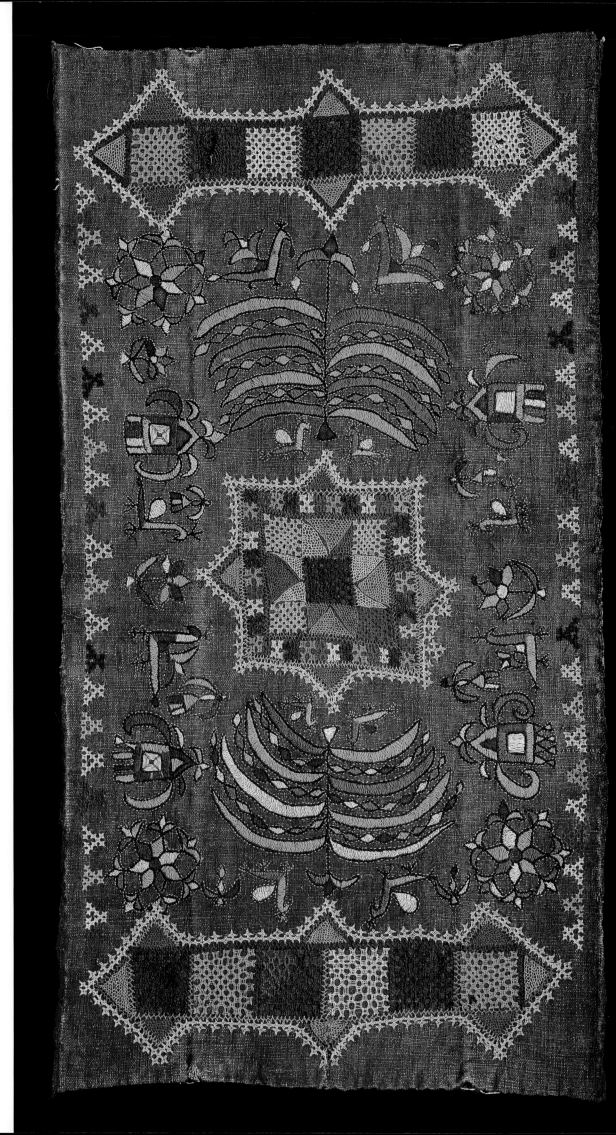

92. Part of a pillow cover (*oshikun*)
Saurashtra, Gujarat, early 20th century.
IS 32-1977

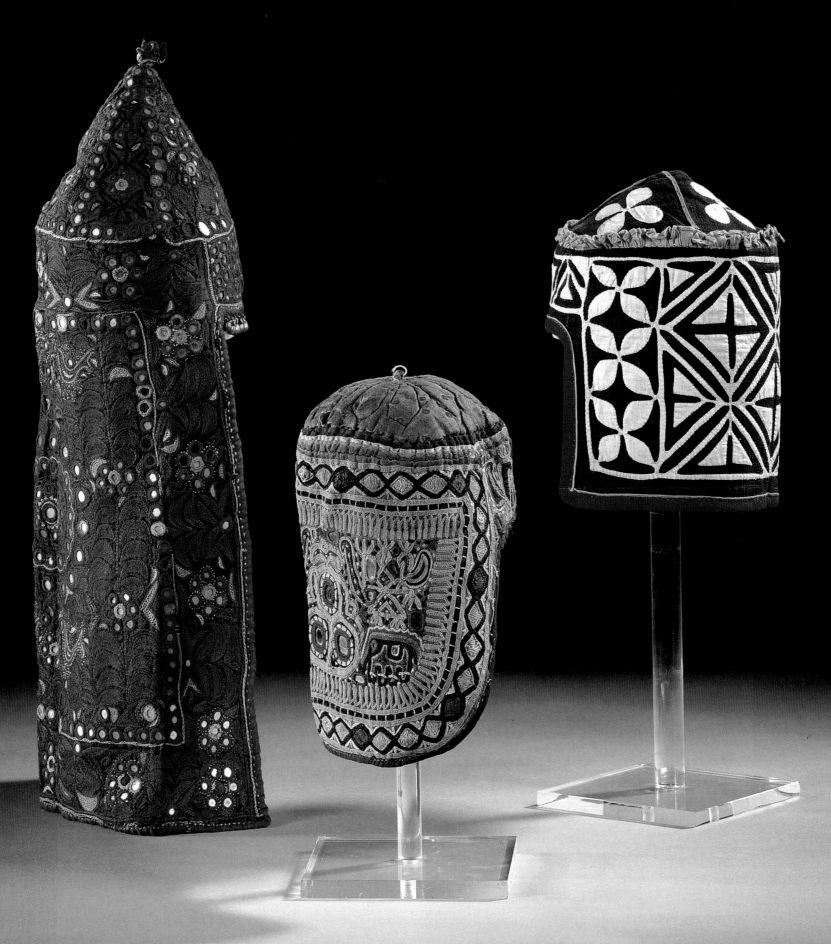

93. Three children's hats
Gujarat *(left and centre)*, Bihar *(right)*, 20th century.
Left to right: IS 145-1960; IS 56-1981; IS 28-1967

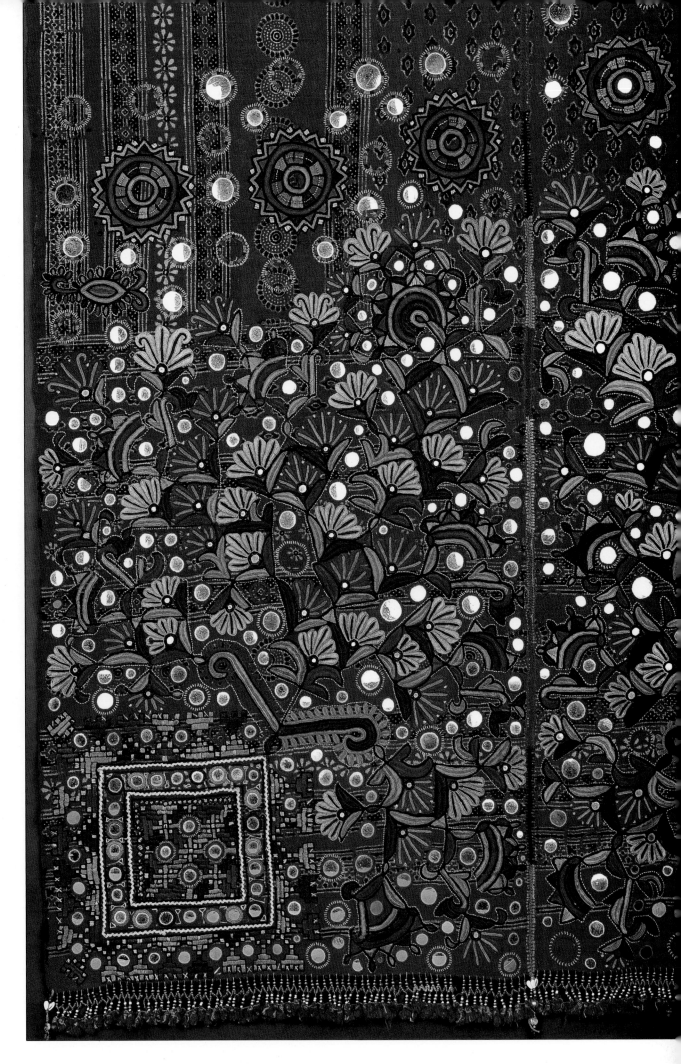

94. Man's wedding shawl
(*malir* or *doṡhalo*) (detail)
Sindh, Pakistan, 20th century.
IS 7-1981

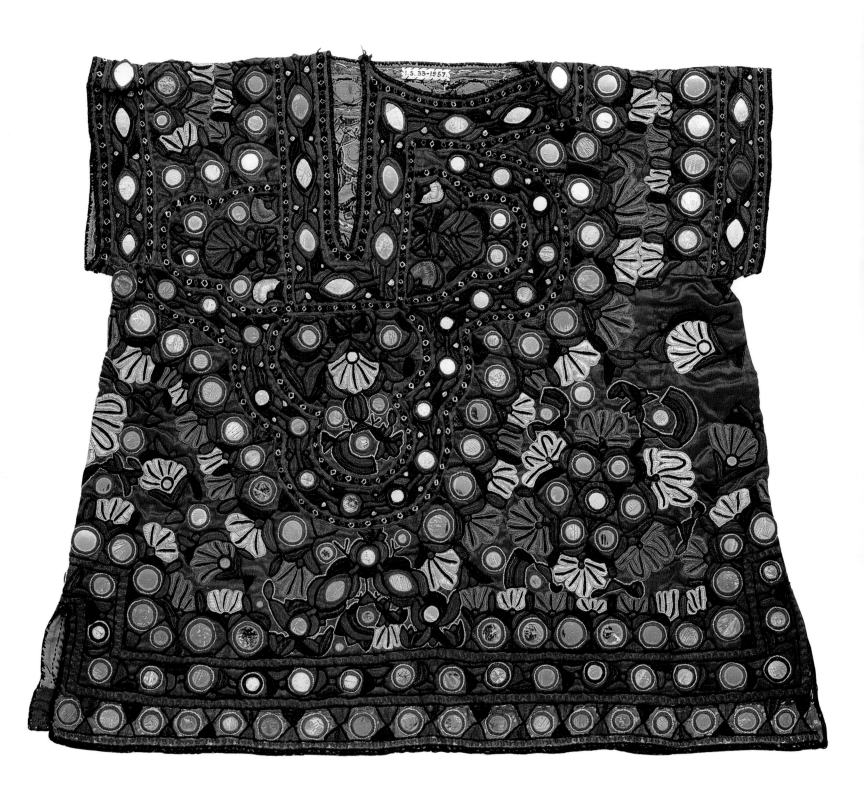

95. Child's dress

Sindh, Pakistan, mid-20th century.

IS 33-1957

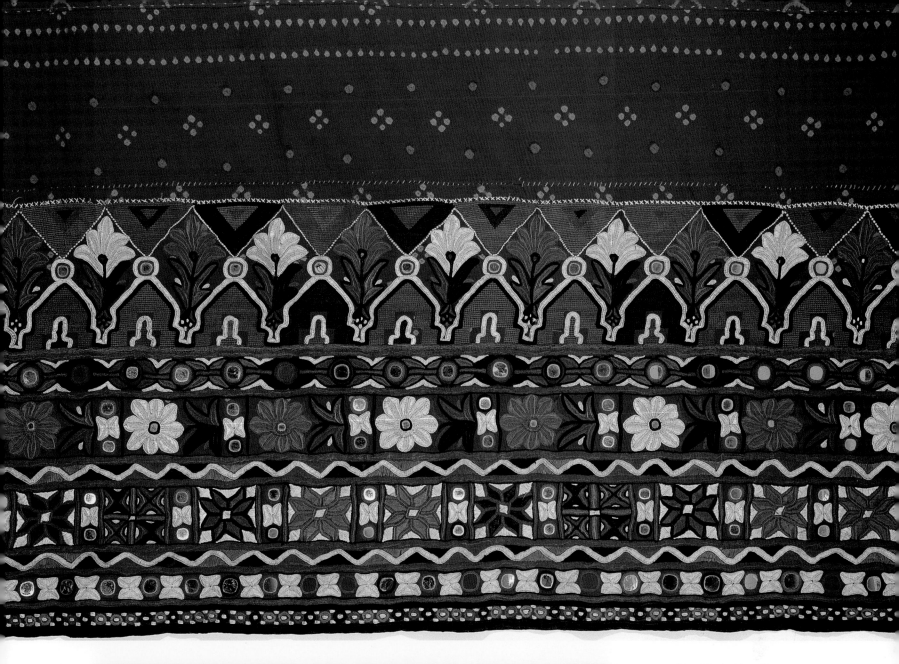

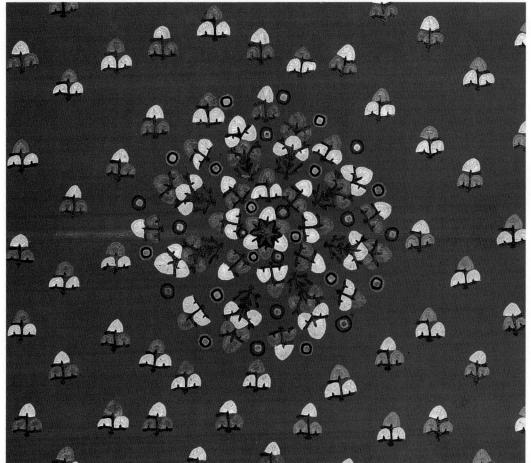

96. Skirt fabric (detail)
Sindh, Pakistan, or Kutch, Gujarat,
mid-20th century.
IS 6-1981

97. Woman's shawl (*abochhini*)
(detail)
Sindh, Pakistan, mid-20th century.
IS 8-1981

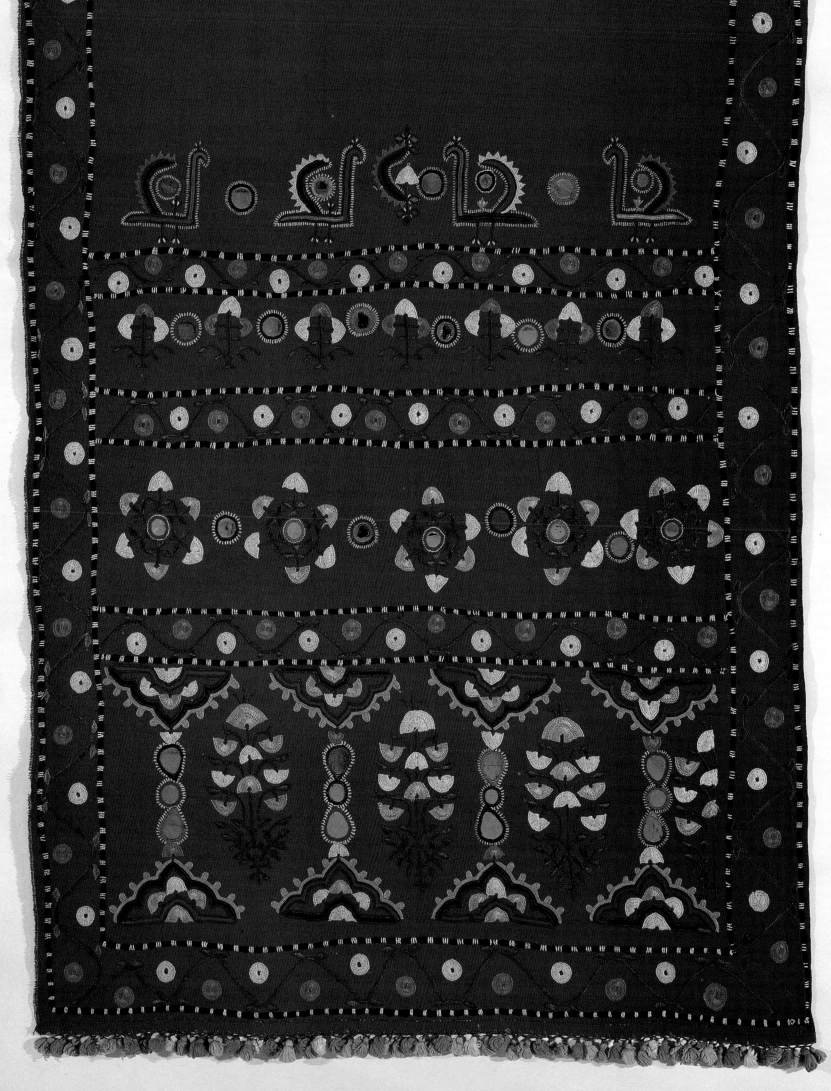

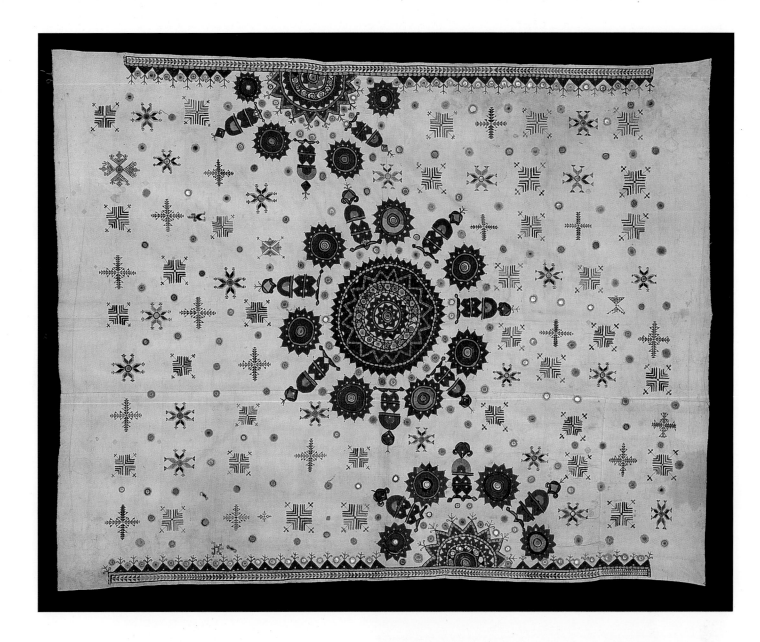

98. *(opposite)* **Man's wedding scarf (*bokano*)** (detail)
Sindh, Pakistan, early 20th century.
IS 13-1981

99. *(above)* **Woman's shawl (*abochhini*)**
Sindh, Pakistan, early 20th century.
IS 10-1981

100. Man's wedding scarf (*bokano*) (detail)
Sindh, Pakistan, 20th century.
IS 14-1981

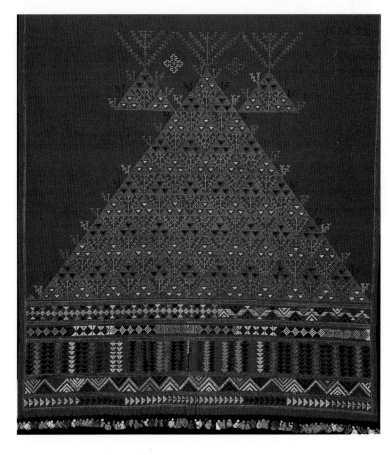

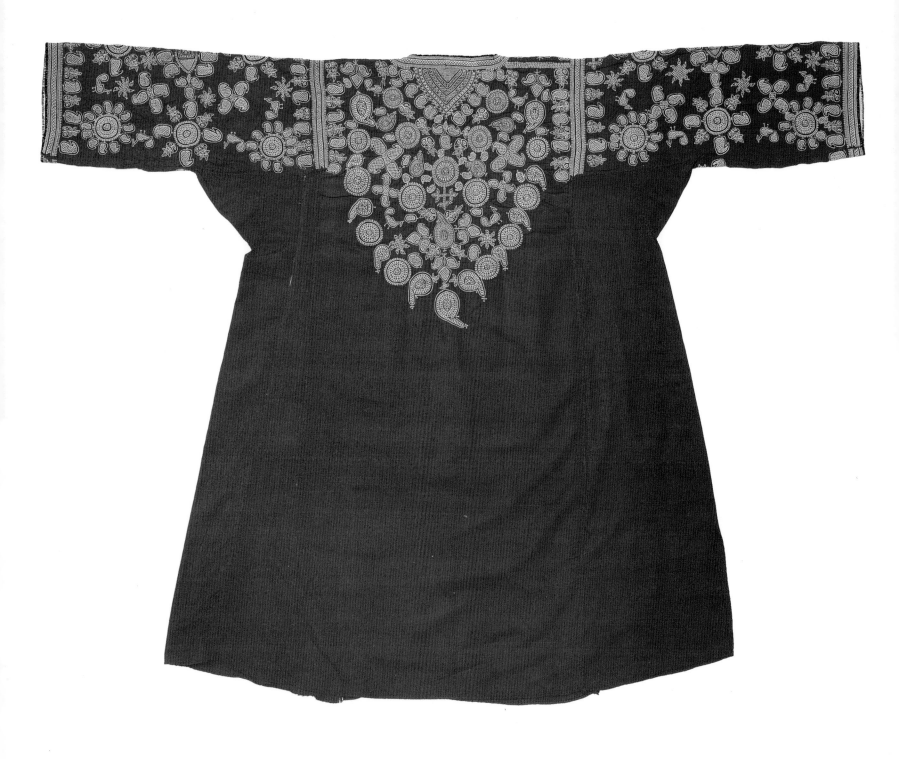

101. Boy's shirt (back)
Sindh, Pakistan, early 20th century.
IS 58-1981

102. *(opposite above)* **Skirt length** (detail)
Sindh, Pakistan, late 19th or early 20th century.
IM 278-1920

103. *(opposite below)* **Panel for a blouse** (*choli*)
Probably Sindh, Pakistan, early 20th century.
Silk, embroidered with silk.
IS 27-1957

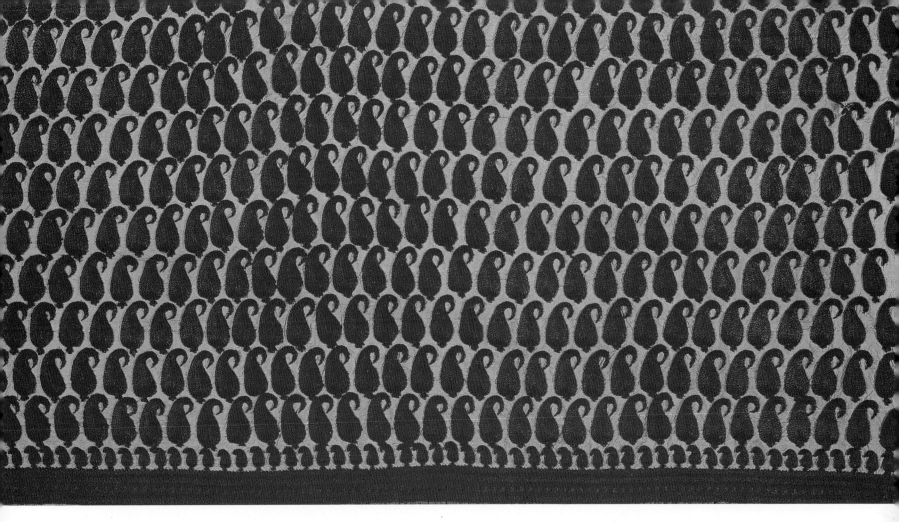

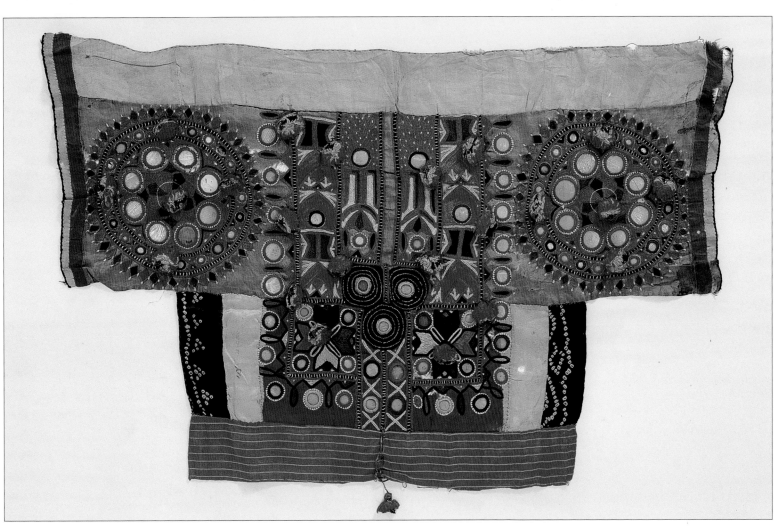

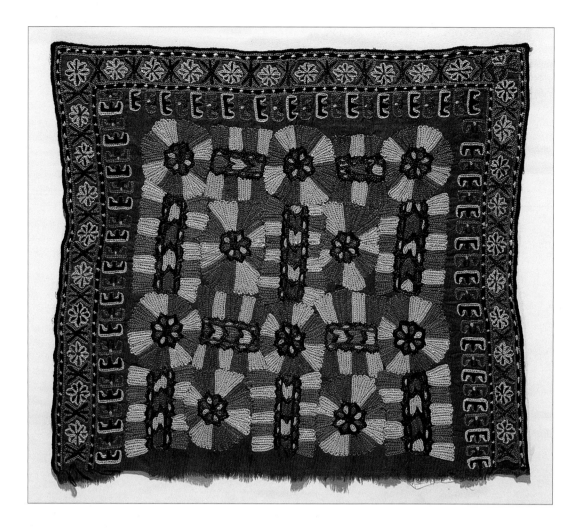

104. Panel for a blouse (*choli*)
Sindh, Pakistan, early 20th century.
IS 158-1960

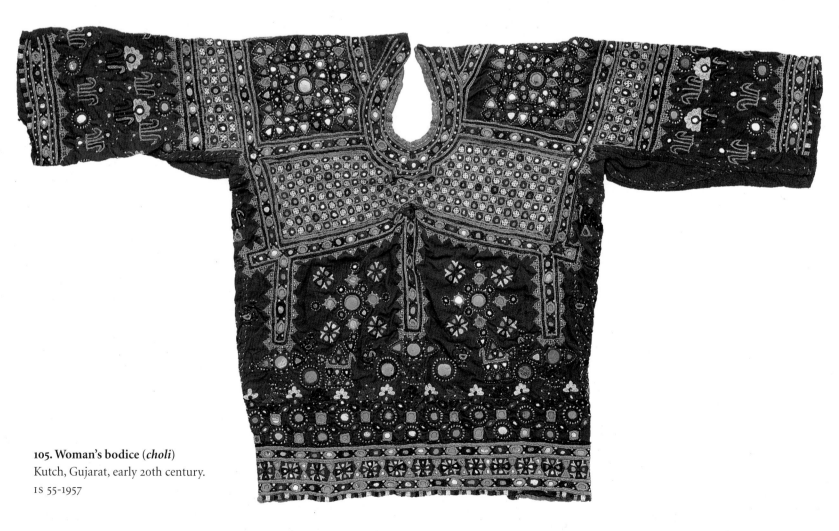

105. Woman's bodice (*choli*)
Kutch, Gujarat, early 20th century.
IS 55-1957

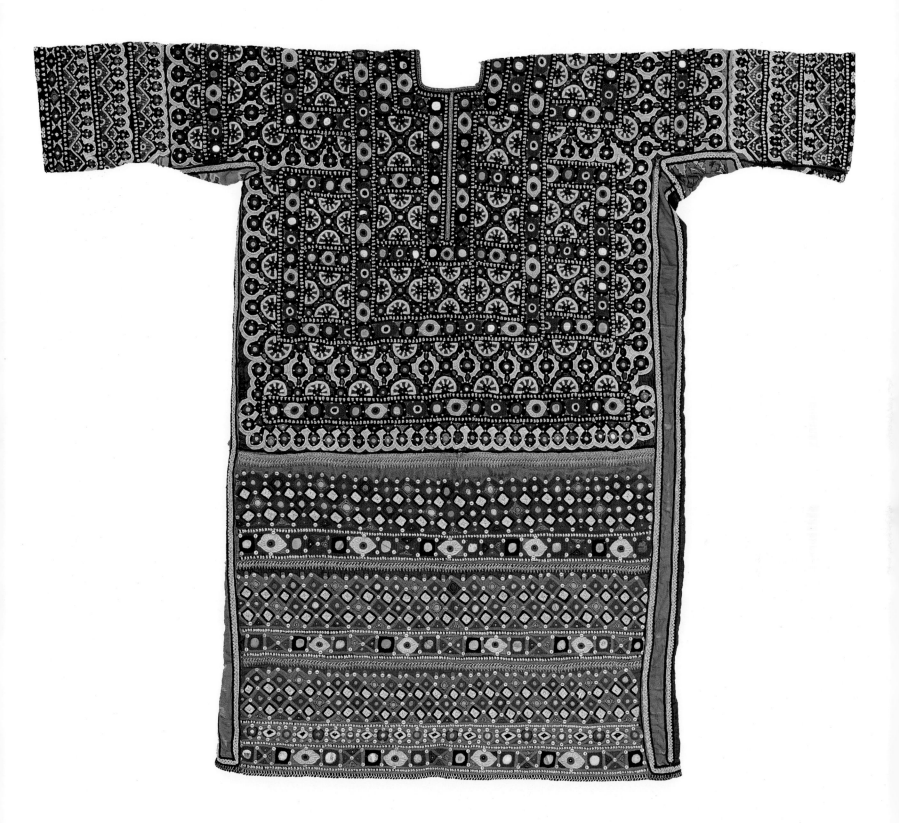

106. Woman's tunic (*cholo*)
Sindh, Pakistan, mid-20th century.
IS 15-1974

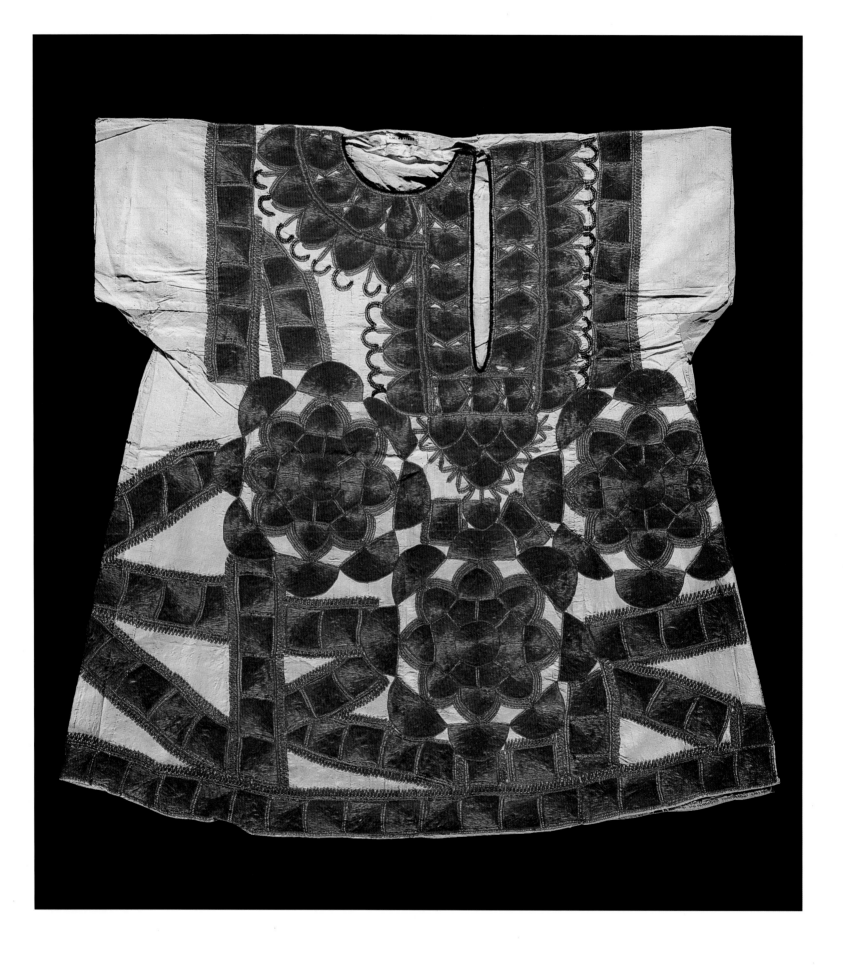

107. Child's dress
Sindh, Pakistan, *c.*1900.
49-1908

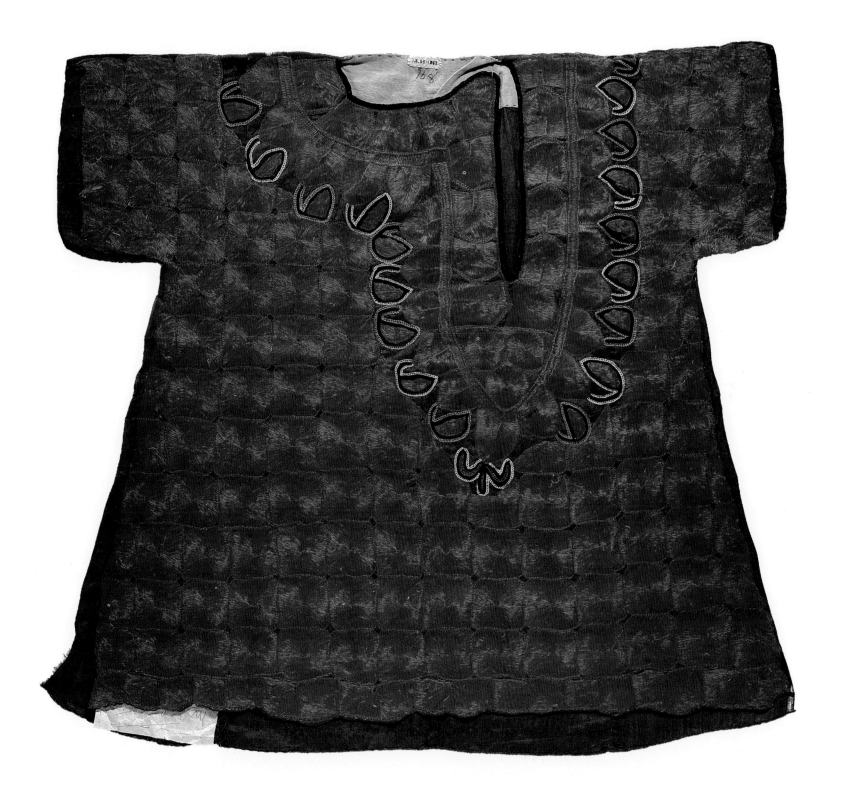

108. Child's dress
Sindh, Pakistan, early 20th century.
IS 55-1962

109. *(opposite)* **Woman's shawl** (***abochhini***) (detail)
Sindh, Pakistan,
mid-20th century.
IS 82-1958

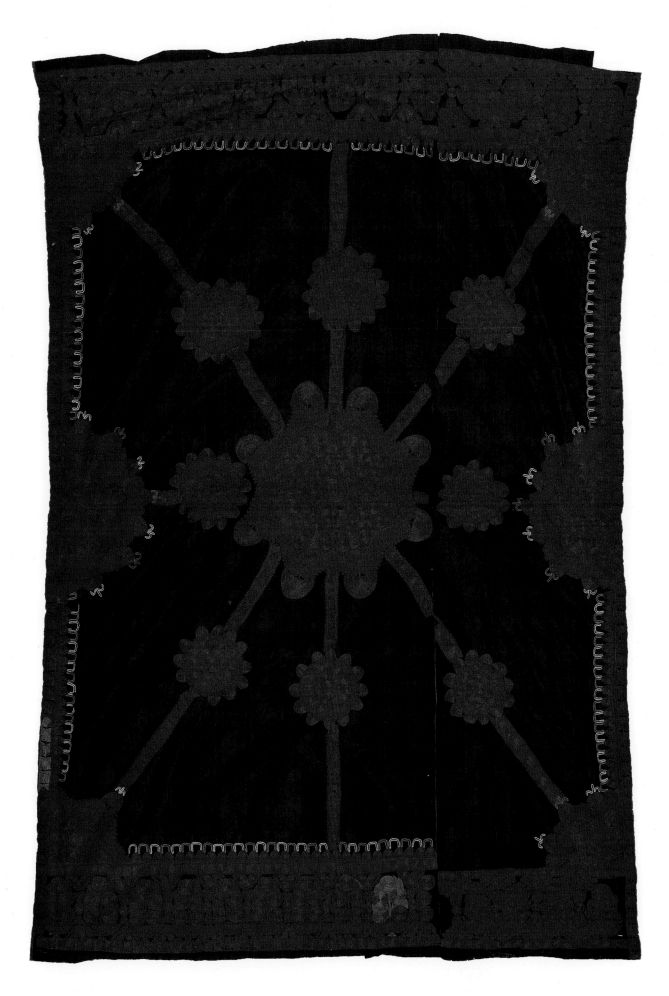

110. *(right)* **Woman's shawl** (***abochhini***)
Sindh, Pakistan,
early 20th century.
IS 19-1957

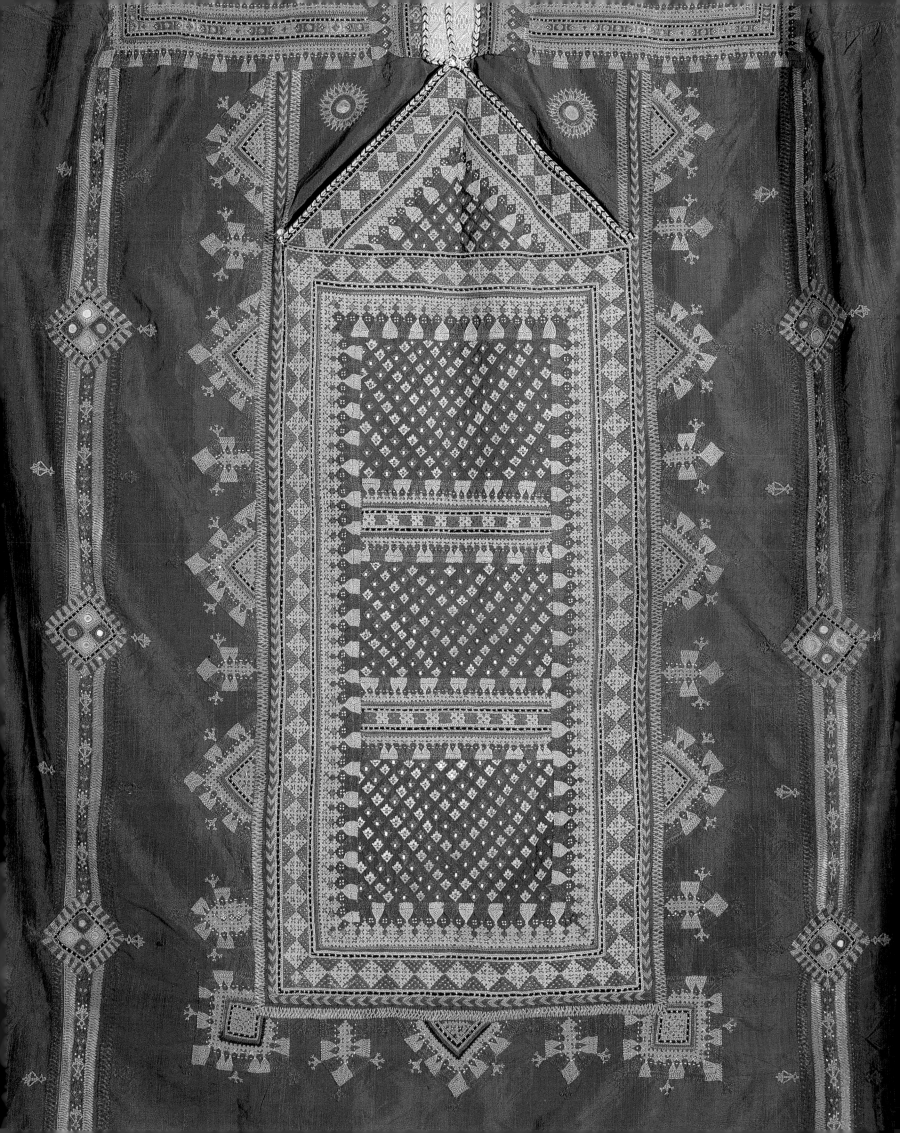

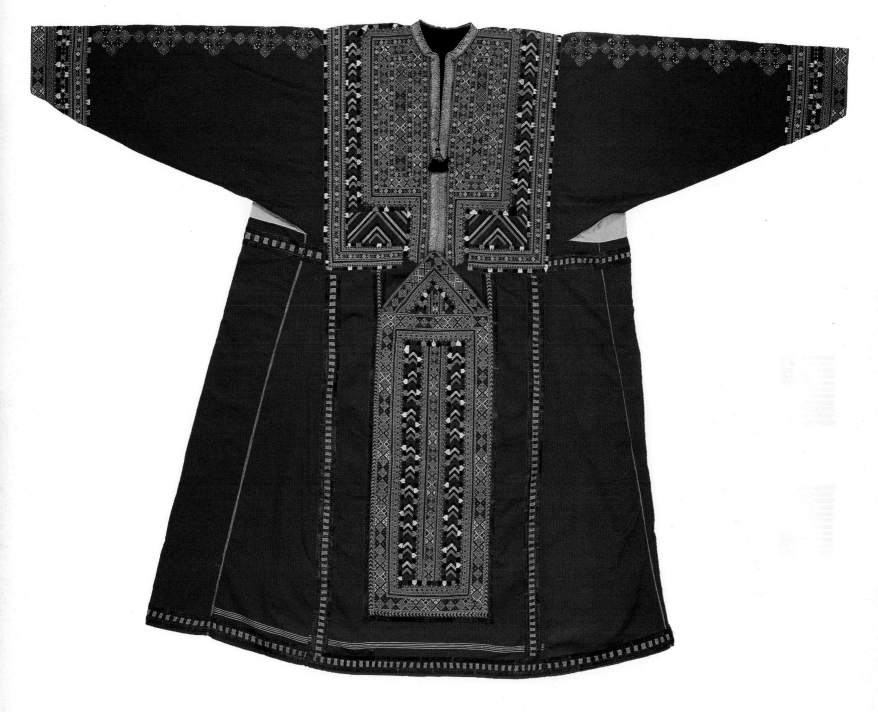

112. Woman's dress (*pashk*)
Baluchistan, Pakistan, late 19th or early 20th century.
IS 33-1969

111. *(opposite)* **Woman's dress (*pashk*)**
(detail of pocket)
Baluchistan, Pakistan, late 19th or early 20th century.
IS 14-1971

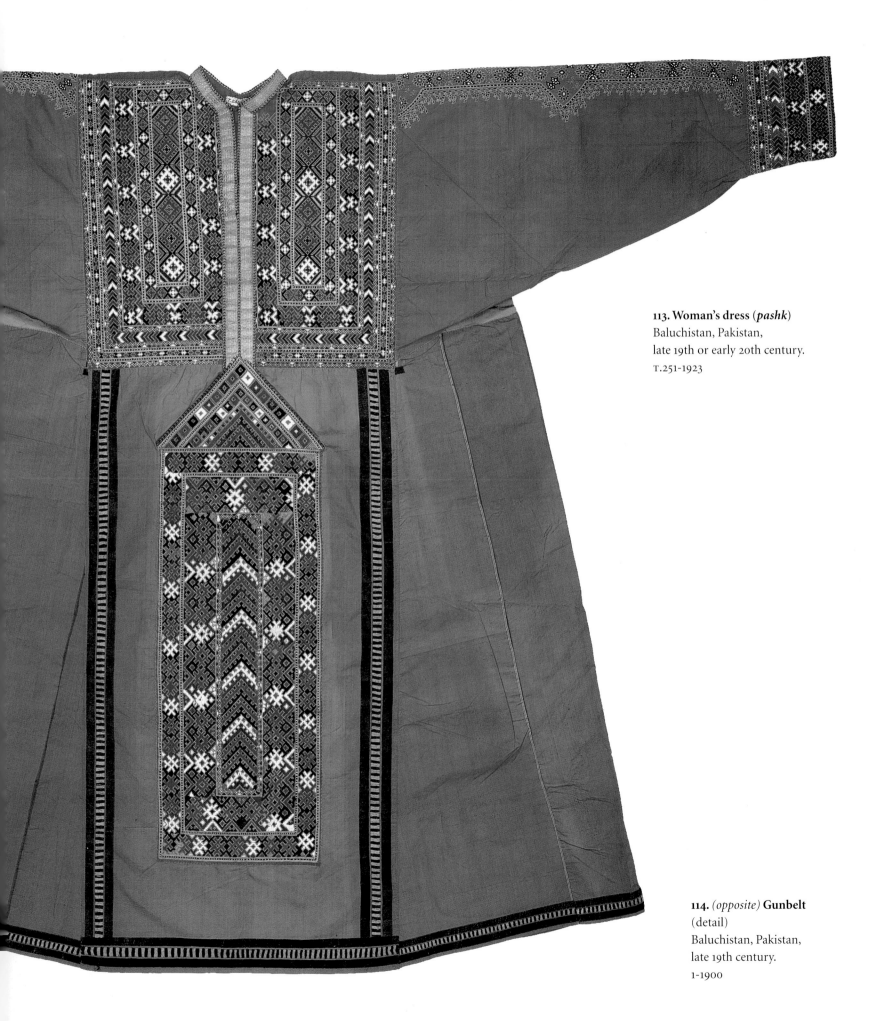

113. Woman's dress (*pashk*)
Baluchistan, Pakistan,
late 19th or early 20th century.
T.251-1923

114. *(opposite)* **Gunbelt**
(detail)
Baluchistan, Pakistan,
late 19th century.
I-1900

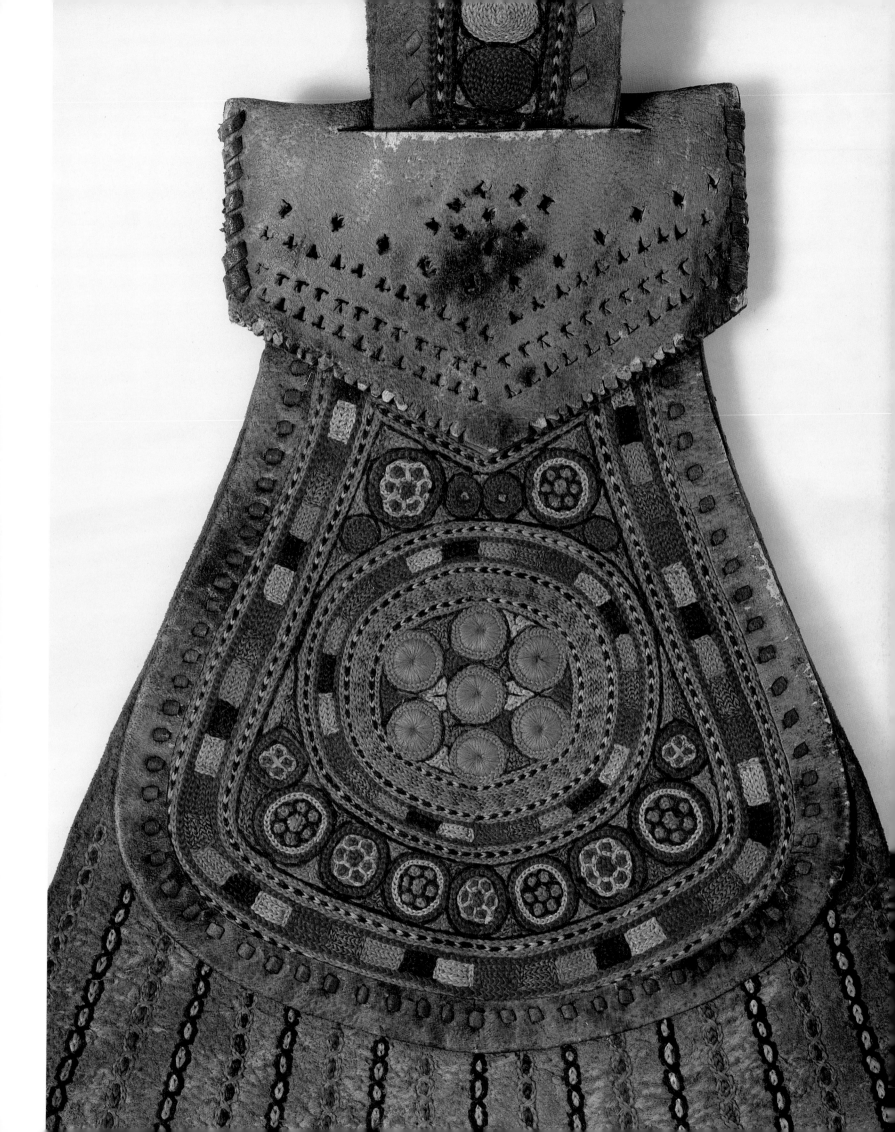

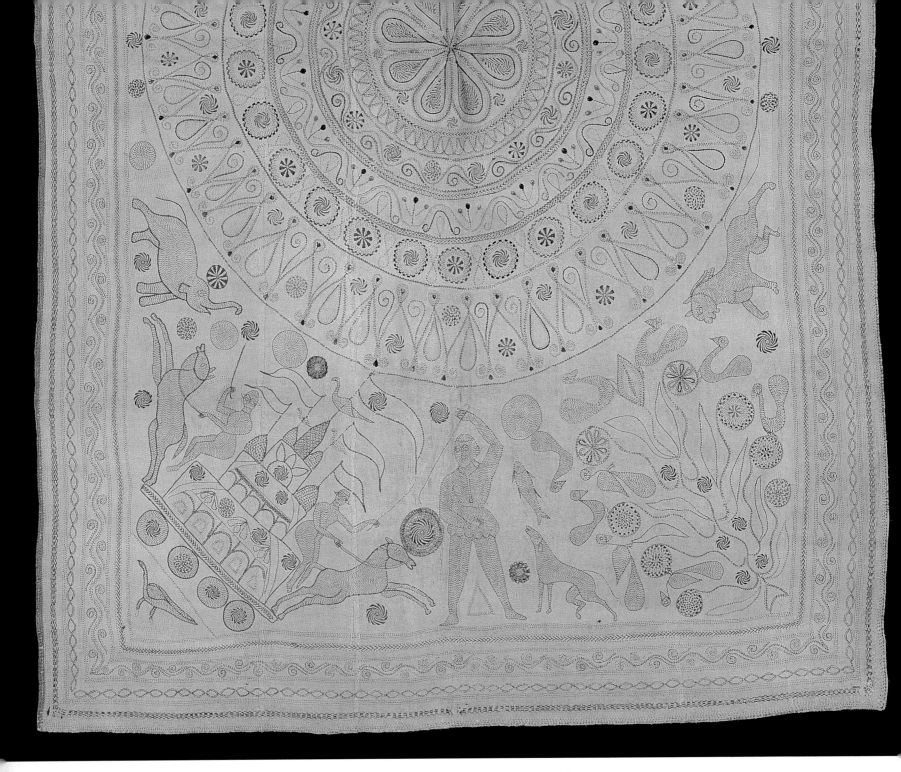

115. Bedcover (*kantha*) (detail)
Jessore District, Bangladesh, early 20th century.
IS 22-1983

116. *(opposite)* **Bedcover (*kantha*)**
Faridpur or Jessore District, Bangladesh,
late 19th or early 20th century.
IS 62-1981

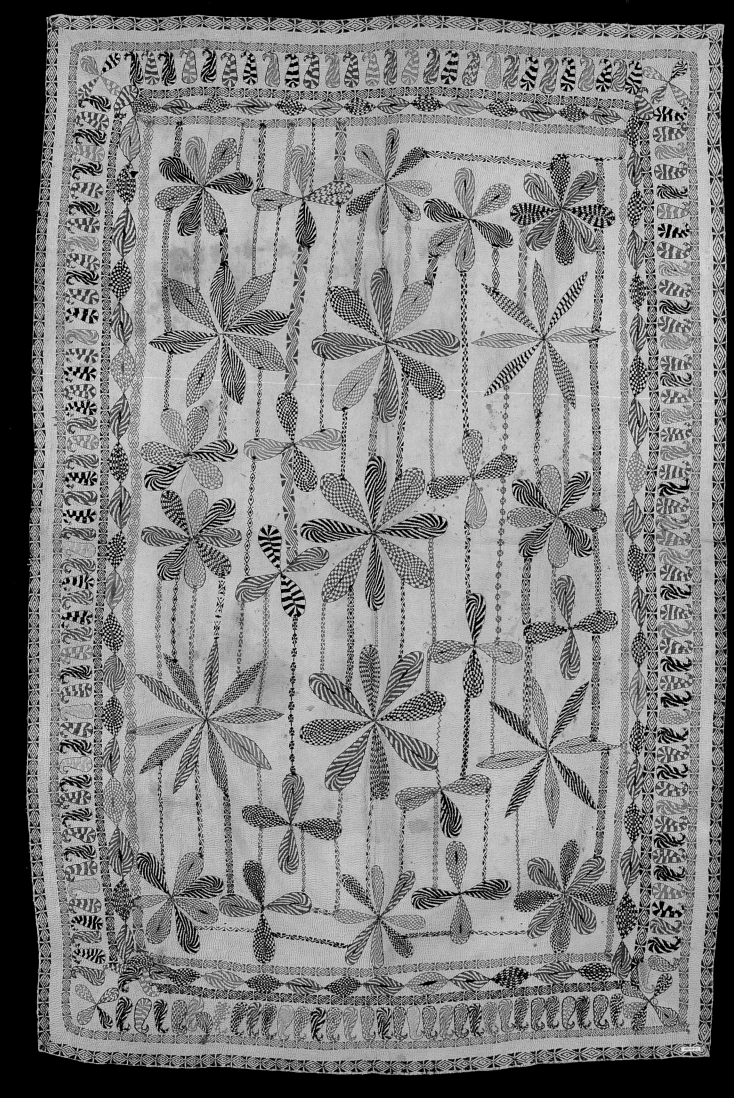

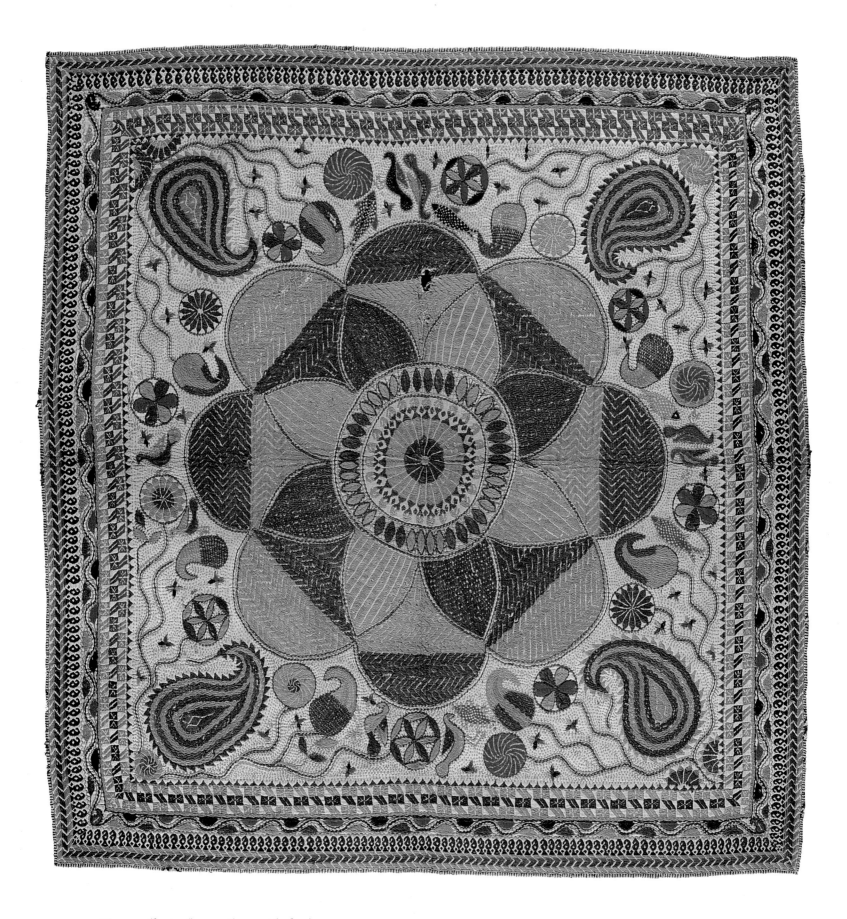

117. Wrapper (*bostani*) or seating mat (*ashon*)
Bangladesh, early 20th century.
IS 61-1981

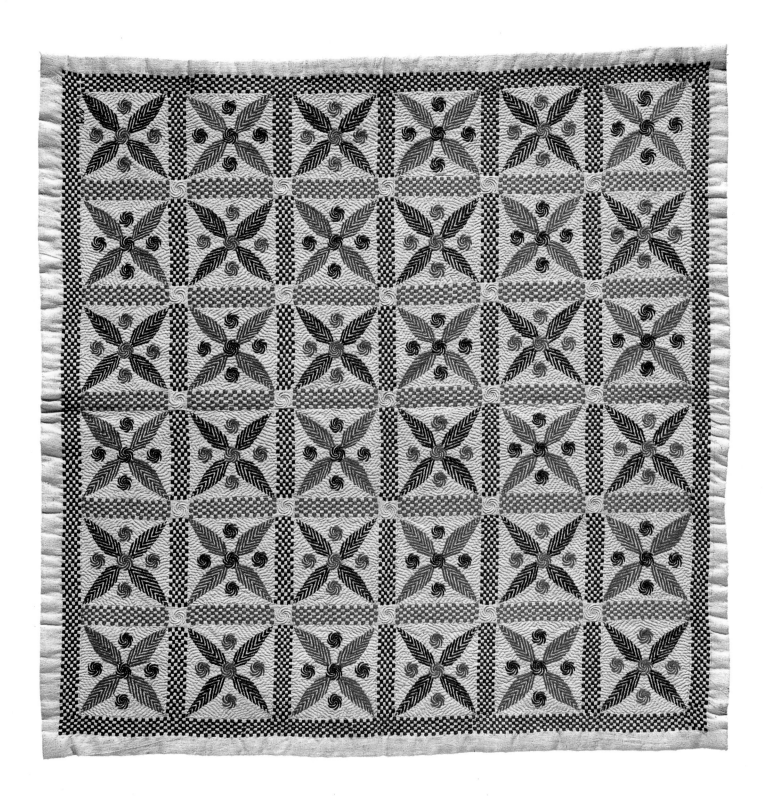

118. Coverlet
Calcutta, West Bengal, 1996.
IS 13-1996

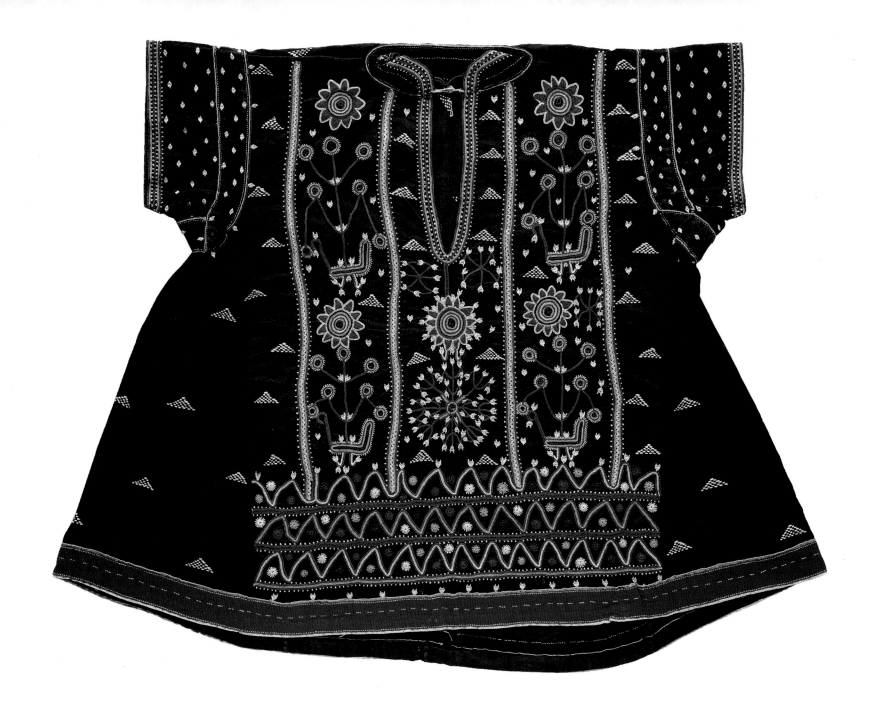

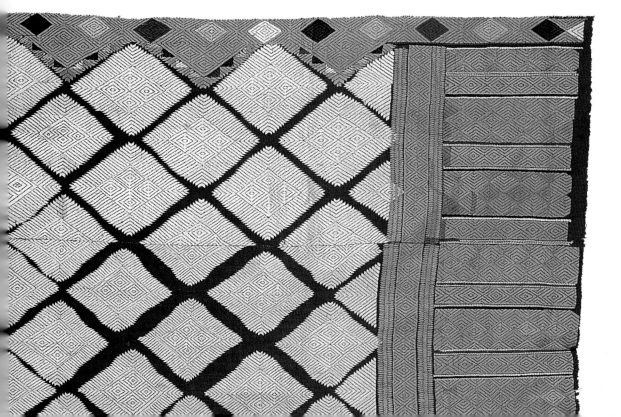

119. *(above)* **Child's dress**
Dharbanga District, Bihar,
mid-20th century.
IS 6-1961

120. *(left)* **Woman's headcover (*bagh*)**
(detail)
Western Panjab, early 20th century.
IS 4-1961

121. *(opposite)* **Woman's headcover (*bagh*)**
(detail)
Western Panjab, mid-20th century.
IS 28-1983

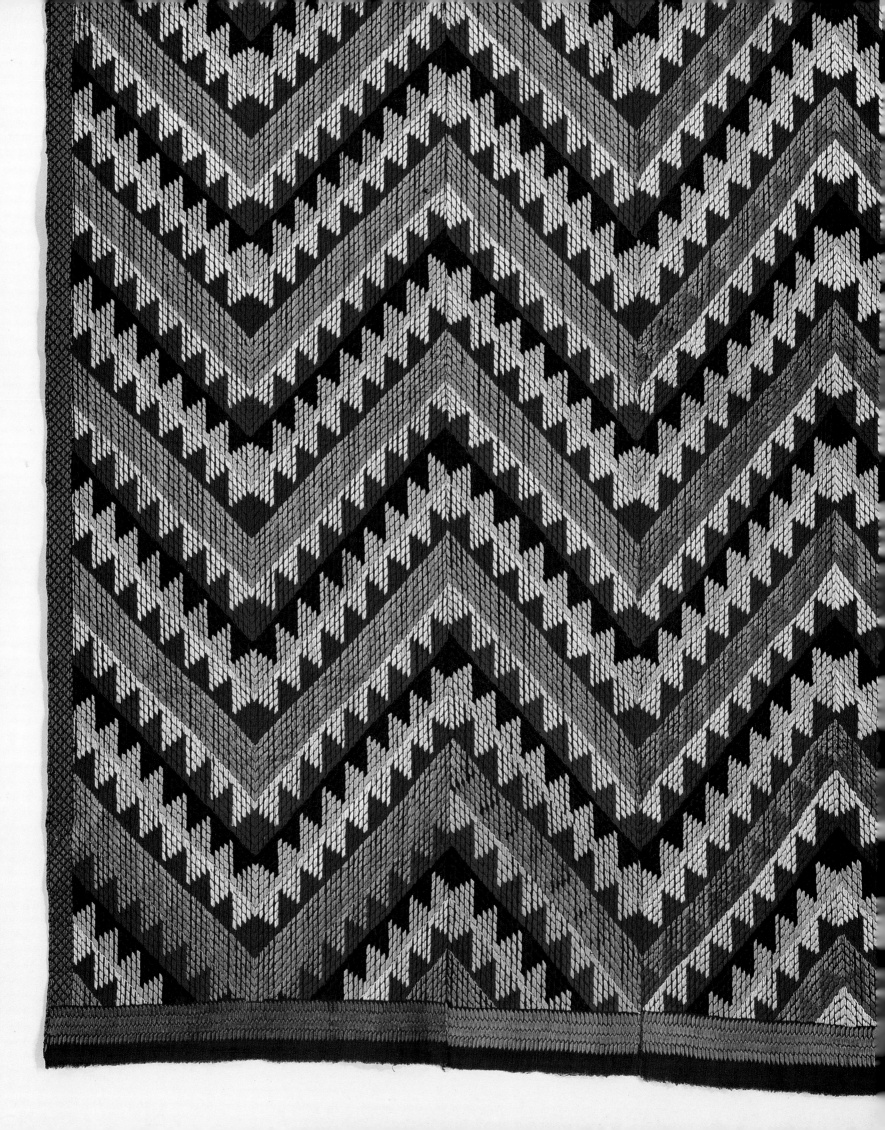

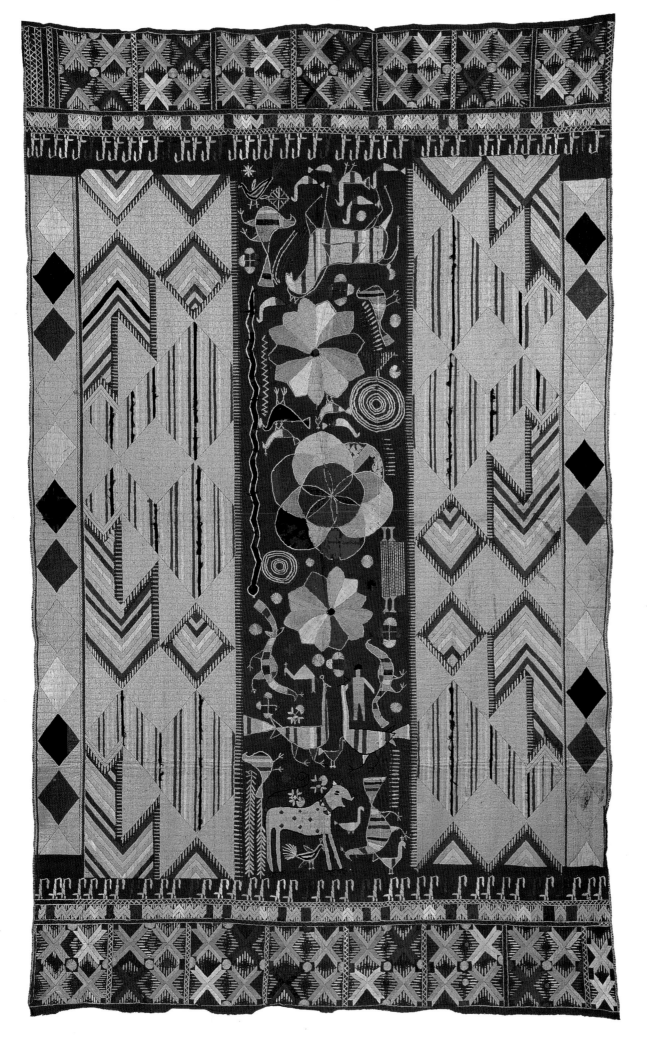

122. *(left)* **Woman's headcover (*chadar*)** Eastern Panjab, mid-20th century. IS 34-1970

123. *(opposite)* **Woman's headcover (*chadar*)** Eastern Panjab, early 20th century. IS 24-1983

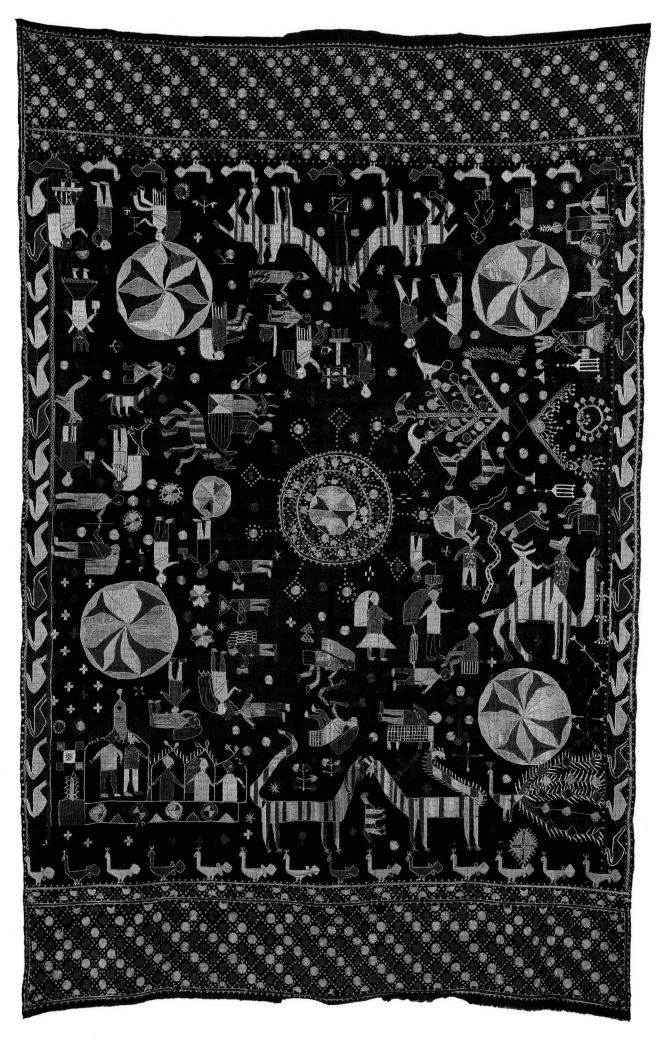

124. Skirt
Hissar, Haryana, *c.*1880.
1823-1883 (IS)

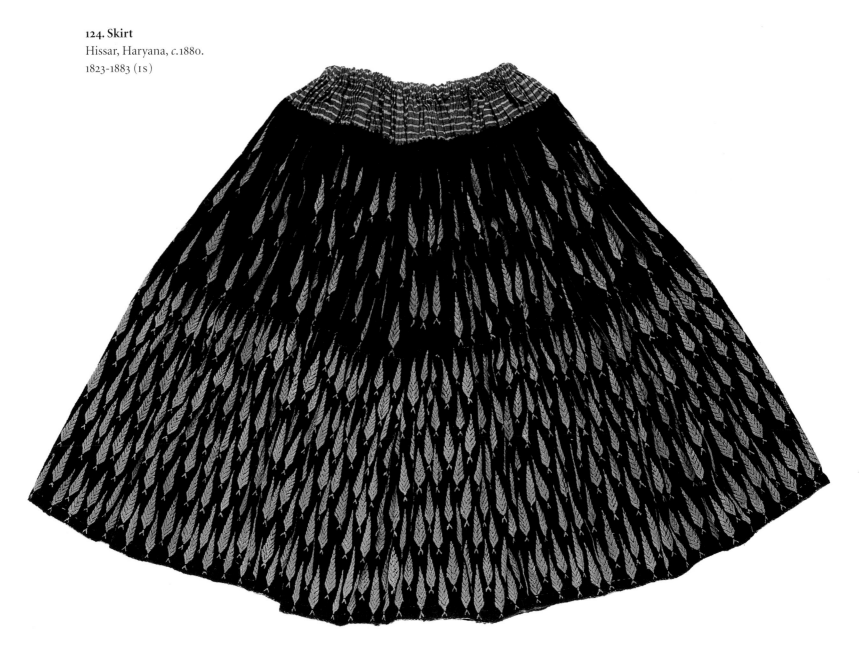

Detail of plate 124.

125. *(opposite)* **Woman's headcover**
(detail)
Rohtak, Haryana, *c.*1880.
1842-1883 (IS)

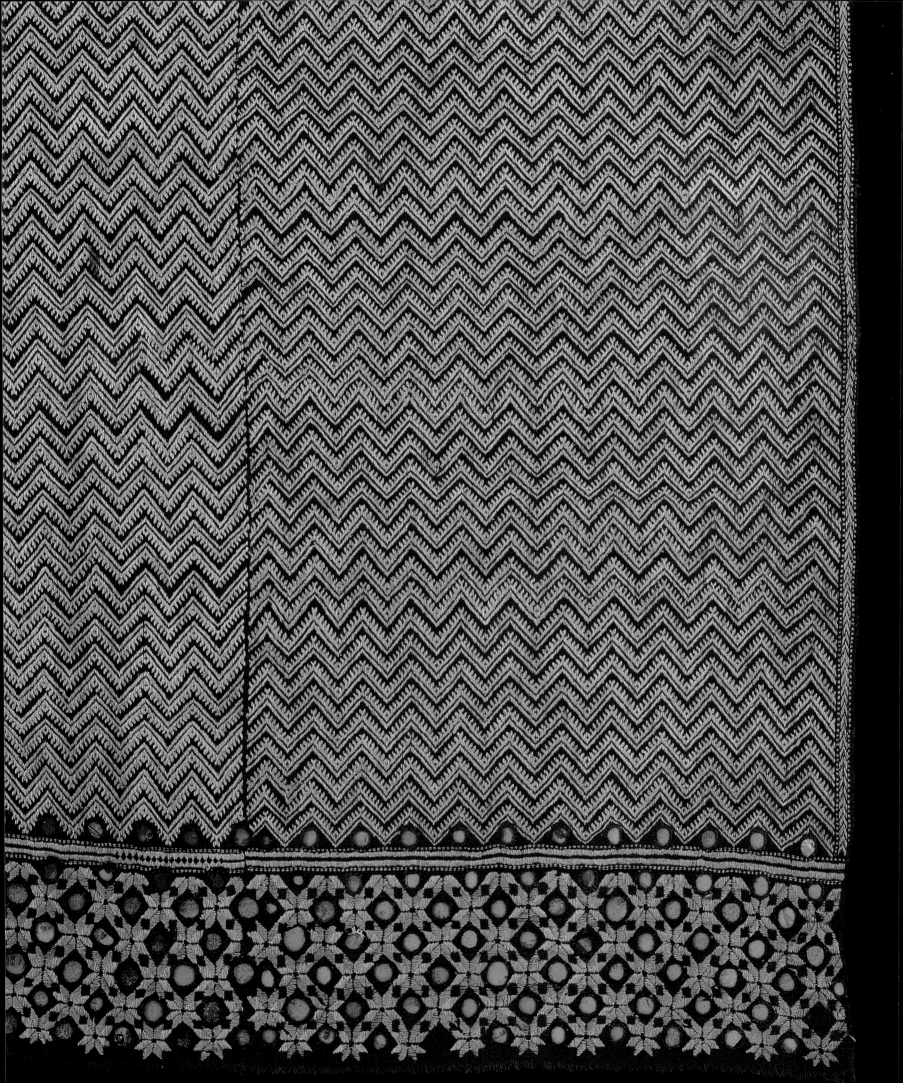

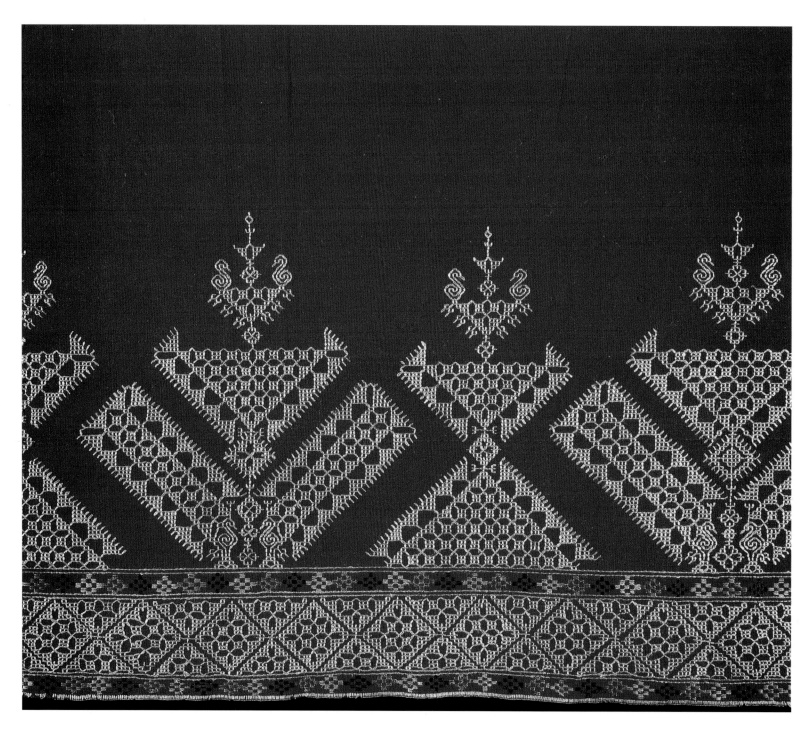

126. Part of a woman's headcover (*chope*) (detail)
Panjab, early 20th century.
IS 91-1985

127. *(opposite)* **Shawl**
Hissar, Haryana, *c.*1880.
1839-1883 (IS)

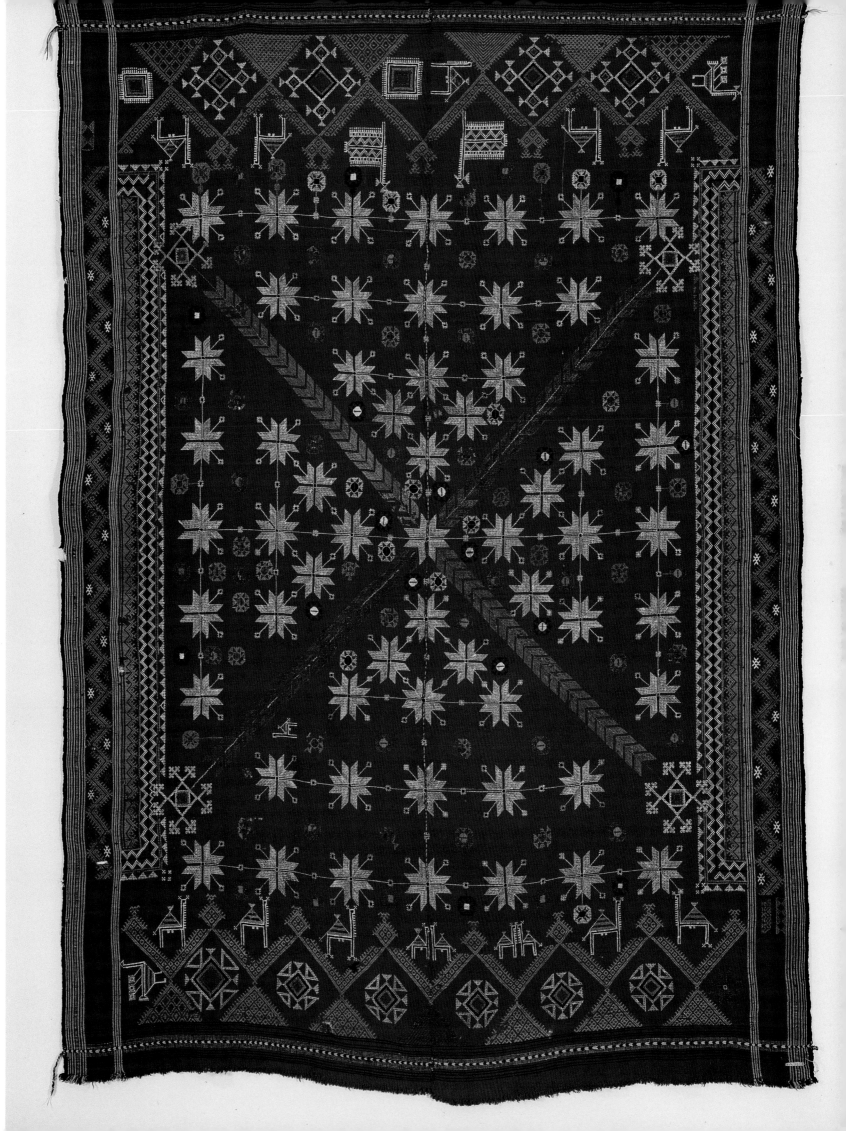

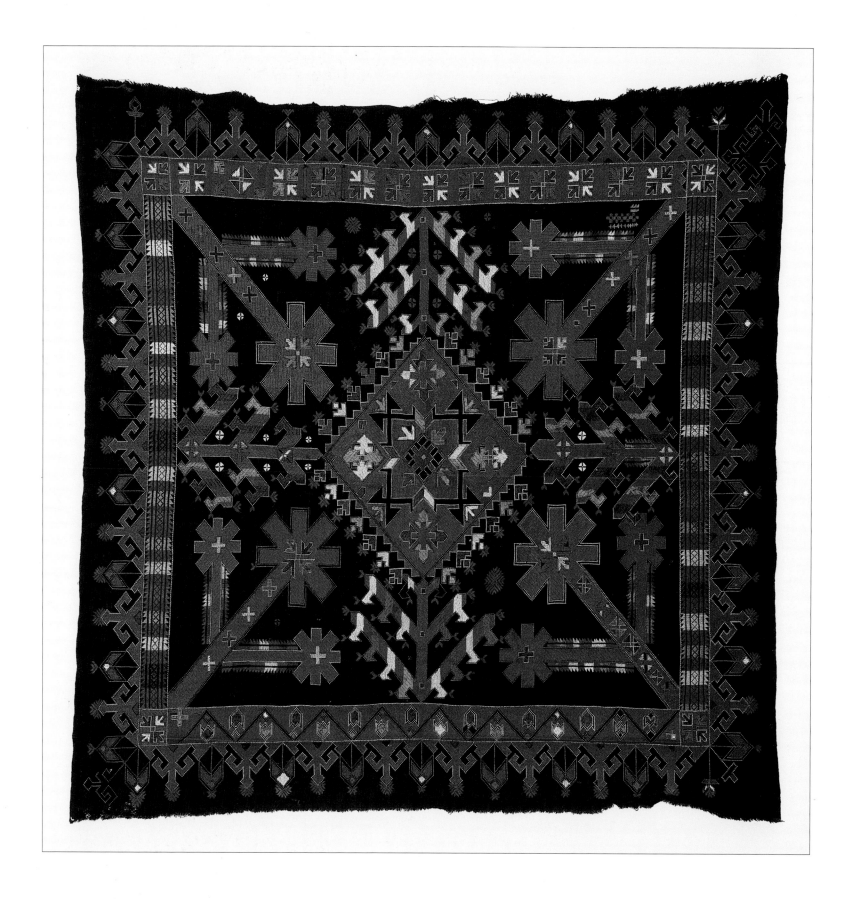

128. Coverlet (*rumal*)

Swat Valley, Pakistan, *c.*1935.

IM 37-1938

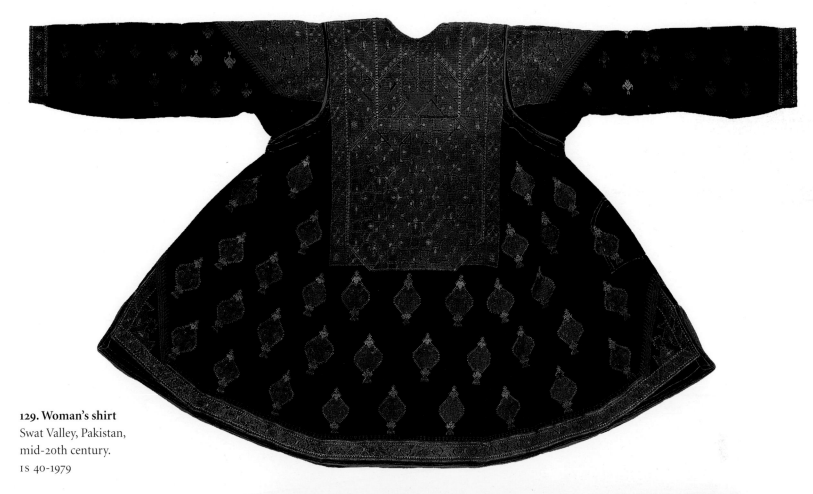

129. Woman's shirt
Swat Valley, Pakistan,
mid-20th century.
IS 40-1979

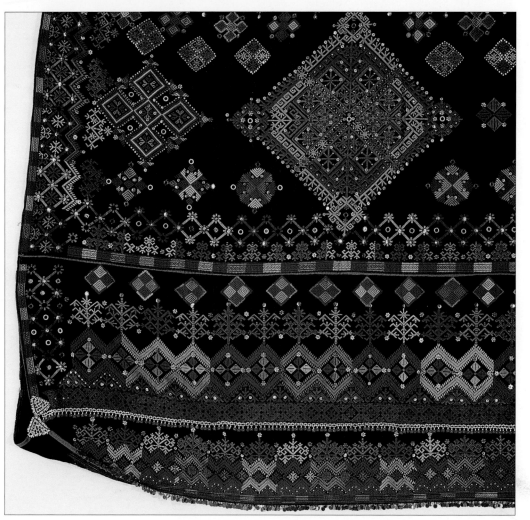

130. Woman's shawl *(detail)*
Indus Kohistan, Pakistan,
mid-20th century.
IS 2-1997

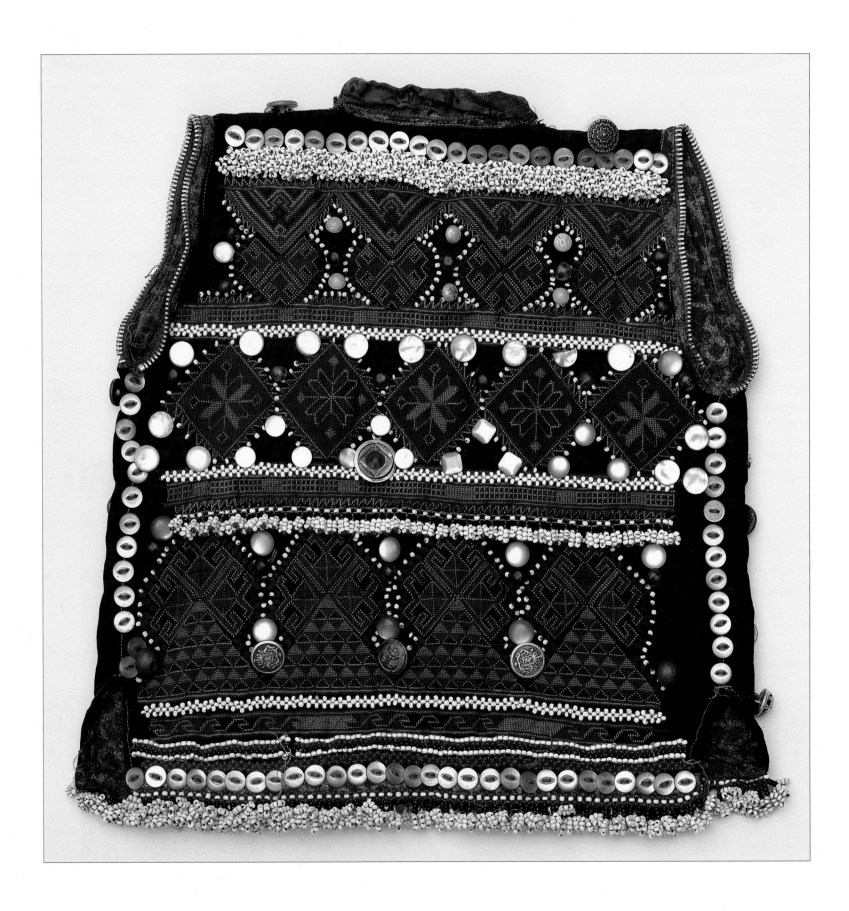

131. Child's jacket (back)
Indus Kohistan, Pakistan, mid-20th century.
IS 32-1996

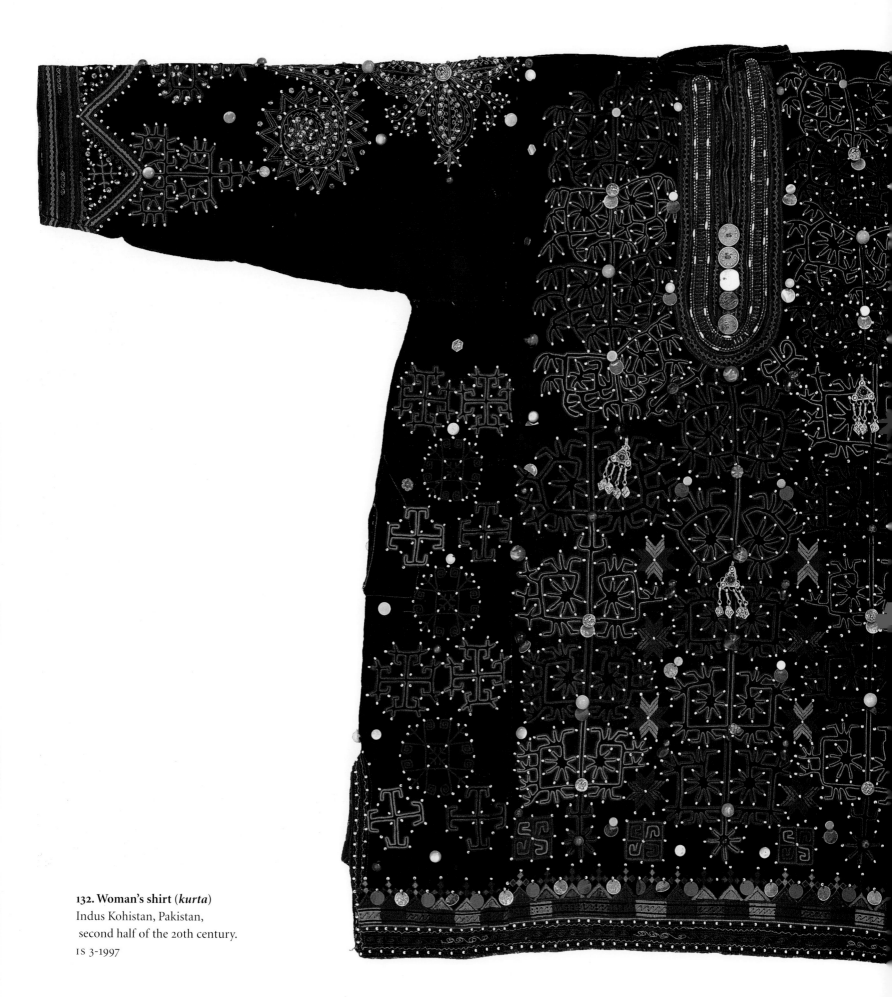

132. Woman's shirt (*kurta*)
Indus Kohistan, Pakistan,
second half of the 20th century.
IS 3-1997

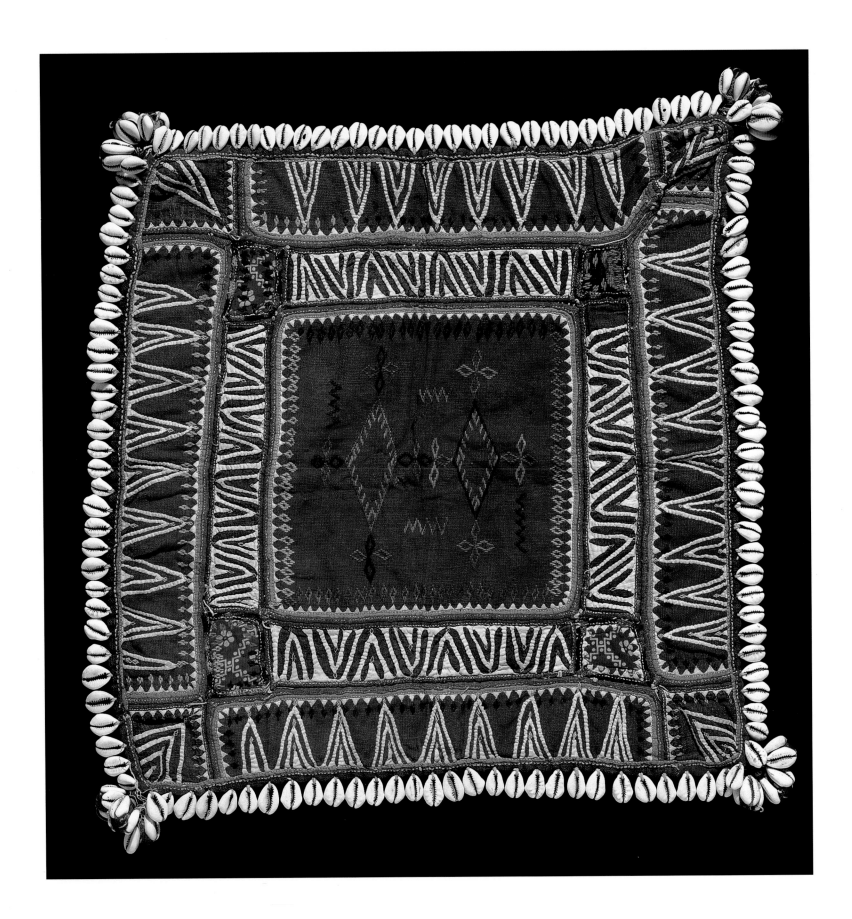

133. Coverlet (*rumal*)
Banjara community, Central India, probably Maharashtra, 20th century.
IS 476-1993

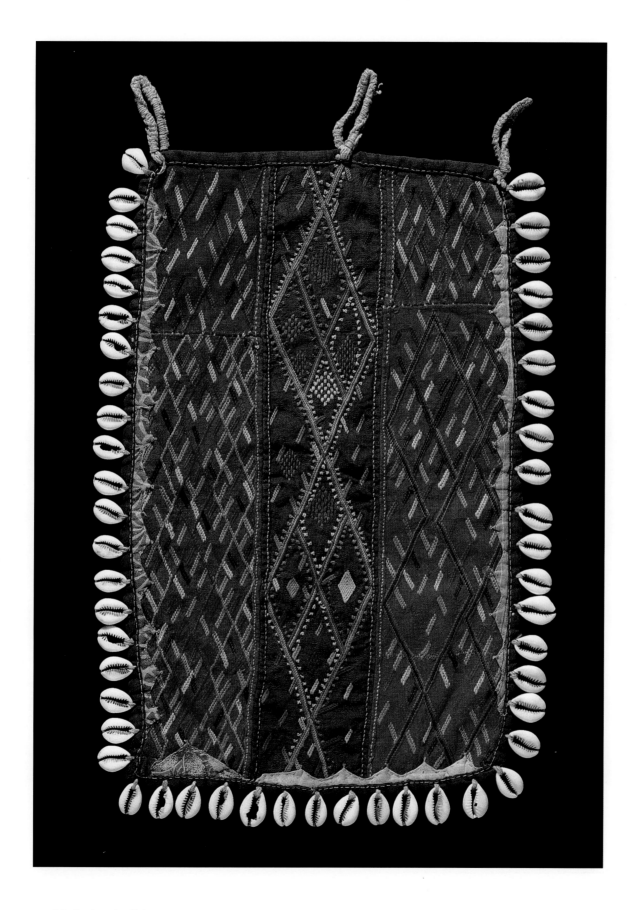

134. Neck piece (*galla*)
Banjara community, Central India, probably Maharashtra, 20th century.
IS 477-1993

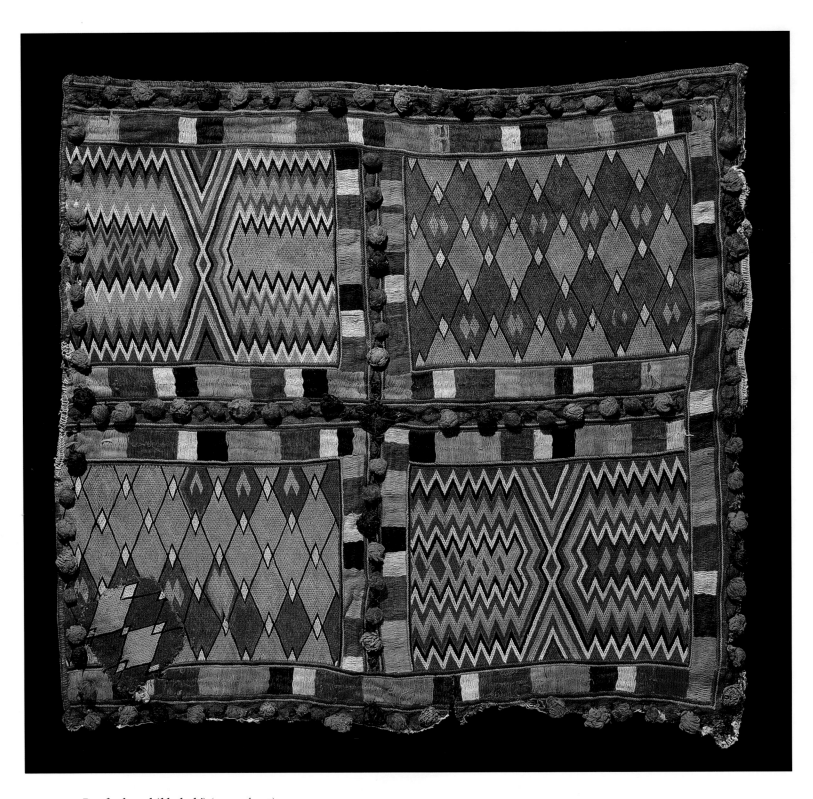

135. Bag for bread (*khalechi*) (opened out)
Banjara community, probably Maharashtra,
20th century.
IS 168-1984

136. *(opposite)* **Mat (*asana*)** (detail)
Banjara community, Central India,
mid-20th century.
IS 169-1984

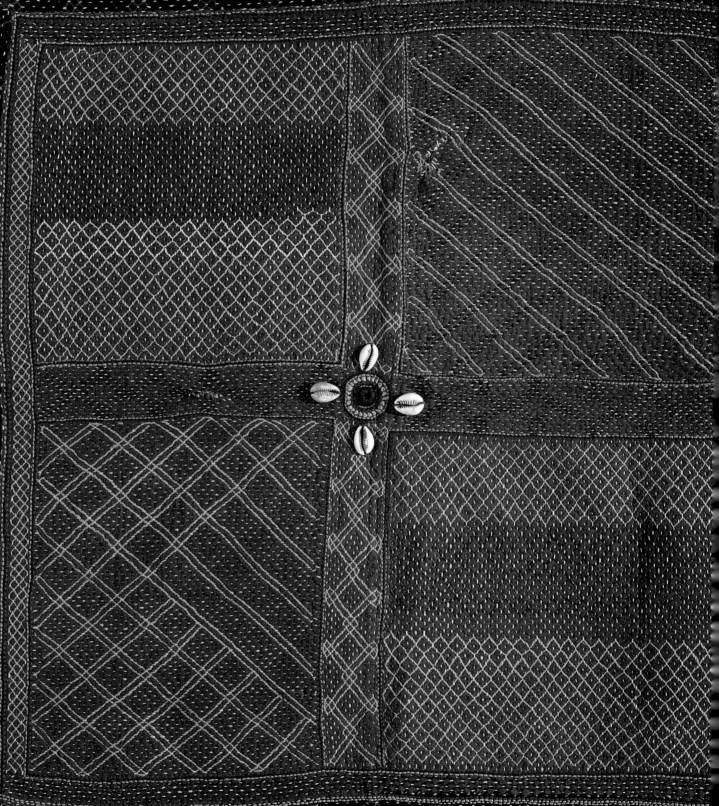

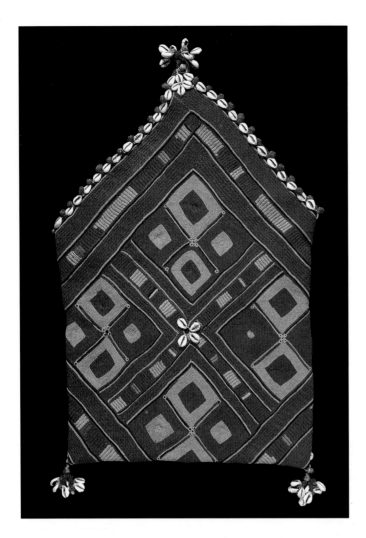

137. Bag
Banjara community, probably Karnataka, 20th century.
IS 474-1993

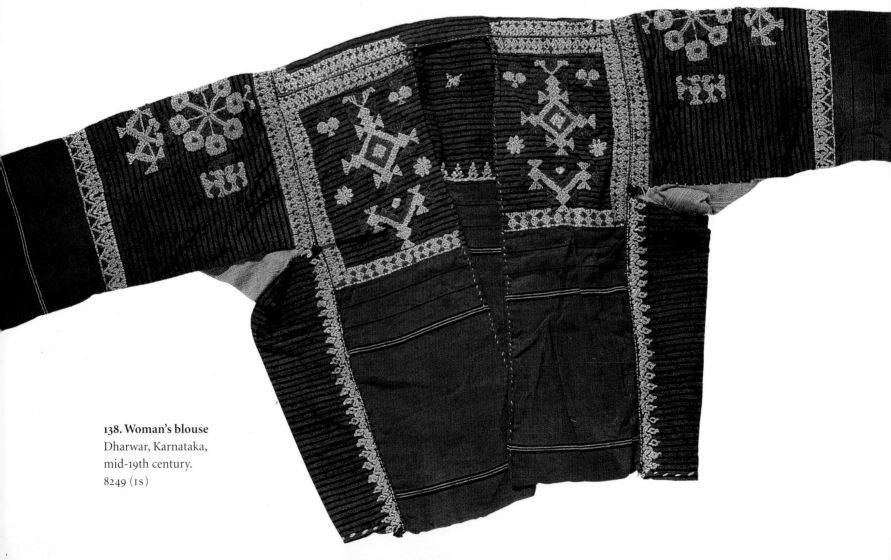

138. Woman's blouse
Dharwar, Karnataka,
mid-19th century.
8249 (IS)

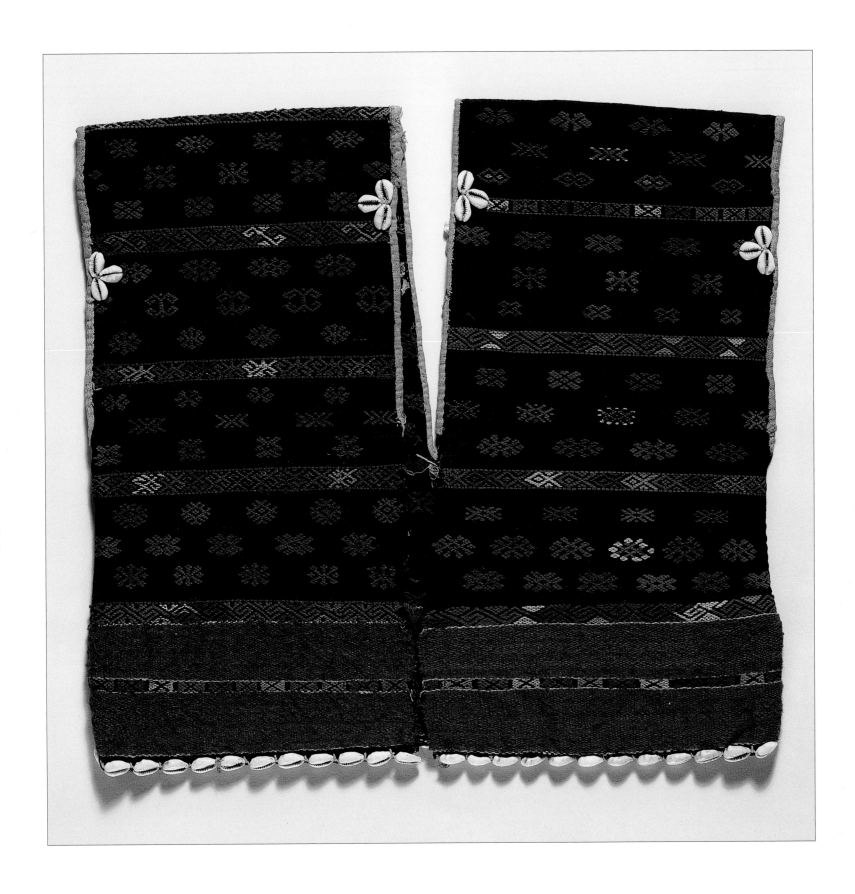

139. Jacket

Assam, early 20th century.

IM 49a-1939

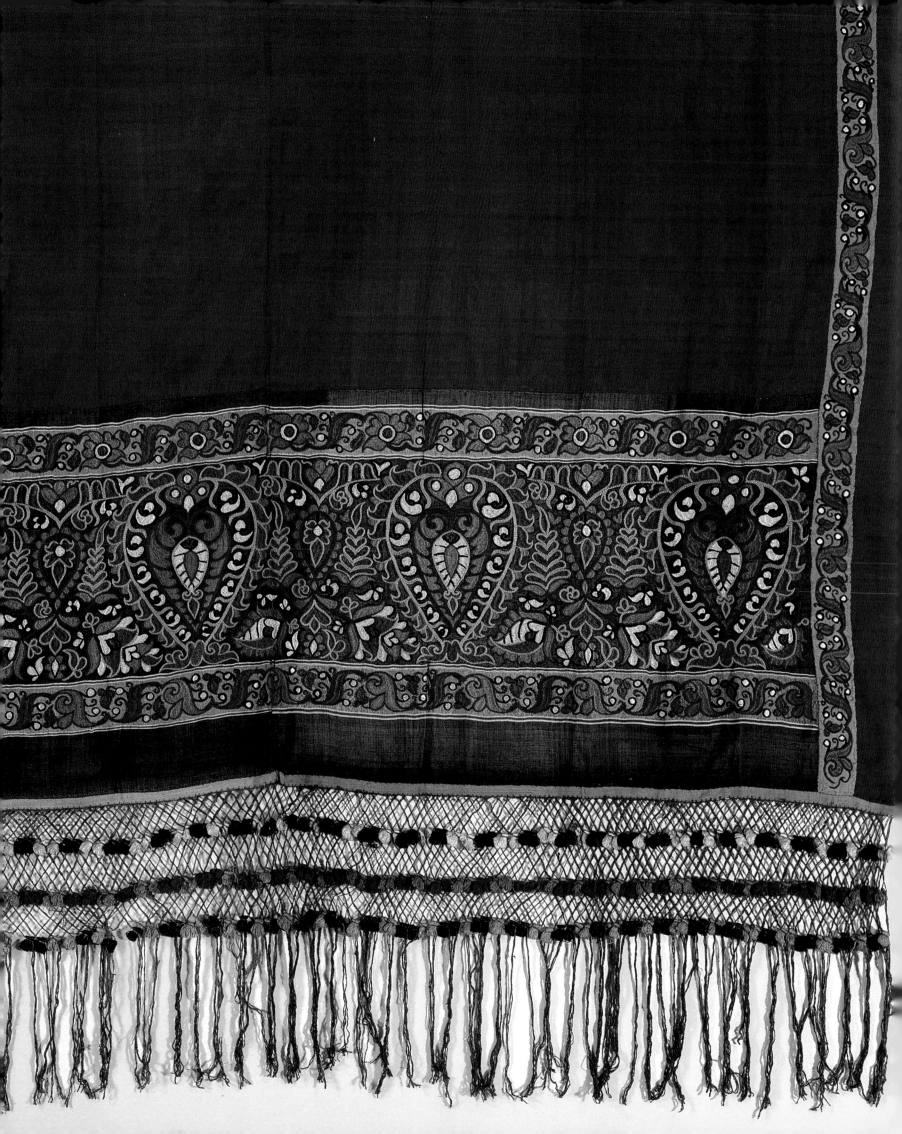

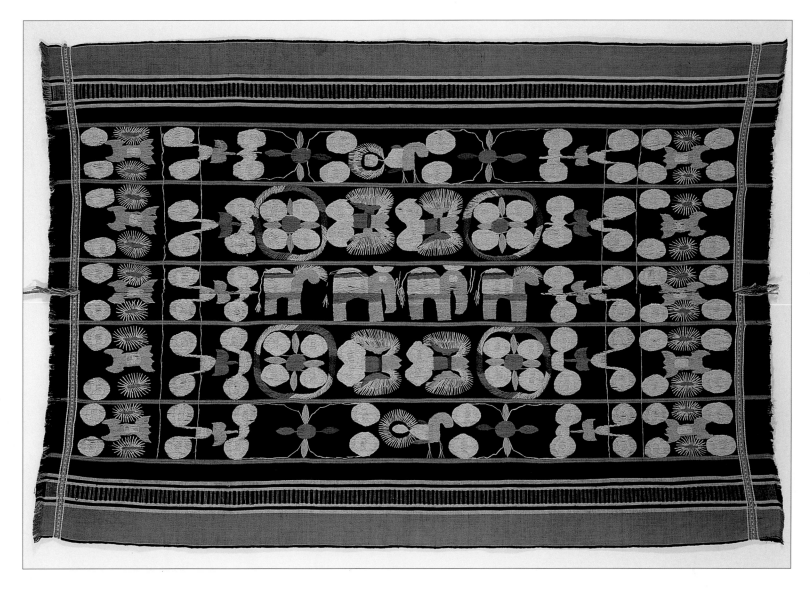

141. Man's shawl
Manipur for use by Eastern Angami Nagas, *c.*1940.
IS 165-1989

140. Man's shawl *(opposite)* (detail)
Manipur, mid-19th century.
0190 (IS)

Stitch Details

These details illustrate some of the main stitches used in Indian embroidery. Some of these, for example chain-stitch, are used in essentially the same way in Western embroidery, while others are found in forms peculiar to the Indian sub-continent. The 'Sindhi stitch' for example (details F and H), combines radiating stitches with an edging of buttonhole-stitch, and is used extensively throughout Sindh, as well as neighbouring parts of Gujarat and Rajasthan. Also found in these areas is mirror or *shisha* work (detail F), which uses a variety of stitches including forms of cretan and herring-bone-stitches. In the absence of a survey of Indian emboidery stitches and their local names, Western stitch terms have been used, although Western stitches may not always be identical to their closest Indian equivalents.

A(i) Chain-stitch
Cotton embroidered with silk.
Bed or wall hanging.
Gujarat.
(Detail of plate 1).

A(ii) Reverse.

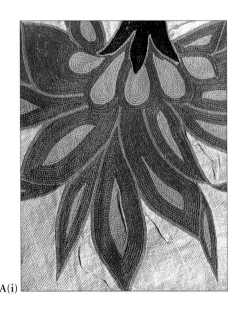

A(i)

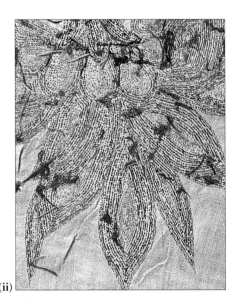

A(ii)

B(i) Chain-stitch
Cotton embroidered with *tussar* silk.
Border of a bedcover.
Bengal.
(Detail of plate 20).

B(ii) Reverse.

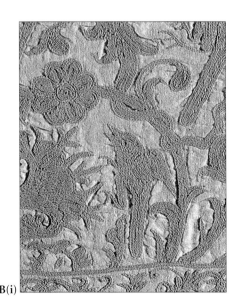

B(i)

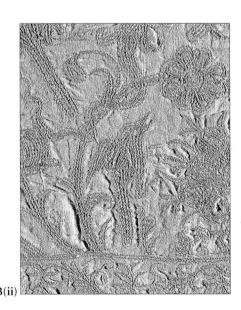

B(ii)

C(i) Back-stitch
Cotton, quilted with cotton thread and
wadded with blue cotton.
Bedcover.
Ahmedabad.
(Detail of plate 51).

C(ii) Reverse.

Below:
D(i) Chain-stitch.
Silk satin embroidered with silk thread.
Skirt.
Mochi community, Kutch.
(Detail of plate 75).

D(ii) Reverse.

C(i) C(ii)

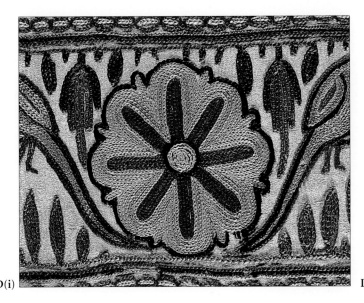
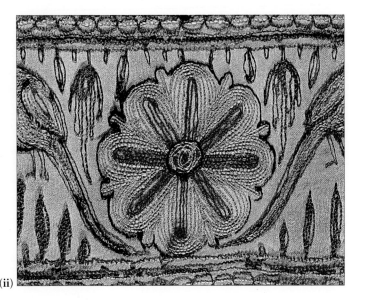

D(i) D(ii)

**E(i) Chain-stitch, interlacing-stitch,
herringbone-stitch.**
Silk embroidered with floss silk.
Skirt fabric.
Lohana community, Kutch.
(Detail of plate 84).

E(ii) Reverse.

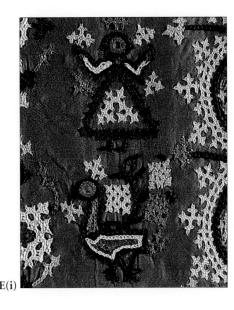
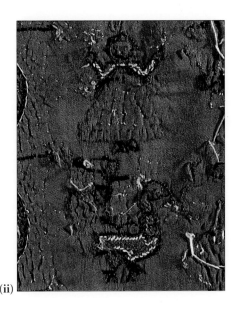

E(i) E(ii)

**F(i) 'Sindhi stitch': radiating stitches
combined with buttonhole-stitch,
Roman stitch over laid thread**
Cotton embroidered with silk.
Man's wedding scarf (*bokano*).
Tharparkar, Sindh.
(Detail of plate 98).

F(ii) Reverse.

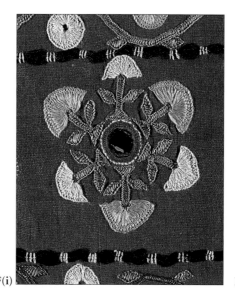

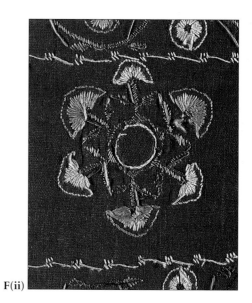

F(i)

F(ii)

**G(i) Satin-stitch, double running-stitch,
interlacing-stitch, hem-stitch**
Cotton embroidered with silk.
Man's wedding scarf (*bokano*).
Sodha Rajput or Suthar community, Sindh.
(Detail of plate 100).

G(ii) Reverse.

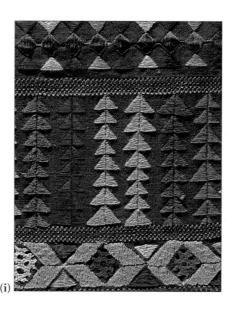

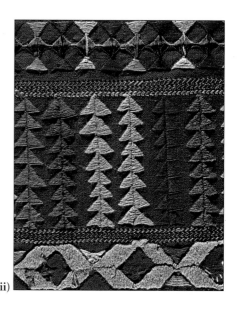

G(i)

G(ii)

**H(i) 'Sindhi stitch': surface satin-stitch
combined with buttonhole-stitch, open
chain-stitch, Roman stitch**
Silk embroidered with floss silk.
Child's dress.
Badin, Sindh.
(Detail of plate 107).

H(ii) Reverse.

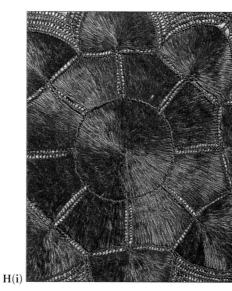

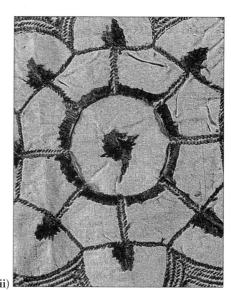

H(i)

H(ii)

I(i) Running-stitch, pattern darning-stitch, satin-stitch, buttonhole-stitch
Cotton, quilted and embroidered with cotton thread.
Wrapper (*bostani*) or seating mat (*ashon*).
Bangladesh.
(Detail of plate 117).

I(ii) Reverse.

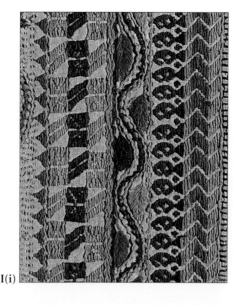
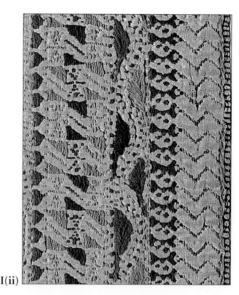

I(i)　　　　　　　　　　　　I(ii)

J(i) Surface darning-stitch
Cotton embroidered with floss silk.
Woman's headcover (*chadar*).
Eastern Punjab.
(Detail of plate 123).

J(ii) Reverse.

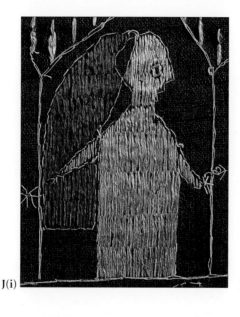
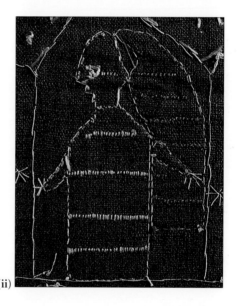

J(i)　　　　　　　　　　　　J(ii)

K(i) Surface darning-stitch
Cotton embroidered with floss silk.
Coverlet (*rumal*).
Swat Valley, Pakistan.
Cotton embroidered with floss silk.
(Detail of plate 128).

K(ii) Reverse.

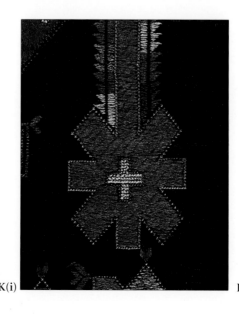
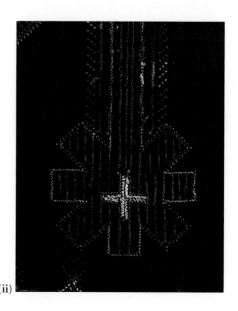

K(i)　　　　　　　　　　　　K(ii)

⧼ *Bibliography* ⧽

Askari, Nasreen and Crill, Rosemary. *Colours of the Indus. Costume and Textiles of Pakistan* (London, Merrell Holberton 1997)

Bérinstain, Valérie. *Phulkari. Embroidered flowers from the Punjab* (Paris, AEDTA 1991)

Cousin, Françoise. 'Blouses brodées de Kutch. Coupe et décor', *Objets et Mondes* (Autumn 1972), vol. XII, fasc. 3

Elson, Vickie. *Dowries from Kutch. A Women's Folk Art Tradition in India* (Los Angeles, Museum of Cultural History, University of California 1979)

Fisher, Nora, ed. *Mud, Mirror and Thread. Folk Traditions of Rural India* (Ahmedabad, Mapin Publishing 1993)

Frater, Judy. *Threads of Identity. Embroidery and Adornment of the Nomadic Rabaris* (Ahmedabad, Mapin Publishing 1995)

Gillow, John and Barnard, Nicholas. *Traditional Indian Textiles* (London, Thames & Hudson 1991)

Guy, John and Swallow, Deborah, eds. *Arts of India 1550–1900* (London, Victoria and Albert Museum 1990)

Hitkari, S.S. *Ganesha-Sthapana. The Folk Art of Gujarat* (New Delhi, Phulkari Publications 1981)

Irwin, John. *Indian Embroidery* (London, HMSO 1951)

Irwin, John and Hall, Margaret. *Indian Embroideries* (Ahmedabad, Calico Museum of Textiles 1973)

Irwin, John and Hanish, Babette. 'Notes of the use of the hook in Indian embroidery', *The Bulletin of the Needle and Bobbin Club* (1970), vol.53, nos. 1–2

Irwin, John and Schwartz, P.R. *Studies in Indo-European Textile History* (Ahmedabad, Calico Museum of Textiles 1966)

London, Kensington Palace. *Embroidered Quilts from the Museu Nacional de Arte Antiga Lisboa. India Portugal China 16th/17th century* (1978)

London, Victoria and Albert Museum. *The Indian Heritage. Court Life and Arts under Mughal Rule* (1982)

London, Whitechapel Art Gallery. *Woven Air. The Muslin and Kantha Tradition of Bangladesh* (1988)

Marg (1964), vol. XVII, no. 2 (issue devoted to Indian embroidery)

Morrell, Anne. *The Techniques of Indian Embroidery* (London, Batsford 1994)

Nabholz-Kartaschoff, Marie-Louise. *Golden Sprays and Scarlet Flowers. Traditional Indian Textiles from the Museum of Ethnography, Basel* (Kyoto, Shikosha Publishing 1986)

Nana, Shireen, née Mirza. *Sindhi Embroideries and Blocks* (Karachi, Department of Culture and Tourism, Government of Sindh 1990)

Nanavati, J.M. *et al.* The Embroidery and Bead Work of Kutch and Saurashtra (Baroda, Department of Archaeology, Gujarat State 1966)

Paine, Sheila. *Chikan Embroidery. The Floral Whitework of India* (Aylesbury, Shire Publications 1989)

Rai, Ashok. *Chikankari Embroidery of Lucknow* (Ahmedabad, National Institute of Design 1992)

Steel, Flora Annie. 'Phulkari work in the Punjab', *Journal of Indian Art* (1988), vol. II, no. 24

Watt, George. *Indian Art at Delhi 1903, being the official catalogue of the Delhi Exhibition, 1902–3* (Calcutta, Superintendent of Government Printing [1903])

Zaman, Niaz. *The Art of Kantha Embroidery* (Dhaka, University Press 1993, 2nd edn)